Photo Restoration:
From
Snapshots to
Great Shots

Robert Correll

**Peachpit
Press**

Photo Restoration: From Snapshots to Great Shots
Robert Correll

Peachpit Press
www.peachpit.com

To report errors, please send a note to errata@peachpit.com

Peachpit Press is a division of Pearson Education
Copyright © 2015 by Peachpit Press
All images copyright © 2015 by Robert Correll

Project Editor: Valerie Witte
Senior Production Editor: Lisa Brazieal
Development and Copy Editor: Emily K. Wolman
Proofreader: Steffi Drewes
Composition: WolfsonDesign
Indexer: James Minkin
Cover Image: Robert Correll
Cover Design: Aren Straiger
Interior Design: Mimi Heft

ISBN-13: 9780134120119
ISBN-10: 0134120116

9 8 7 6 5 4 3 2 1

Printed and bound in the United States of America

Dedication

To my family.

Acknowledgments

Although this page is shown at the beginning of things, it is actually among the last things I will write. For me, it is a time of celebration and rejoicing. Finishing a book is like winning a battle at the end of a long war. I get to hand out medals and express my thanks to those who have been at my side during the hard work.

Let me share how wonderful it was to work with everyone at Peachpit. I was given the freedom and support to write the book I thought should be written to help you transform your old raggedy snapshots into great shots using Adobe Photoshop.

I want to thank Valerie Witte (Project Editor), Lisa Brazieal (Senior Production Editor), Emily K. Wolman (Development and Copy Editor), Steffi Drewes (Proofreader), and WolfsonDesign (Composition) by name. Thank you all for your hard work, expertise, and camaraderie as we put this book together.

It is always a pleasure to thank my agent and friend, David Fugate, of LaunchBooks Literary Agency. David, thank you for all of your work and support.

My family continually encourages me, strengthens me, puts up with me, and helps me through every project. Special thanks to the love of my life, Anne, for sitting in the office looking at photos and reading chapters with me.

Contents

Introduction

I love introductions. They let us sit down and have a quick chat about the book you're considering purchasing. You get your first taste of who I am and how I think.

In writing *Photo Restoration: From Snapshots to Great Shots,* my goal was to create a user-friendly guidebook that shows you how to select, handle, scan, and restore aged or damaged photos using Adobe Photoshop (and, to a lesser extent, Photoshop Elements). I organized the material according to my own general restoration workflow. After selecting and scanning photos, I clean their surface and repair any damage. I then make color corrections and enhance the brightness and contrast. I conclude by putting my finishing touches on the photos.

As you can imagine, there are a lot of technical bits and pieces along the way. To keep things manageable, I focused on distilling and concentrating my knowledge and expertise for you. I winnowed out anything that was not absolutely necessary and prioritized what was left. I also tried to impart as much about the touch and feel of restoring photos as I could.

I hope this book is fun, friendly, detailed, and practical for you. Bon appétit!

Q: Who is this book for?

A: Anyone who wants to learn more about restoring old or damaged photos using Adobe Photoshop. Although there are occasional differences, you will be able to follow along if you plan on using Photoshop Elements.

Q: Do I need to be a Photoshop expert?

A: No, but it will help if you've used Photoshop before. If you know nothing about Photoshop, you have to be willing to learn the basics of the program on your own. I did not have the space to show you how to use Photoshop from the ground up *and then* teach you how to restore photos. I had to choose what to focus on.

Q: Should I start at the beginning of the book?

A: Yes and no. I introduce topics in the book according to a very specific workflow. You will benefit most from this design if you start at the beginning and continue fairly linearly. However, you can (and should) skip to subjects that interest you. Either way, by the time you've finished, you'll have learned that each small part of photo restoration is joined to a larger whole. Learning how these pieces fit together will help you restore photos in the long run.

Q: I don't get your sense of humor. Do you have one?

A: Yes. I love irony and absurdity. My humor can be dry and wet at the same time. I have tried to be friendly and funny but not slap you in the face with it. Mostly.

Q: Are the assignments important?

A: Yes, but not because they offer new information. I designed the assignments to help you review the important points in each chapter. By giving you something concrete to accomplish, I hope to focus your attention and lock the details into your memory. It would be a shame if you skipped them.

Q: How did you get started restoring photos?

A: Some time ago, my wife was going through her family photos and organizing them with her mom. When I looked through the photos with her, I realized that I could help by scanning and restoring some of them. I fell in love with it right away. I've learned far more about our families than I would have otherwise. It has been both rewarding and therapeutic.

1
The Art and Science of Photo Restoration

Making Lemonade

I love a good glass of lemonade (and pecan pie, hamburgers, bread and butter pickles, and my mom's spaghetti sauce; but those are other stories). My favorite kind is the type you get from county fairs. It's freshly squeezed and deliciously sweet, and quenches your thirst on a hot and lively summer night.

I would like for you to feel the same lemonade-y goodness from photo restoration: taking old or damaged photos and making something better out of them. This chapter will get you started.

Poring Over the Picture

This unrestored photo of my wife was taken in Colorado in 1995 with a 35mm film camera. It's pure *snapshot*. I love the subject (of course), the composition, and the scenery behind her. The problem is, the print itself has been exposed to the elements for about 20 years. While it's not even close to being ancient, it's showing signs of deterioration. It's a perfect candidate for restoration.

The photo as a whole has a yellowish color cast.

Small specks, dust, lint, and other marks appear throughout.

Some surface blemishes are apparent even when the photo is not magnified.

The sky is an odd shade of blue.

The sky has discolored areas, probably caused by handling.

These clouds should be bright white.

The foreground appears fuzzy and lacks definition.

Poring Over the Picture

I approached this photo knowing that if I could correct the yellow color cast and brighten it up, it would look far better than the original. However, that's not all I did. I covered up as many specks of dust and debris as I could to clean the photo and sharpen the details. This is now a *great shot.*

I corrected the colors in the photo to remove the yellow tint.

I removed most of the surface blemishes, paying special attention to the largest ones.

This shade of blue makes the sky look like the sky should and not like water.

I covered the discolored areas to hide them.

I brightened the photo so that the clouds were white.

I sharpened the photo to enhance the clarity in the foreground.

What You Need to Get Started

One mystery of photo restoration is that, while each photo is unique, you can approach them all with the same basic equipment and overall mindset. You'll gather photos for restoration, choose the ones you want to work on, and follow a consistent plan of attack to turn them from snapshots to great shots. To accomplish this, you need photos, a scanner, a computer of some sort, photo manipulation software with which to restore the photos, and the right frame of mind.

Photos

To begin a photo restoration project, the first thing you'll need is a collection of old photographs as your source material. Old photos gather together in albums, photo envelopes from the developer, shoe boxes, folders, three-ring binders, plastic tubs, file cabinets, and other types of containers. **Figure 1.1** illustrates some of the types of albums you may have. They come in many sizes, shapes, and colors. The orange fuzzy thing in the background photobombing the picture is just a cat, however.

Figure 1.1
A small portion of my collection of albums and photos (cat not included).

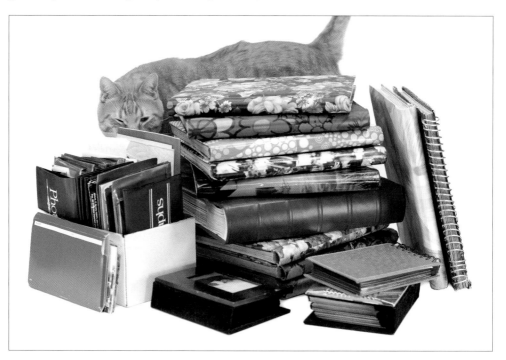

Dust off your fedora and get your leather jacket on if your albums and loose photos are not readily accessible. They may be inconveniently stored in out-of-the-way places. Look in your attic, basement, garage, or storage unit—or halfway across the country with your great aunt. As you hunt for your snapshots, be on the lookout for negatives, photos in frames, and old daguerreotypes, tintypes, and postcards.

Hardware

To restore photos, you will need the following hardware to perform various tasks:

- **Scanner**: You'll need a scanner to optically scan your photos. Although there are many types of scanners, I suggest working with a traditional flatbed scanner for photo restoration. More on this in Chapter 2, "Preparing and Scanning Photos."

- **Computer**: You'll also need a computer or other device to operate your scanner, store the digitized photos as image files, and run Adobe Photoshop. Until recently, this would have meant a robust desktop or laptop computer (Windows or Macintosh). However, Photoshop can now run on Microsoft tablets. Believe it or not, you don't need a Cray supercomputer or HAL 9000 (which technically would be obsolete by now, but still seems futuristic) to get the job done. As long as your system is compatible with your scanner and satisfies Photoshop's minimum requirements, you'll be fine. However, using a newer, faster computer with loads of processing power, storage space, and memory will make working on large photos much easier.

If you are shopping for a new system or deciding on upgrades (not all systems can be easily upgraded), here are some areas related to photo restoration that you should consider:

- **Storage space**: Make sure you have enough free hard-drive space to store and back up your photos. Photoshop will use some of this space for extra memory.

- **Monitors**: Using two (or more) monitors will revolutionize how you compute. It opens up your desktop and gives you the room to work without having everything stacked on top of each other.

 I use Photoshop on one screen and whatever I like on the second, whether it's the original scan, my e-mail program, a folder showing my files, Photoshop's help documents, or something from the Web. It's utterly fantastic being able to work like this. I will not willingly go back to using a single monitor.

- **Graphics card**: A fast graphics card (look for speeds of at least 1 gigahertz) with lots of memory (2 gigabytes or more) can speed things up. Look for a graphics card that supports dual monitors.

- **RAM**: More RAM is better when working with memory-intensive programs like Photoshop. Eight gigabytes of memory is the new minimum. Treat yourself to at least 16 or 32 GB if you can afford to.

- **Mouse**: Although it might seem trivial, think about a mouse upgrade. Although you may not need a top-of-the-line programmable gaming mouse with 55 and a half buttons, find something that fits your hand well and has more precision than the bargain-bin variety. You may also want to go cordless.

- **Pen tablet**: I recommend trying a pen tablet and seeing what you think. In **Figure 1.2**, I'm using my rather old Wacom Graphire4 tablet. Check Wacom's (www.wacom.com) line of Bamboo tablets for an entry-level experience or their Intuos line for more power. These tablets are very intuitive to use, and make painting or brushing in Photoshop a breeze.

- **Calibration**: Whether you use one or two monitors, look into getting a hardware-based display calibration system. It is not an absolute necessity, as you can use software to calibrate your monitor. However, it's a reliable way to make sure the reds you see on your monitor are actually red.

Figure 1.2
Work with a pen tablet like you would a pen and drawing pad.

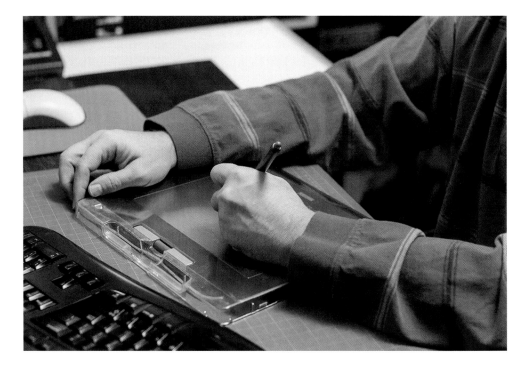

Using Laptops and Tablets

I don't normally use a laptop or tablet when restoring photos. My reasons are related to screen size (they're smaller than desktop monitors), keyboard size (they're smaller than a standard desktop keyboard), pointing device (I prefer using a mouse to a trackpad or touch screen), and the fact that it has only a single screen (as opposed to my multi-monitor setup). Your mileage may vary. As long as your laptop or tablet has the horsepower to run Photoshop, there's no reason you can't use it, especially if you're traveling or need to work away from your home or office.

Software

You'll need software to scan and manipulate your photos.

Scanners come with their own drivers and software, so you don't have to worry about buying anything extra for scanning your photos. However, you can purchase third-party scanning software if you want to try something different.

To restore photos, this book features Photoshop as the primary tool of choice. It's the gold standard photo-manipulation application, and for good reason. Photoshop is powerful, easy to use (but hard to master), has become more accessible, has a million tools and options, and is well supported. I have used it for many years now without a hint of disappointment.

Oddly enough, there are two current versions of Photoshop available at the time of writing: Photoshop CS6 (CS stands for Creative Suite) and Photoshop CC (2014) (CC stands for Creative Cloud). CC 2014 is the newer of the two and includes some features that CS6 does not have.

Keeping to Adobe products, the less expensive but viable alternative to Photoshop is Photoshop Elements. When it comes to photo restoration, Elements has many of the same basic tools and capabilities as Photoshop.

If you don't already have it, I recommend trying Adobe Lightroom. Although it's more of a photographer's tool, Lightroom can effectively assist Photoshop by organizing your collection of scans and providing nice options for printing, slide shows, bookmaking, and Web galleries. Photoshop Elements has similar options built into its Organizer.

A Methodical, Problem-Solving Mindset

You may be the type of person who likes to wing it. While there is nothing intrinsically wrong with that, flying by the seat of your pants has some drawbacks—namely, consistency and time. Photo restoration is an exercise in problem solving. Your job is to look at the photos you have, uncover what's wrong with them, and then try to fix them up. It really helps to develop a "way you like to do things" and stick with it for every photo.

If two photos have the same or similar problems, it stands to reason that you should be able to restore them using the same tools and techniques. You can, and you should.

Approaching photo restoration methodically will save you many hours as you move from photo to photo. You won't have to reinvent the wheel each time you start on a new photo. Overall, you'll apply your solutions more consistently and get better (and faster) as you perform the same activities.

Figure 1.3 is a photo of my grandmother sitting on her porch. The photo is close to 60 years old. Although faded a bit with age, it is still in very good condition overall. The main problems are with color and contrast. I have seen these same issues in many other photos. It's no surprise, therefore, that I was able to apply the same approach I have used many times before to the specifics of this photo. I was able to restore the photo in large part by correcting the color and improving the brightness and contrast. The result, shown in **Figure 1.4**, is clearer, brighter, cleaner, and better.

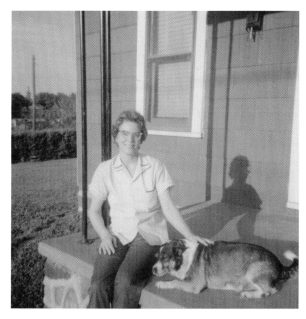

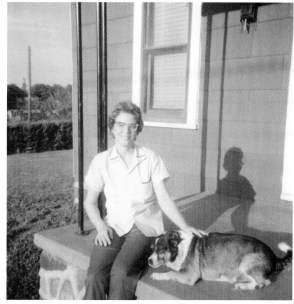

Figure 1.3 By learning to look at photos and evaluate them with a problem-solving mindset…

Figure 1.4 …you will be able to restore them much more effectively.

Photo restoration is a skill that requires effort and practice. Having a methodical, problem-solving mindset keeps you from feeling overwhelmed, and helps you organize your thoughts and focus on the work at hand.

Having said that, you can (and should) experiment with new tools and techniques. Let your hair down and restore some photos artistically. These activities are fun and will help keep your approach fresh.

Ultimately, your goal should not be to perfect each photo you work on. If only that were possible! Regardless of their condition, most photos you work on will not come anywhere near the overall quality of a well-photographed digital picture.

Gathering and Evaluating Photos

If you're like me, you have old photos from your past, albums from your family, and a collection of albums and loose photos from those who have passed away. If you have 20 albums, each with 20 pages averaging four photos per page, you have at least 1600 pictures in albums alone!

You can't restore them all at once. How can you narrow the field? The answer might surprise you: Be picky.

As a general rule, choose the photos you like the most to restore. These are the ones that you can't seem to put down, that have something about them that grabs your attention. Some will be really great and have very little wrong with them. Others will challenge you.

I took the photo in **Figure 1.5** while flying in a UK C-130 over a refugee camp in eastern Kenya in 1993. We were coming in to land at a field that was barely long and wide enough to hold us. It was quite a memorable experience, and I love this photo. I would choose to restore this photo over many others. The finished version is shown in **Figure 1.6**.

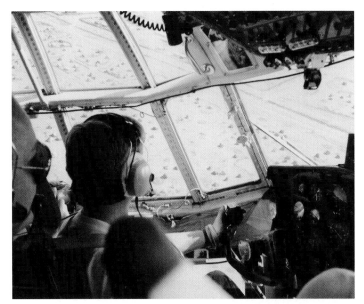

Figure 1.5
This photo has poor contrast and the colors are dull.

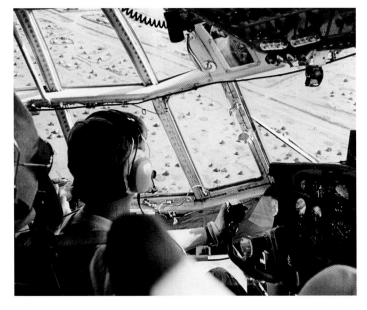

Figure 1.6
After restoration, it is ready to be printed and hung on the wall.

Not every picture needs to be saved (or certainly not all at once). **Figure 1.7** shows the type of shot that you should not feel embarrassed to pass up. It was taken in 1977 on a family trip to Florida's east coast. It's so blurry you can hardly tell who is in it.

My wife and I have hundreds of pictures of some members of our family. If we run across a poor photo that is otherwise unremarkable, we will put it aside. If we have others that are much better, we will throw away the blurry, out of focus, or seriously degraded shot. Those who come after you will thank you for managing your collection by keeping only the best or most memorable shots.

You should also evaluate photos based on why you want to restore them. The next few sections cover three categories that you may fall into.

Figure 1.7 Don't worry about not restoring some photos—they're not all worth the effort.

Emotions Ahead

While I love restoring old (and not so old) photographs, I realize that not every memory is a good one. Believe me, I know. Even in the best of circumstances, old photographs can bring back painful memories that may unsettle you. Family, friends, and circumstances all can be the source of great pain.

If you think you'll be shedding more painful tears than happy ones, my advice is to make sure that you don't go through old photos alone. Have someone you love and trust pore over the albums and boxes of photos with you.

Sentimentality

If you want to restore photos for sentimental reasons, first you should decide how many you have time to work on. Pick a number you think you can finish, even if it's small. Three might work for you. If it's more or less, that's okay!

To begin, look through your photo collection and pull out those most emotionally significant to you. When finished, you should have a reasonably sized stack of photos. If your final goal is three, try gathering at least ten photos.

Next, begin narrowing down the choices. It can feel hard, but don't worry: Anything you don't start with now can go in the "do next" stack. Find the most interesting snapshots. Ask yourself if this is a photo you would put on your wall. Do you want to see it all the time? Over time (and with experience), you will develop this skill and be able to winnow out photos more quickly.

Finally, estimate how hard each photo will be to restore. Do not forget to take this into account. If the photo will take too much time or you don't feel like you can do it justice, set it aside to restore later.

When you have chosen your final photos, place the others in a safe place. If you know that you won't work on them anytime soon, you may want to put them back in their original location.

Figure 1.8 is a great example of a sentimental photo; it's of my father-in-law and his dog in 1942. This photo is not in the best shape—it has yellowed with age, has brightness problems, and the focus is poor—but it's a great snapshot of him as a child. Even though it cannot be made to look like a new, pristine digital photo, it is still worth restoring (see the refurbished image in **Figure 1.9**).

Archiving Versus Restoring

Some photos have little to no potential to be restored, yet are still very valuable for sentimental reasons. Maybe it's the only photo of a person you have. Set aside these photos to scan and preserve digitally, even if you don't think you can restore them. Always be on the lookout for these important treasures worth saving.

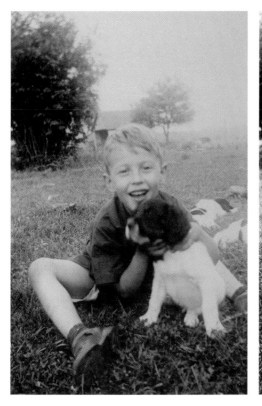

Figure 1.8 **Sentimental photos tug at your heartstrings.**

Figure 1.9 **When restored, they are even more appealing.**

Artistry

You may want to evaluate photos based on their artistic potential. Perhaps you're looking for something to decorate with or use as a background on your computer desktop.

Look through your collection for anything you think is cool, pretty, different, beautiful, interesting, amazing, funny, somber, colorful, or weird. It might be the best photo in your collection—or the worst. You can be creative and artistic with many different types of photos.

Set aside a number of photos so that you can have several to play around with. If you need only one, try looking for five. You'll have fun working with them all.

I took the photo shown in **Figure 1.10** in 1986 during a heavy snow storm. I was a student at the US Air Force Academy, and this is the view from my dorm room window. The details that stand out are the chapel, the cadets walking across the terrazzo, and the plane on static display. Although it's a color photo, it screams to be artistically restored as a high-contrast black-and-white image (see **Figure 1.11**).

One challenge of artistic restoration is seeing a photo's artistic potential. What makes it harder is that even bad photos or damaged snapshots can make great artistic statements. Therefore, be prepared for trial and error. In the end, not every photo you choose will turn into something cool—but there will be some that surprise you.

Figure 1.10
Look for distinctive photos to transform artistically.

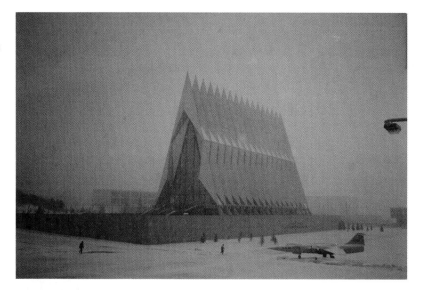

Figure 1.11
Converting the photo to black and white and enhancing the contrast results in an amazing transformation.

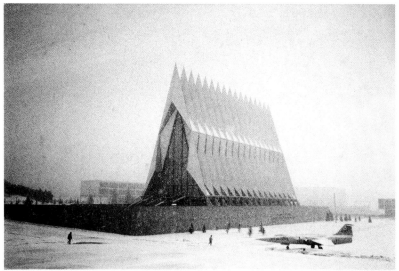

Projects

Photo restoration makes a great project-based activity. Try looking through your photos and putting together a digital photo frame full of restored birthday celebrations, baby photos, and photos of all your family pets, family events (yearly trips to the lake, for example), weddings, honeymoons, vacations, time in the service, or photos to illustrate a family genealogy project.

For projects, find photos of subjects that support your specific topic, such as the school photo of my wife in **Figure 1.12**, and then narrow them down in light of how many you need. Look at sentimental value, composition, and the amount of damage present (less is better) to break ties. The restored version, shown in **Figure 1.13**, is brighter and cleaner, and has much better color than before.

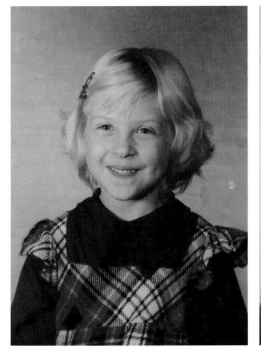

Figure 1.12 **School photos make great restoration projects.**

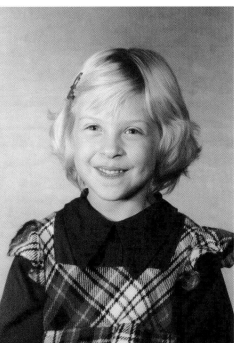

Figure 1.13 **This photo looks like it was just taken.**

Categorizing Common Problems

While there are a million and one things that can be wrong with photos, they all fall into a few fairly simple categories. Part of my purpose in this chapter is to show you what they are. I'll use the rest of the book to cook up some recipes that will help you fix what's wrong.

Before getting into the categories, review these general thoughts on the problems that photos share:

- Every photo you restore will have something you can clean (digitally), repair, or improve.

- Once you've successfully corrected the color in one photo, you will have a good idea how to do it in all the rest.

- Most photos share similar problems. I'm always cleaning dust and specs off the surface of photos, whether they are two, five, ten, or 100 years old.

- Most photos have a "signature" problem—that is, the most obvious defect when you look at it. It might be blemishes, damage, color, brightness, noise, or another type of problem.

- Being able to recognize the problems a photo has and put them into the right categories will boost your photo restoration skills tremendously. This skill saves you time and trouble, and makes the workflow go much more smoothly.

Surface Blemishes

Blemishes and debris will appear on the surface of virtually every photo you will restore. You can expect to find imperfections like dust, lint, small specks, hair, writing, ink smudges, scuff marks, spots, stains, splotches, chemical stains, gunk, tape, and tape residue. While the specific maladies may be different, you'll deal with all of them very similarly.

Figure 1.14 shows three examples of the types of things you will find on your photos. There is a scrap of something and stains on the first photo, as well as specks, lint, dust, and numerous other surface blemishes on all of the photos. And as you can see, you have no control over where the blemishes are. Some will be located in the background of your photo; others will be directly on people's faces.

Figure 1.14
These photos are plagued by gunk, dust, and lint.

Physical Damage

Physical damage includes scratches, holes, creases, damaged edges, bent corners, missing pieces, cuts or tears, and more. Superficially, repairing physical damage is similar to cleaning the surface of a photo. However, the size and extent of the damage is generally greater. You will learn to re-create damaged areas from undamaged areas of the photo.

Figure 1.15 shows three photos that have physical damage. Creases, scratches, and bends are very common, as you can see from the outer photos. If these problems are on people's faces, it will be a challenge to repair them. However, when the damage is in an area without much detail, the repairs go very smoothly.

Figure 1.15
Physical damage comes in many forms.

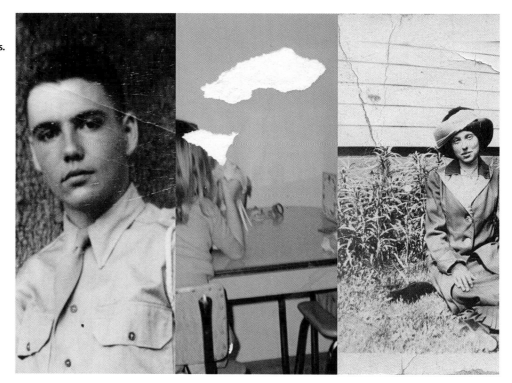

Color

Color problems are often the result of age. Different photo papers react to time and storage differently. Black-and-white photos can turn yellow-brown, and color photos turn odd tints with age. Other color problems are caused by poor storage and developing errors.

The solution to color problems is either to discard all color information or to have Photoshop remap the colors to the correct hue. Rebalancing existing colors is actually pretty easy.

Figure 1.16 shows three photos with color issues. The first and second are color photos whose colors have gotten funky with age; the final shot is a black-and-white photo that has yellowed. If you can repair them, these photos will look dramatically better than their originals.

Figure 1.16
Color problems are easy to spot.

Brightness and Contrast

Brightness problems, such as bright and featureless skies, are generally caused at the time a photo is taken. Photos that are too bright tend to be caused by an overachieving flash. It can be very hard (but not impossible) to improve lighting in photos. Poor contrast (most often too little), on the other hand, is a very common problem and can readily be fixed.

Figure 1.17 shows three examples of brightness and contrast problems. The challenge when restoring photos like this is not to ruin them. Changing the brightness too much can alter colors, increase noise, or make the photo look very unnatural.

Figure 1.17
Brightness and
contrast problems
can be tricky to fix.

Problems in Other Areas

As you might imagine, there are many other types of problems photos can have in addition to those just listed (see **Figure 1.18**). You should be prepared to fix red eye, for example, or attempt to reduce glare on glasses.

Additionally, some photos need to be straightened. Others have distracting elements in them, such as camera straps, which can be removed. Others could be improved by recomposition or cropping. Some photos are either slightly out of focus or too soft; they may look better if sharpened.

Film grain, sometimes referred to as noise, is a factor in photos that have been enlarged or shot using high-ISO film. Noise in a color photo can look better if you convert it to black and white.

Figure 1.18
Other problems include crooked photos, red eye, and noise.

Following a Consistent Plan

As you restore your photos, I encourage you to follow a consistent plan. Your skills will improve far more by being consistent than by approaching each photo differently. When your skills get better, the photos you restore will look better, and that's a good thing.

Here is the general workflow I follow, and the rationale behind why I do what I do when I do it. As you read through the list, realize that knowing what the problems are helps you put them in the correct step to solve. Over the course of the entire process, you'll end up fixing everything.

1. Choose one or more photos to restore.

2. Scan and save the photos using your scanner and scanner software.

3. Pick the first photo to restore, open it in Photoshop or Photoshop Elements, and save it as a Photoshop file (.psd).

I choose not to use Adobe Lightroom at this point, although it is possible to import scans into a Lightroom Catalog to organize and develop them. You can also send files (or copies) to Photoshop from Lightroom for more advanced editing, and save your work as a Photoshop file (which is faithfully imported into Lightroom for you). Your primary work will almost always be done in Photoshop (or Elements), so I have avoided switching back and forth between programs.

4. Identify what needs fixing and brainstorm potential solutions.

 Experiment with different solutions and settings. Don't worry about doing things "in order" when brainstorming. Let your creativity and interest guide you. This is the step during which you want to come to grips with photos that can't be restored effectively.

 After brainstorming, you should have a good idea whether the photo can be restored to your liking and how you want to proceed.

 You can save your brainstorming ideas in the same file if you like, or revert back to the original scan or a previously saved Photoshop file. I prefer to save these ideas in a separate file (Save As is your friend). This allows me to review my ideas later and keep my working file smaller and more manageable. I always begin the next step with a clean Photoshop file.

5. Digitally clean the photo's surface.

 Restoring a photo's surface is pretty cut and dry, and you want to do this before moving on to anything else. Repairing physical damage, color, brightness, noise, sharpness, and other problems often requires more judgment.

 And, of course, that judgment can change. You may want to develop different adjustments, and you will not be sure which one will look the best in the end. If you don't fix the surface first, you may never get around to it! When you do, you may have to do it two, three, or more times for each option you've developed. And, if you choose one line and then change your mind, you'll have to go back to the beginning and repair the surface.

 Trust me on this: Clean the photo's surface before you continue. Use the brainstorming step to experiment with different approaches and alternatives to things like color adjustments, brightness and contrast changes, artistic effects, sharpening, and noise reduction.

 From this point to the end, it can be helpful to occasionally save a flattened copy of the photo you are working on as a JPEG and look at it using your operating system's software (Preview for Mac or Windows Photo Viewer). Oddly enough, you'll often spot things you miss in Photoshop.

6. Repair as much physical damage as you can.

7. Correct or enhance the color.

8. Improve the photo's brightness and contrast if possible.

9. Fix other problems like noise or softness.

10. Make final adjustments and corrections to improve the photo.

11. Save the final Photoshop file.

12. Flatten the layers and save the result as a separate, single-layer TIF.

 This gives you a smaller file that can be printed or sent to a printer. You should also use this version to resize and convert to JPG for Web use.

Figure 1.19 is an example of a sentimental photo taken of my wife's Grandma Jo in 1956. When restored, photos like this knock your socks off (see **Figure 1.20**).

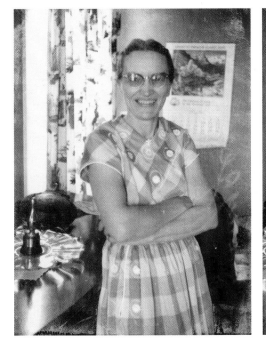

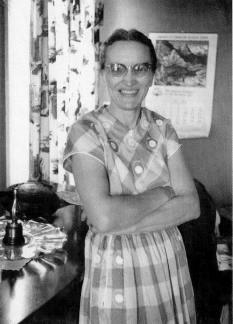

Figure 1.19 **Your challenge is to follow a plan that transforms an unrestored photo...**

Figure 1.20 **...into something better as effectively as possible.**

Experiment and Improve

I've come up with this workflow over years of experience and after working on thousands of photos. I offer it to you to try, with the expectation (and encouragement) that you should experiment on your own and modify any or all of it.

Keep Calm and Carry On

Restoring photos should be fun and rewarding. When you perform miracles on some photos, your family will lift you up on their shoulders and carry you around, singing cheers of approbation.

Alas, there are also times when it can get downright frustrating.

Some photos are too far gone to rescue effectively. Some were never good to begin with. Some have damage that might take you a year to erase, if ever.

If you ever feel like throwing the mouse through your computer monitor, I encourage you to remain calm. I offer these thoughts to help you weather the storm:

- Your goal should not be perfection. You are not working with something taken with a 24-MP digital camera.

- Photo restoration can be very incremental. Even the smallest improvement is still an improvement. A number of small improvements typically make the photo look much better. You don't have to get it all from one adjustment.

- You aren't the cause of the problems. You're there to help, and if you can't help as much as you would like, that's okay.

- Approach photos like you were a doctor treating a patient. Do your best to make them better, but for heaven's sake, don't make them worse! You may be tempted to push the limits because you think you should be able to take out all of the noise or sharpen the photo perfectly. Don't.

- Love the photos you work on, even the ones you can't fully repair. Appreciate them and think about when they were taken and what life was like for the subjects.

- Even damaged photos can be appreciated. It's not all or nothing. **Figure 1.21** is an example of a sentimental photo taken of my uncle, grandpa, and me after an impressive fishing trip. Even though the photo wasn't taken with the best camera, wasn't printed on the best paper, and has aged, it brings back wonderful memories (see **Figure 1.22**).

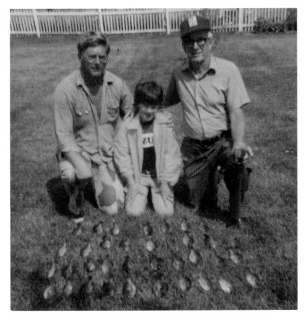

Figure 1.21 Choose photos that carry great value, even though they are not perfect.

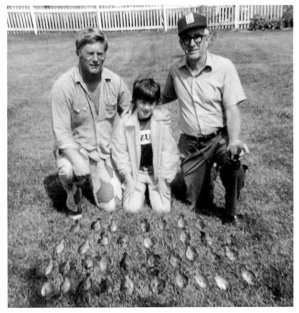

Figure 1.22 Restoring and preserving these photos makes you appreciate them even more.

On a more technical level, keep these thoughts in mind as you restore your photos:

- If you want great shots, pick good photos to begin with.

- On the other hand, photos you may not think are prize winners can be the catalysts for creative restoration. Be quirky and have fun with them.

- Don't change things just to change them. If you make an adjustment or do something and you can't tell if it made the photo better, don't bother with it. Meaningless changes accumulate and can make the Photoshop file impossible to handle or end up hurting the photo.

- In fact, try to do as little as possible to improve the photo. That protects you from overkill and making a mess of things.

- In the end, learn to trust your eyes. You know what looks good. Disregard all changes you make that don't pass the test—and remember, you didn't put the problems there.

Ten Teasers

Here are ten teasers to prepare you for what's coming up in the rest of the book:

1. Photo restoration takes practice. Hone your skills on as many photos as you can. You'll get better each time. (Chapters 1-7)

2. According to the Library of Congress, the best way to preserve your photos as you handle them is to wear clean nitrite or lint-free cotton gloves. (Chapter 2)

3. I'll show you how to duplicate the background layer in Photoshop and use the copy to compare your work with the original photo. (Chapter 3)

4. It's sometimes difficult to tell debris apart from objects. Try not to remove distinguishing marks on people's faces or other important content thinking they are specks on the photo's surface. (Chapter 4)

 For example, one time I mistakenly erased part of my wife's grandfather's hair because I thought it looked too much like Kramer's on *Seinfeld*. Well, it was supposed to look that way. When I realized my mistake, I had to go back and undo those changes.

5. Repairing physical damage is one of the most difficult aspects of photo restoration. Tackle a bit at a time. If it doesn't look right, don't do it. (Chapter 5)

6. When using the Clone Stamp or Spot Healing Brush tools, your goal is never to be noticed. (Chapters 3, 4, and 5)

7. Pure black-and-white photos can look somewhat artificial. In your zeal to restore your photos, don't remove all age-related tinting. A smidgen of sepia-toning can look great. (Chapter 6)

8. Brightness problems are notoriously hard to correct without elevating noise. (Chapter 6)

9. Noise reduction and sharpening almost always result in trading detail for smoothness or detail for noise. (Chapter 7)

10. A touch of dodging and burning can make things stand out in your photos. (Chapter 7)

Chapter 1 Assignments

After reading through this chapter, you should have an idea of how to approach photo restoration. It's not just a series of tools and technical details.

These practical, productive assignments are designed to help you get started and set you up for the rest of the book. You will find, evaluate, and select three photos that you can use as you try out and practice the techniques shown in later chapters. That sounds like more fun than conducting a lame equipment inventory, right?

Find a cool snapshot to restore

This one is simple. Find a cool snapshot from your collection of photos to restore. Look for something that's a great picture. Don't worry about finding a photo with damage or something obviously wrong to fix. Make this one easy.

Choose a photo with damage

Next, find another photo, possibly older than the first, with some sort of damage. Don't go overboard and pick the most damaged photo that you have. Try and find something with a few creases, bends, or other simple forms of damage that you can repair.

Select a photo with color problems

Finally, find a photo that has faded or yellowed. It can be black and white or color. Again, don't stack the deck against yourself. If possible, choose a photo whose problems are mainly consigned to color.

Share your results with the book's Flickr group!
Join the group here: www.flickr.com/groups/photo_restoration_fromsnapshotstogreatshots

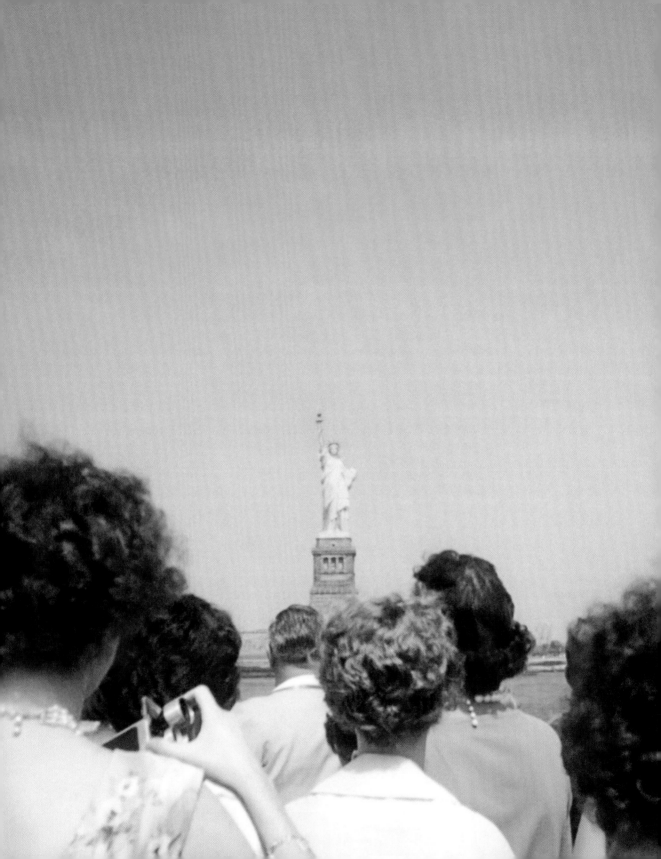

2

Preparing and Scanning Photos

Things You Need to Know

My goal for this chapter is to get you thinking about how to handle your photos, albums, and frames, and to review the basics of scanning. Although it may sound simple enough, getting photos out of albums and scanning them can be challenging.

I've ruined photos, scratched negatives, damaged albums, made my fair share of bad scans, obsessed over quality when I didn't need to, mistaken one setting for another, left options accidentally on when I didn't mean to, and not known what scanner settings to use. Learn from my experiences so that you don't make the same mistakes that I have.

Poring Over the Picture

Contrast is lacking.

Notice the moving child.

There are specks and spots throughout.

The background is overexposed.

Some details appear very sharp,
even in the unretouched photo.

The most obvious problem with
this photo is the yellowing.

This charming photo of a family picnic was
taken in the late 1920s. It's a snapshot of my wife's
grandfather (the dark-haired boy looking right at
the camera), his immediate family, and a collection
of aunts, uncles, and cousins. The photo itself is
approaching 90 years old, and it could use some
tender loving care.

Poring Over the Picture

I improved the contrast.

The child shows up better.

I thoroughly cleaned the surface
of spots and specks.

In this case, I left the background lighting alone.

I sharpened most of the faces.

I took most of the yellow out of the photo.

My intent in restoring this photo was to tackle the obvious problems without overdoing it. I took out most of the yellow but did not remove all signs of color. I improved the photo's contrast but left most other exposure problems alone. I sharpened faces without trying too hard, and accepted the fact that the photo was a bit grainy. The photo's imperfections add character but do not overpower it anymore.

To begin with, I want to share two important "big picture" thoughts that I wish I had known when I started restoring photos:

1. Within reason, do what you can to preserve and protect your photos and film. In other words, you don't have to handle most photos as if they were made out of dynamite and will explode at the slightest touch—but don't be negligent either. If you're a goal-oriented person who loves a challenge, take a step back and realize that when you face difficulties removing photos from albums and frames, the challenge is not about the album. It's about the photo.

2. Scanning is an imperfect means to an end. Within the limits of your time, equipment, and interest, do what you can to produce good scans of your photos and film. Decide what scanner to use, know what settings work for you, and then don't fret about whether or not you're getting the best conceivable scan. You probably aren't, but as long as you're in the ballpark, you're good.

Removing Photos from Albums and Frames

As you gather photos to restore, you will run into many different types of albums and frames. The purpose of this section is to review several techniques for removing your photos that will help keep you from damaging them.

Albums

Ideally, photo albums protect photos. The problem is, they can develop "fatal attractions" to photos over the years and refuse to break up with them.

Many albums, both new and old, have a clear plastic protective sheet that covers the photos and seals the page. Carefully peel back the sheet from the corner, as shown in **Figure 2.1**, to get at the photos. If the sheet feels like it is sticking to any photo on the page, stop and investigate before continuing. If necessary, place the sheet back in place and scan the photo with the sheet before trying again.

Figure 2.1 **Lift back the clear plastic sheet carefully.**

Don't use your fingers to pry up photos from their corners. This can crinkle or bend them. Slip one tip of a pair of tweezers or the point of a hobby knife under a corner and gently lift up (see **Figure 2.2**). Do not use the knife to pry; lift with it gently. If the photo remains stuck, do not continue. Try another corner and work your way in from around the photo. Ideally, the photo will pop out quickly.

Older albums are bound with string and have construction-paper pages. Photos in these albums tend to be mounted with corner mounts and come out rather easily. I freed the photo in **Figure 2.3** by gently lifting the center of the photo with my index finger. The trick is not to bend the photo excessively.

Some albums are three-ring binders with photos mounted on construction paper (mostly using corner mounts) inside sheet protectors. Open the binder rings to lift up the protective sheet and access the photos, as shown in **Figure 2.4**. You may want to remove the entire page from the album to work with photos.

Figure 2.2 **Use the knife to gently separate the photo from the paper without prying.**

Figure 2.3 **Do not exert too much force when lifting up a photo.**

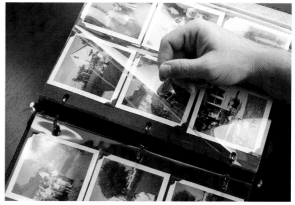

Figure 2.4 **Open the binder to free the sheet and lift it up and out of the way.**

Some prints were bound in flip-books (see **Figure 2.5**). To scan these photos, you will need to remove the photos from the album—never try to squish this type of book onto the scanner to flatten it. Look carefully at how everything is attached so you can take out the photos without damaging them, and then reassemble them into the binding when you're finished.

Magnetic albums (those with sticky pages) keep photos from sliding around, but the same stickiness that helps hold the photos in place can lock them down so tightly that you may never get them up. Do not try to pull a photo off these pages by lifting its corners: You will very likely ruin the photo by bending and creasing it. The photo's paper backing may also come off and remain stuck to the page, as shown in **Figure 2.6**. Getting the idea here? Magnetic album pages are a nightmare, and they are everywhere.

My advice in this situation is to scan the photo without attempting to remove it from the album and then set the album aside. It is not an ideal situation, but ruining the photo is even worse. There are options and techniques for attempting to remove photos stuck in albums like this, but I leave it to you to research and choose what method you want to try—and then, *don't*. Scanning photos is the least intrusive method of saving them.

Albums that have separate compartments for photos are a breeze to use. Gently slip the photo out to scan it.

If an album has labels, be sure to copy them (you can scan them, copy them to a word-processing document, or even put them into a database) and keep them with the scanned photo file for long-term archiving. Make sure you note which photo each label belongs to.

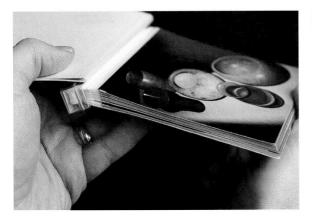

Figure 2.5 **Pay attention to details as you remove photos from flip-book albums so you can put them back together.**

Figure 2.6 **Thankfully, this was a test photo that I didn't care about keeping.**

Frames

When removing photos from frames, give yourself lots of elbow room. Use a large desk or moderately sized table so that you have space to spread out. You'll want the extra area for tools and so that you can set the glass, backing, matting, and pieces of the frame aside without feeling crowded. Tables in rooms that have a good amount of natural light, as shown in **Figure 2.7**, are perfect.

Some frames do not have glass in them. If you run across missing glass, be sure not to place other photos, frames, tools, or your coffee on top of the unprotected photo and risk scratching or damaging it.

A pair of needle-nose pliers (see **Figure 2.8**) will enable you to gently pull out small nails that may hold photos in frames without bending the nails or marring the frame. Framing is a specialty in and of itself. Although you can use a small hammer to tap the nails back in, you may want to look into specialty framing products that help you secure the contents in the frame with flexible or rigid points (also called inserts).

Old frames can come apart easily and may be hard to reassemble. Pay attention to how you hold the frame, and support it with care when removing any pins or nails.

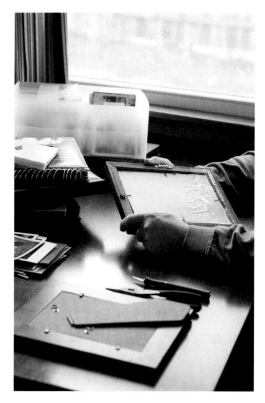

Figure 2.7 Give yourself room to work. The more light the better.

Daguerreotypes and tintypes often come packaged in complex cases with several removable parts, as shown in **Figure 2.9**. Exercise care when taking apart the case and make notes on how things will fit back together again.

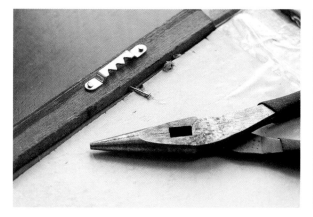

Figure 2.8 These nails were jammed in by the original framer; remove them with pliers.

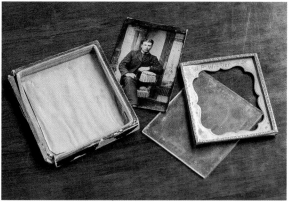

Figure 2.9 You should be able to reassemble the case when you're done scanning the photo.

Photos sometimes stick to the glass in frames. When you get to the point where you can lift the photo off the glass, try to do so gently. Do not become frustrated and peel it off like an adhesive bandage. If it remains stuck, scan the photo with the glass to preserve it before attempting any other removal technique.

Come up with a routine for taking photos out of frames and setting things aside. Be consistent. Don't turn one thing this way and another thing that way and set a third thing over here and a fourth part over there. Aside from risking losing things, a random approach makes it harder to put the frame back together. Carefully handle any matting or other material that was in the frame with the photo.

One final note: Be on the lookout for photos stuck inside frames with other photos, or for notes or writing on the back of frames, on photos in frames, on paper inside the frame, on the matte, on the core, or on the back paper. Be an investigator.

Helpful Links

The Internet is full of ideas—both good and bad—that show how to handle and store photos. I encourage you to investigate the subject on your own to supplement the basic information I present in this chapter. Simply search the Web for terms that correspond to your project or problem.

To get you started, I performed a few searches and found a handful of Web pages at the National Archives and the Library of Congress. I think that you will find them as interesting as I have.

- The National Archives has a page devoted to removing photos from albums:
 www.archives.gov/preservation/family-archives/detaching-photos.html

- The Library of Congress has information regarding the care, handling, and storage of photos:
 www.loc.gov/preservation/care/photo.html

- For information on storing negatives and transparencies, start here:
 www.archives.gov/preservation/storage/negatives-transparencies.html

- Finally, be sure to read this information from the National Archives on how to store photos:
 www.archives.gov/preservation/family-archives/storing-photos.html

Handling Photos and Film

You will be handling a lot of photos and film (most often negatives or slides) as you scan them. Clearly, you should do so with care. However, you do not have to create a NASA-style clean room as if you were assembling a Mars lander. This section offers some handy hints for how to protect your photos from yourself.

Handling Tips

Most photos are fairly sturdy and can be handled without too much fuss as long as you do so gently. Acquaint yourself with these reasonable practices and precautions.

Do's:

- Clean your hands before handling photos.

- Handle photos by their edges, if possible. Photos with borders make this easier. **Figure 2.10** shows my technique: I use my thumbs to control the photo while supporting the photo's weight with my fingers underneath.

- Keep photos out of bright light or direct sunlight.

- Keep photos flat.

- Although a bit impractical, use gloves to handle very aged or valuable photos.

Figure 2.10 **Keep fingers away from corners so that you don't bend them.**

Don'ts:

- Do not touch the photo's surface. Your fingers can leave oily, dirty prints or other residue that can harm the photo.

- Do not eat cheese puffs, potato chips, french fries, or other greasy snack foods when handling and scanning photos. (I really hope you get my sense of humor—it's dry, I tell ya.)

- Do not bend or curl photos.

- Do not stack photos and put pressure on them. If they aren't flat, don't try to press them flat. Photos have a bad habit of sticking together and scratching each other.

- Do not write on the back of photos, especially by turning them over and using a stack of photos as a lap desk. Make annotations in Photoshop, in another document, or on a notecard stored with the photo.

- Do not clip photos together or clip anything to them.

Not all loose photos are loose, as shown in **Figure 2.11**. Some come in complex mounts that can make handling more difficult. Treat these photos with extreme care and do not attempt to remove them from the mount. The more you open and close mounts like this, the more the folds will wear out. Be very careful not to bend or "over-open" these photos when placing them on a scanner.

Figure 2.11
This gorgeous photo is matted within a complex mount that one should handle with extra care.

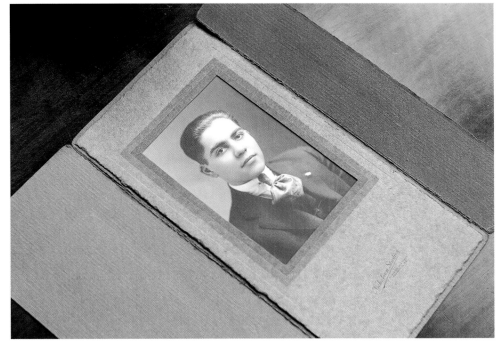

When handling film and slides:

- Touch film as little as possible. Unlike photos, film is not meant to be handled by hand. Use gloves diligently, as shown in **Figure 2.12**.

- Keep negatives in the protective sleeve they came in.

- Do not let negatives slip and slide against each other. They can be scratched, just like photos.

- Buy protective sheets to store loose negatives and other types of film. You can also use these sheets to reorganize and make storing easier. I use protectors that can hold six strips of 35mm film, each containing five frames.

- Keep slides in nice storage boxes or trays. Carousel trays, as shown in **Figure 2.13**, work well too.

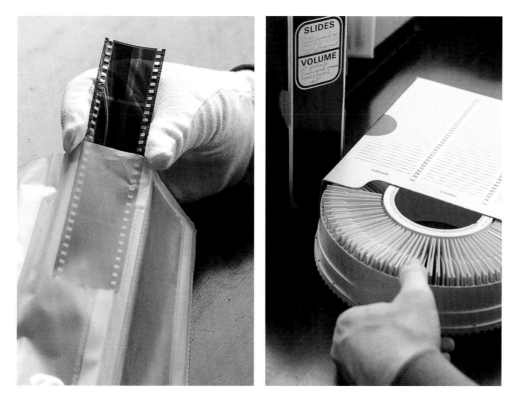

Figure 2.12 Keep your negatives under wraps and treat them with kid gloves.

Figure 2.13 Keep slides in storage boxes or carousel trays.

Cleaning Advice

Before attempting to clean your photos or film, remember: Even if your photo is dirty or damaged, you can scan and clean it using Photoshop without risking losing the photo forever.

If you do want to clean the original, do not try it without doing some serious research first. Kodak and Fujifilm have photo-cleaning recommendations on the Web. You may also be able to find helpful ideas from museums or historical preservation societies.

It's also important to practice on photos you would ordinarily throw away. You don't want to lose priceless shots from a botched attempt using the wrong technique.

To Dust or Not?

As you restore photos, you may become infuriated with dust. What you don't see with the unaided eye will be magnified a thousand times in Photoshop. This will tempt you to do something about it. After all, cleaning or dusting a photo will make the restoration job easier, right?

Not necessarily. By and large, you should ignore the urge to spit, clean, and polish. Instead, simply deal with the dust in software. The worst that can happen is that you spend a bit more time in Photoshop. That's not a problem compared to scratching or ruining the photo.

A soft puff of air or a gentle pass with an antistatic brush before scanning won't ruin the photo if it's not already falling apart. Kinetronics makes several types of antistatic brushes, which you can easily find online.

You can also use an air blower (the kind photographers use to blow dust out of their cameras) to blow air gently across photos and film before you put them on the scanner. Though if you blow too hard, you risk sandblasting the surface. If you don't have a blower, try using a soft lint-free cloth or duster—or your mouth, but you didn't hear me say that.

Shopping for a Scanner

Having a good scanner is an important part of photo restoration. If you can't get a decent scan to begin with, you will fight an uphill battle as you restore your photos.

The good news is that you don't have to obsess over every technical detail when shopping for a scanner. The things you will need a scanner to do are readily available on all major models that you will likely be shopping for.

I suggest looking for a flatbed reflective scanner that has a high scan resolution and the capability to scan film and slides. Optical (not digital or software) resolutions of 4800 dpi (dots per inch) for photos and 9600 dpi for film are fine.

Document, photo, and some film or slide scanners have less resolution and are not optimized for photo restoration. Some are casual appliances that fill a niche for quick scanning and archiving. In the same way, scanners built into most printers are adequate for basic scans but do not tend to have the same level of quality or options as dedicated flatbed scanners. There are very high-quality film and drum scanners available, but they are expensive. If budget is not a problem, investigate them to see if it's worth it for you.

For a decent scanner, expect to pay less than you would for all but the least expensive digital cameras. My Microtek ScanMaker S400 listed for $150 in 2004 and still runs fine. I have upgraded, however, and now use a Canon CanoScan 9000F (see **Figure 2.14**), which listed for $199.99 in 2010. The updated 9000F Mark II's list price is the same.

The cheapest scanners do, in fact, scan, but the maxim that "you get what you pay for" holds true in this case. These scanners are often slower, have fewer options, and skimp on scan resolution, color options, and quality.

In the end, stick with the middle of the road. Don't get the cheapest scanner, and don't get pulled into a contest to find the perfect scanner. It doesn't exist.

Figure 2.14
Mid-range flatbed scanners deliver decent quality and performance.

About Scanner Software

Most scanners come with software that has two modes of operation: a basic mode (also called Standard mode) and a more advanced mode (sometimes referred to simply as the Scanner Driver). **Figure 2.15** shows the Microtek ScanWizard 5 in Standard mode. **Figure 2.16** (on the following page) shows the same software using the Advanced Control Panel (I placed the photo crooked so that you can see how it unnecessarily complicates restoring the file later).

It might surprise you to know that they are both viable modes. You will not win any awards scanning in the Advanced mode instead of Standard mode. Which one you decide to use comes down to what you're comfortable with and how much time you want to spend digging around with settings.

Figure 2.15 Basic (or Standard) mode typically presents you with very simple options.

Figure 2.16
Use the Advanced mode for more control over all aspects of scanning.

You may be able to operate your scanner from within other applications, including Photoshop. If running Microsoft Windows, the Windows Image Acquisition (WIA) driver controls the scan, as shown in **Figure 2.17**. Macintosh computers running OS X can use Image Capture. Investigate these options on your system if you wish. However, when restoring photos, I recommend controlling your scanner using the dedicated scanner software.

Figure 2.17 **Agent Smith, prepare to be scanned.**

To launch your scanner software, follow these general steps:

1. Connect your scanner to your computer and turn on the scanner.

2. If your scanner software does not detect the scanner and open automatically, launch the scanner software as you would any other program.

 You may be able to press a button on your scanner to launch the software and get started.

3. Enter the mode that you want to use.

Choosing Scanner Settings

Choosing scanner settings is a breeze if you know what you want. That's the trick, really (and an important life lesson, by the way). When you know what you're after, you can quickly set up the scanner and get to work.

Common Basic Scan Mode Settings

In basic scanner modes, you are typically given "translated" choices that hide the technicalities of the specific scanner settings. You will make choices based on easy-to-understand questions and options the software presents. Typically, these options are ordered or numbered to make it easy to figure out what to do first, second, and so forth.

Figure 2.18 shows the basic dialog box that runs the Canon CanoScan 9000F. Although your software may have different options and names, it will behave generally the same way. **Figure 2.19** is the Scan Settings dialog box, where you can select specific basic mode scan settings.

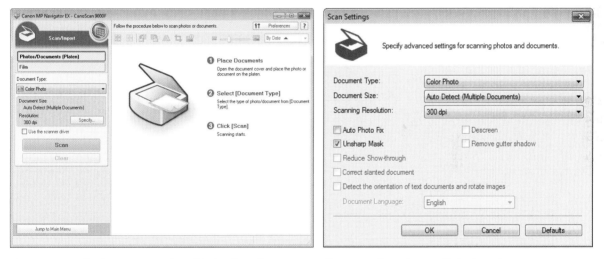

Figure 2.18 **Another basic scan interface, this time from Canon**

Figure 2.19 **Accessing specific basic settings**

When operating your scanner in a basic mode, be prepared to decide on the following settings.

Source or Document Type

This is the type of material you are scanning, as shown in **Figure 2.20**. This setting may be named Original or Scan Type.

Figure 2.20 For the most part, choose Color Photo when scanning photos.

- Options relevant to photographs typically include Color Photo, Black and White Photo, Color Negative, or Black and White Negative. Your scanner may also have document source types such as Magazine, Color Document, and Text.

- Choose the option that matches the type of photo or negative you want to scan. I suggest scanning black-and-white photos in color and converting them to black and white once you have loaded them into Photoshop.

- When scanning film, make sure to select Film as the type of document type, then the type of film (negative or positive).

Destination or Purpose

This option sets the scan resolution, which is an important factor in scanning quality. To determine this, some scanners prompt you to identify what you plan on doing with your scan. **Figure 2.21** shows this option as it appears in Microtek's ScanWizard 5. Settings may include Viewing (to display on a monitor), Online (for example, to post on Facebook), and Print. Scan resolutions assigned to these categories vary from scanner to scanner, but viewing and online settings typically result in scanned photos with far less resolution than those meant to be printed. For the highest scan quality, choose Print or the option that corresponds to the highest resolution.

Onscreen Viewing
Ink-Jet Printing
Laser Print Standard
Laser Print Fine
Fax
OCR Text
✓ Custom
300 DPI

Figure 2.21 If given the option, enter a resolution.

Resolution

You may be able to choose the scan resolution from a drop-down list, as shown in **Figure 2.22**, or specify a specific resolution by entering it in a text box.

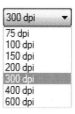

- Consider a scan resolution of 300 dpi to be the minimum for photo restoration. Raising this from 600 dpi to 1200 dpi will capture more detail, but at the cost of scan time and file size.

- When scanning 35mm negatives, I recommend scans of at least 1200 dpi. This will enable you to print a 4x6-inch photo with a reasonable output resolution. Use anything from 2400 dpi to 4800 dpi for higher quality.

Figure 2.22
Typical predefined resolutions are relatively low.

- Remember, the quality of your scan depends as much on the quality and level of detail contained in the original print or frame of film as it does on the scan resolution. Scanning a poor print at high resolution will not make the photo better.

- Resolution is often located with or near Destination settings.

Document Size

Some scanners automatically detect the size of the document you placed on the scanner bed. You may have the option to select a size from a list, as shown in **Figure 2.23**. This sets the size of the initial preview scan.

For photos, I suggest setting this to Auto Detect unless the scanner can't detect the photo's borders correctly. If the scanner is not scanning the entire photo, and you cannot refine the scan area before the final scan, set the size to the largest size possible (the entire scanner bed).

Figure 2.23 I suggest leaving Document Size on Auto Detect.

Scale

Some scanning software has a feature that lets you scale the output (see **Figure 2.24**). The scanner software resamples the scanned photo and scales the image size up or down by the given amount. (Note: This does not change the scan resolution.) For example, if you scan a 4x6-inch photo at 300 dpi and scale the output by 200%, the final dimensions will be 2400x3600 pixels instead of 1200x1800. Where did the extra pixels come from? The software made them up.

Figure 2.24
Do not change scaling to anything other than 100% for photo restoration work.

When scanning photos for restoration, never change the size or scaling factor to anything other than 100%. Make all size changes in Photoshop after you have restored the photo.

Adjustments, Corrections, or Enhancements

Most scanners have a plethora of automatic enhancements and corrections, as shown in **Figure 2.25**. These range from Brightness, Contrast, Sharp(ness), Color, and Color Saturation to Noise Reduction, Fade Correction, Backlight Correction, and more.

Feel free to play around with these options and see what you think. Frankly, I always turn them all off. I prefer to handle the work myself in Photoshop. This approach gives me total control over the process, the settings, and the order in which I do things, and enables me to change settings without having to constantly rescan the photo.

Figure 2.25 **Photo adjustments are often available within the scanner software.**

Save As File Type

Save As File Type saves the scan in a given format, such as .jpg or .tif. For general use, each has its pros and cons. When scanning, however, Choosy Scanners Choose Tiff.

This option may be associated with the Scan, Scan To, or even Preferences button.

Naming Your Scanned Image Files

File naming is one of the more frustrating parts of the scanning process for me. I think it's because I would like there to be a "best way" to do it, and it seems that there just isn't.

Most scanners offer the option of saving scans by date, and then using a standard file name and an incremental suffix. For example, my first scan today would be named IMG_0001.tif and be located in a folder named 2014_12_13. Not bad, but not good either. If I scanned five photos over five days, they would all be named IMG_0001.tif. Who wants that? Not me.

The solution is either to name the scans something descriptive or to store them in a common folder not organized by date.

I am not a huge fan of descriptive names, so I do not recommend naming your files according to the subject or other descriptive criteria. You risk driving yourself crazy when trying to figure out whether a photo should be named "Anne_Colorado_1995.tif" or "Anne_sitting_on_rock.tif". Rather, I suggest the following approach to file naming and scan organization.

Organize your scans by year. Save all permanent scans in each year's folder. Number each scan by the order in which you scanned it (for example, IMG_0001.tif). Optionally, include the year in the scan name (for example, IMG_2015_0001.tif). As you scan new photos, save them to a temporary folder and review them. Rename those you want to keep with the next number available, according to the scans already in that year's permanent folder. Finally, move the scans from the temporary folder to the final location. Delete the ones you don't want to keep.

If you do a tremendous amount of scanning, consider organizing by quarter or by month instead of by year.

Advanced Mode Settings

If you're new to scanning, your scanner's advanced mode may seem intimidating. It will appear to have a million and one options and settings (see **Figure 2.26**). The trick is to turn off the settings that you don't need, set the ones that you do need correctly, and ignore the rest. You'll soon be scanning like a pro.

Scan resolution

Deciding what scan, sample, or output *resolution* (the number of data samples per inch) to use is an important choice to make when scanning photos and film. The scan resolution you choose tells the scanner how often it needs to sample the source material and record a measurement. It turns each data sample into an image pixel.

Figure 2.26 Advanced scan mode using Canon's ScanGear software

For a given size, greater scan resolutions create more pixels than lower scan resolutions, which yield more data per inch. Up to a certain point, having more data per inch is better than having less. The 64-million-dollar question is, "How much is enough?" The answer is (are you ready for it?), "It depends."

Not every photo has the same amount of information per inch. If you scan two similarly sized photos with the same scan resolution but each has a different level of detail, the scans will reveal this.

Some photos were taken with cheap cameras. The negatives may have been small and the photo might have been printed on poor paper. These photos simply do not have very much detail. It's a waste of time to scan photos with poor detail at extreme scan resolution.

Other photos were taken with high-quality equipment and printed on good paper. They may have a tremendous amount of detail and can be scanned at high resolutions.

Small photos and most negatives benefit greatly from high scan resolutions. **Figure 2.27** shows a photo of Mt. Rushmore. It measures 3.5 by 2.5 inches. That's pretty small, so I scanned it at 2400 dpi. If it were not taken with a decent camera, no increase in scan resolution would have added detail to the photo.

Figure 2.27 Scan small photos with good details at high resolutions.

The larger a photo is, the less you need to increase scan resolution. Small details show up better, allowing you to capture them with a lower scan resolution than if you were to scan the same photo from a smaller print.

Here are my tips on what resolution to use when scanning different sized photos and film:

- **Very small prints** (up to and including 3x5-inch photos): At this size, scan at 1200 dpi in order to capture as much detail as possible. File sizes remain manageable even when using large scan resolutions because the original photo is so small. Treat tiny photos (up to an inch or so) like negatives and boost scan dpi to 2400 or more.

- **Small prints** (from 3x5-inch up to and including 4x6-inch photos): Scan using resolutions from 900 to 1200 dpi. These resolutions will capture small details and enable you to make large prints from reasonably small photos. I use a minimum resolution of 1200 dpi.

- **Large prints** (over 4x6 inches): Scan anywhere from 600 to 1200 dpi. I prefer to use 1200 dpi for photos up to 8x10 inches. At that size, however, I compromise and switch to 900 or 1000 dpi. Image files start getting ridiculously large at this point, and it's not always practical to edit a 2 GB image, regardless of how good the scan is.

- **Film:** Scan each frame of a 35mm negative with a minimum resolution of 2400 dpi. This will enable you to make reasonably large prints (around 8x10 inches). Use 4800 dpi or greater to capture smaller details. I typically scan negatives at 4800 dpi. For important photos, I may scan at 6400 dpi, however this produces a very large file that is often cumbersome to work with.

Estimating Required Scan Resolution

One way of deciding on a scan resolution is to factor in the largest size at which you may ultimately want to print your restored photos and set the desired print resolution at 300 dpi.

Using the print size and the print resolution, you can easily figure out what scan resolution to use. Simply multiply the print resolution (300 dpi) by the length or width of the print, then divide that result by the length or width of the original photo (it doesn't matter whether you use the length or the width as long as you are consistent).

For example, if you want to print a 30x20-inch poster at 300 dpi and the original photo is 4x6 inches, you should scan the photo at 1500 dpi. Here's the math:

- 30 inches (the long side of the print) x 300 dpi (the print resolution) = 6000 dots

 or
- 20 inches (the short side of the print) x 300 dpi (the print resolution) = 9000 dots

Next, divide either one by the length of the corresponding side of the photo:

- 6000 dots (the short size of the print) / 4 inches (the short side of the photo) = 1500 dpi

 or
- 9000 dots (the long side of the print) / 6 inches (the long side of the photo) = 1500 dpi

Now, this doesn't mean that the large print will look good, even though you scanned the original at 1500 dpi. An exceptionally large print will show all the flaws in the original print. However, the large print will be a reasonable facsimile of the photo, only larger.

Let's say you don't want to scan your 4x6-inch photo at 1500 dpi. What would the print resolution be if you scanned the photo at 1200 dpi?

You can get the answer by taking the photo's pixel dimensions (in this case, 7200x4800) and dividing by the size of the print (in inches). The math:

- 7200 (the long side of a 4x6-inch photo scanned at 1200 dpi) divided by 30 (the size of the long side of the poster in inches) = 240 dpi

 or
- 4800 (the short side of a 4x6-inch photo scanned at 1200 dpi) divided by 20 (the size of the short side of the poster in inches) = 240 dpi

Close enough! Although not 300 dpi, it would suffice.

If the aspect ratio of the photo and paper size on which you want to print are not the same, do the math for both sides of the photo. For example, 8x10-inch photo paper has a different aspect ratio than 4x6-inch photo paper. You will get different answers because the aspect ratios are different. Choose the greater of the two calculated dpi values.

The next two figures illustrate some of the quirkiness of dealing with resolution. They both contain five panels taken from the same photo of Mt. Rushmore shown in Figure 2.27. All were scanned at different resolutions. From left to right, they were scanned at 100, 300, 600, 1200, and 2400 dpi.

Figure 2.28 reveals the magnification levels where each scan resolution "breaks down" and starts showing individual pixels. (In other words, I want you to see the imperfections in these scans; that's part of the point.) At 100 dpi, you can recognize the head of President Washington, but the overall level of detail is very poor. The amount of detail improves steadily as the scan resolution goes up. Clearly, the rightmost panel, scanned at 2400 dpi, has the finest level of detail. But do you need it?

Figure 2.28
Boosting scan
resolution increases
the level of detail
captured and is
apparent when
magnified.

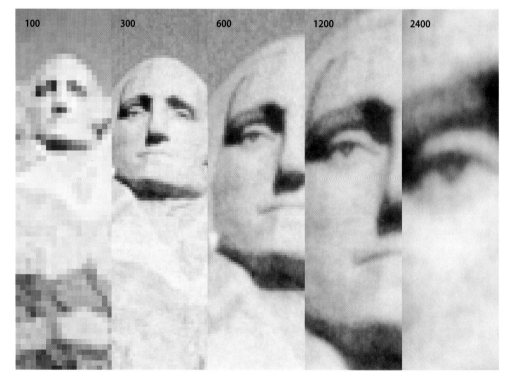

Figure 2.29 shows one way of deciding how to answer that question. This time, rather than zoom in closer and closer to illustrate increasing levels of detail, I have kept the scene framed identically and sized each scan to fit. This shows the effect of diminishing returns on scan resolution. There are clearly bad choices here: 100 and 300 dpi. However, it's hard to see the differences between 600, 1200, and 2400 dpi. If you look closely, the sky shows more grain in the center panel (600 dpi). That's about it.

In the end, I can only give you a range of values that you may want to choose from. Now it's up to you. Schedule a "scanning party" where you scan things using different scan resolutions and see what works best for you.

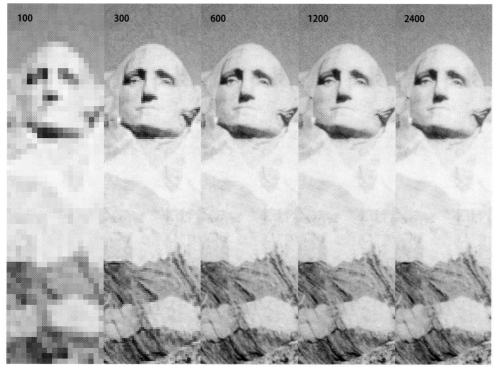

Figure 2.29
Greater scan resolutions do not always translate to more visible details, however.

Color modes

Color mode is another important scan setting. Although you may be able to choose from many possible options, you will end up using only one or two.

- **Web Color:** Your scanner may have one or more 256-color modes that are useful when creating images for use on the Internet. I do not recommend these color modes when scanning original photos for photo restoration. 256-color and Indexed Color modes are very similar, but Indexed Color is not optimized using Web-safe colors.

- **Color (Standard):** Standard color uses 8 bits per color channel (Red, Green, and Blue) per pixel to store color information, resulting in a photo that can contain over 16 million colors. It is often called 8 bits/channel (read as 8 bits per channel) color. It may be called 24-bit color because the channels combine to use a total of 24 bits per pixel. And, as if this mode needed any more names, you may see this called True Color or RGB color. Regardless of the name, this is the setting you should use for most of your scans, as shown in **Figure 2.30**.

Figure 2.30
In most instances, set Color Mode to Color.

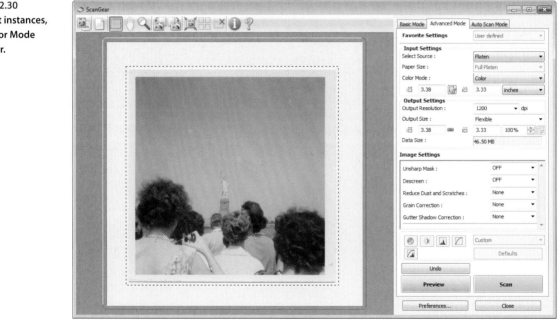

- **Color (48-bit):** In this color mode, each channel uses 16 bits per pixel to store color information in three channels, resulting in photos with oodles on top of oodles multiplied by scads of colors. Photoshop calls this 16 bits/channel color. This is "overkill" mode. In the abstract, the 48-bit color mode is technically better than standard color, but it is rarely practical and comes at great cost: The file sizes are double those scanned using 24-bit color, and as a result, it takes a better computer with more memory to manipulate them. In the end, you may in fact never see the difference between the two. Assuming you scan in a photo using the same cropping frame and resolution, using 48-bit color doubles the file size compared to 24-bit color.

 I have tested 48-bit color on many photos, ranging from good to great, and have yet to find a situation where it was worth using. Your mileage may vary, of course.

- **8-bit Grayscale:** This color setting creates an image that displays 256 shades of gray per pixel in a single color channel, as shown in **Figure 2.31**. If you want a grayscale image, I suggest scanning it using standard color and converting to black and white in Photoshop, where you control the conversion process.

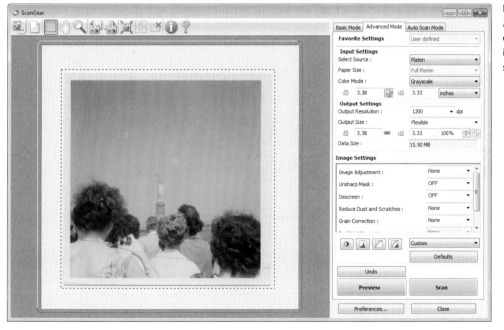

Figure 2.31
Although this looks decent on screen, it has only 256 shades of gray.

- **16-bit Grayscale:** In this color mode, the scanner scans in gray values rather than color. The result is a 16-bit grayscale image with a greater range of tones (up to 65,535 instead of 256) than a standard 8-bit grayscale image.

- **Black and White (Monochrome):** This color mode creates black or white pixels only. You can achieve some interesting results, but again, you don't have access to the original data. It would be better to scan the photo in standard color and use a Threshold adjustment to achieve the same result using Photoshop. This option may be called Line Art.

Image Size and Megapixels

The size of the photo, in conjunction with the scan resolution, determines how many pixels the scanned image will contain. For example, a 4x6-inch photo scanned at 600 dpi measures 2400 by 3600 pixels.

- 4 inches x 600 dpi = 2400 pixels in height
- 6 inches x 600 dpi = 3600 pixels in length

To find the total number of pixels, multiply the length of the image by the height:

- 2400 (pixels high) x 3600 (pixels wide) = 8,640,000 pixels contained in the area

Divide this answer by 1,024,000 to get the number of megapixels in the image, which is a convenient way of comparing scan sizes to photos taken by digital cameras.

- 8,640,000 total pixels divided by 1,024,000 = 8.4375 megapixels

Therefore, a 4x6-inch photo scanned at 600 dpi results in a photo comparable to an 8.44-megapixel digital camera.

Image settings and adjustments

Your scanner software will likely have a good number of photo correction options. These options are for people who don't necessarily want to go to the trouble to load photos into Photoshop to retouch them. Using the scanner's adjustment tools is not a bad idea for many people. However, I suggest turning off these settings and using Photoshop to accomplish the same tasks.

Here is a rundown on what sort of adjustments you might run across:

- **Auto Image Adjustment:** Have the scanner software adjust the scanned photo auto-matically. You may be able to select a type of automatic image adjustment. Settings often range from Auto to Photos, Magazine, Newspaper, or Document.

- **Unsharp Mask:** Sharpens the scan.

- **Descreen:** Attempts to reduce moiré effects that sometimes appear when scanning halftone photos (newspaper photos, which are printed using small dots instead of a continuous tone, are the most obvious example).

- **Reduce Dust and Scratches:** Attempts to automatically remove dust and scratches from photos.

- **Fade Correction:** Reduces fading and color tinting.

- **Grain Correction:** Reduces film grain. This option is similar to digital noise reduction.

- **Backlight Correction:** This is an exposure correction that attempts to improve photos shot against a bright background.

- **Gutter Shadow Correction:** Attempts to correct shadows along the bound edge of a book (the inner margin), which are caused when a book can't lay flat on the scanner.

- **Saturation/Color Balance:** Increases or decreases the photo's color strength. You may be able to balance each channel. Some scanners use CMYK (Cyan, Magenta, Yellow, and Black) while others use RGB (Red, Green, or Blue) color channels.

- **Brightness/Contrast:** Brighten, darken, and increase the overall contrast.

- **Black and White Points:** Enables you to set the black and white points of a photo, which is like saying "This pixel should be black" and "This pixel is white." This is similar to making a Levels adjustment in Photoshop.

- **Tone Curve:** Adjusts brightness levels by tonal region, such as shadows, darks, mid-tones, and highlights. This is like making a Curves adjustment in Photoshop.

- **Filters:** Your scanner software may have filters that you can apply to your scans, ranging from creative filters like Blur or Emboss to more practical filters that sharpen photos.

One word of warning before I finish this section: Scanner software can activate automatic adjustments depending on the template or preset you use, even when in an advanced mode. I suggest double-checking that the settings you want off are indeed off before each scanning session. If you create your own preset, make sure automatic adjustments are off before saving the preset.

Color Profile (Color Matching)

You may be able to set a color profile that the scanner software uses. My Canon software has three options, as shown in **Figure 2.32**: Recommended (which shows vivid colors), Color Matching (which enables you to select a specific color profile to match your monitor), and None.

This option not only affects what you see on the screen, but will affect how your system and Photoshop interpret the colors in the file. In reality, no colors are scanned differently, but the color profile you use when scanning needs to match the color profile you assign the photo in Photoshop.

Figure 2.32 Assign the target color profile to the photo in Photoshop when editing.

If you can, run a test to confirm my findings. Scan the same photo using the same cropping frame, but assign different color-matching profiles each time. Compare sRGB, Adobe RGB, and Pro Photo RGB. Save the images and open them in Photoshop. They will look different if you do not color manage—however, if you assign the correct color profile to each one, they will look identical.

I prefer scanning using the sRGB color profile because I know that I will see the thumbnails and images displayed correctly when I preview them using system software. I assign the sRGB color profile to the scans when I open them in Photoshop and convert them to Adobe RGB before making any changes. Then I save the converted file in an Adobe Photoshop file format (.psd). I do not use the Recommended option in this case because I have no way of knowing what color profile to assign to the photo in Photoshop. That's a huge problem because the colors look different compared to two scans of the same photo using sRGB and Adobe RGB color profiles.

If you are confident that your system can display Adobe RGB images correctly, you could scan photos using Adobe RGB and then assign (not convert) that profile to them in Photoshop if you like.

Creating Custom Scan Presets

I strongly encourage you to create your own custom scan presets. Doing so makes checking scan settings far easier, and you are less likely to make a mistake and not realize it until you've scanned in a dozen photos.

Create presets according to the type of photo or film and resolution. For example, you could create a 24-bit Color Photo 1200 dpi preset for photos that has all auto enhancements turned off and a 48-bit Color Film 4800 dpi preset to scan film with. By now, you should totally understand what that all means!

Scanning Loose Photos

Here are the basic steps I use to scan loose photos. With the scanner correctly installed, turned on, and the software running:

1. Open the scanner lid.

2. Place the photo on the scanner bed and straighten it, if desired.

 I prefer placing the photo near the middle of the scanner bed and straightening it using a piece of card stock. If you want to use the edge of the scanner bed to straighten photos, do a few test scans to confirm that the scanner is able to capture the entire photo. Not all edges are created equal.

3. Carefully close the scanner lid.

 Closing the lid abruptly can cause a gust of air that may move the photo.

4. Ensure that scan source is set to Reflective or Platen (what my scanner software calls the reflective scanner bed).

5. Check the source size so that the image preview will scan the entire scanner bed.

6. Set the color mode.

7. Enter a scan resolution.

8. Press Preview to activate the preview scan.

9. Draw or fine-tune the automatic cropping frame.

 I suggest selecting a bit more than you need and cropping in Photoshop.

10. If desired, make any manual image adjustments or corrections. If not, ensure that all automatic adjustments are off.

 It's a terrible pain when you scan a photo, save the file, remove the photo from the scanner, put it away, and then realize you left Auto Sharpen on.

11. Confirm that all options are set correctly.

Figure 2.33 shows a photo just prior to scanning. Everything is set.

Figure 2.33 Check all settings twice before you press the Scan button.

12. Press Scan to scan the photo.

13. If you would like, save the scanned image now. If you are scanning a number of photos and your scanner saves temporary files for you to save and name later, then it can be more convenient to wait and save them all at the same time.

I recommend saving your scanned images as .tif files.

14. Open the scanner lid and carefully remove the photo. Set it aside in a safe place or place it back in its album.

Take care when you remove photos from the scanner. It is a more dangerous step than you may realize. Some photos lay very flat on the scanner and can be hard to lift off the scanner bed without picking at a corner with your finger. Do not pick so hard that you bend a corner. You should also avoid sliding the photo around on the scanner bed as you try to lift it.

If a photo is hard to lift off the glass, try holding it down with your hand and sliding the corner of a thin note card under it. Gently lift up the card and photo.

15. If you are scanning more than one photo, place it on the scanner now and return to step 3.

16. When finished, make sure all scans are saved, as shown in **Figure 2.34**.

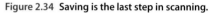

Figure 2.34 Saving is the last step in scanning.

Scanning Photos in Albums

If you can't get a photo out of an album safely, you should scan it before doing anything that could potentially damage either the photo or the album. Once you've scanned the photo, you can leave it in the album and not mess with it. That's the safe play.

To scan photos without removing them from their album, follow these steps:

1. Operate your scanner software the same as you would for loose photos. Use the same software settings. The difference will be how you place the album on the scanner bed.

2. If you can take the lid off your scanner, you may wish to do so.

Getting the lid out of the way enables you to position the album page on the scanner in different orientations, if necessary.

3. If the album's page has a protective sheet, lift it up, and then place the album face down on the scanner bed. Position it so that the photo can lay as flat as possible.

4. Albums can be bulky and not want to lay flat. If necessary, gently put a weight on the album (a few books will do the trick) so that it presses down on the scanner bed.

 Don't use your hand. It's hard to hold your hand steady and use the computer at the same time.

5. Use a blanket, pillow, or a pile of books to support the album so that it doesn't slide off the scanner.

 I prefer using a blanket, as shown in **Figure 2.35**, because I can fold it to different heights that match what I need supported.

6. If light leaks into the scanner from the room and shows up in the image files, put a cloth covering (like a bath towel) over the album and scanner bed to shield everything from the room's ambient light.

Figure 2.35
Support the album so that it doesn't bend or move around on the scanner.

If you left your scanner lid on, don't try to close it on top of an album. You might break the lid or the glass, or bend the album.

Scanning Oversized Photos

Scanning oversized photos can be a real problem because most scanner beds are not that much larger than letter-sized paper. Here are some tips for scanning large photos:

- Scan photos in segments and stich them together in Photoshop. Take care not to bend or crease them as you put them on the scanner bed. Be careful when you close the scanner lid—you do not want to crumple your photos.

- Look for a local print or copy business, library, school, design company, or church that has a large scanner that you can use.

- You can, of course, buy a large-format scanner. They cost several thousand dollars though. Renting may be possible. If not, check out scanning service providers.

- If all else fails, take a photo of the oversized photo using your best camera and lens.

- If you happen to have the negative, consider scanning that or getting a smaller print made.

Scanning Film and Slides

Scanning film and slides is different than scanning photos. Unlike photos, which are scanned reflectively (light shines on the photo, bounces off, and is reflected into the scanner's sensor), light has to shine through film and slides. This is called *transmissive* scanning, and requires the light source and sensor to be on opposite sides of the film.

First, make sure your scanner can scan film and slides. Next, you will probably have to physically reconfigure your scanner.

For my CanoScan 9000F, I have to remove a component called the Film Adapter Unit Protective Sheet from the inside of the lid. This exposes a secondary light source (formally called the Film Adapter Unit) that shines down through the film into the main body of the scanner. Next, I slide the film into the Film Guide Mount, and then attach the film guide to specific tabs on the scanner bed frame.

Figure 2.36 is a detailed photo of the film guide (not in the scanner) with color and black-and-white film loaded. You can clearly see that light is meant to shine *through* the film, which is loaded into the guide.

Figure 2.37 shows a different film guide, one meant to scan slides, mounted on the scanner bed. The lid is currently raised; I will lower it to begin scanning.

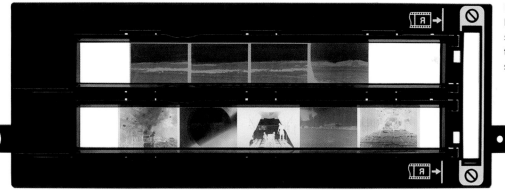

Figure 2.36
Be careful not to scratch film on the film guide as you slide it in.

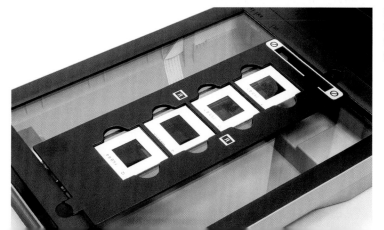

Figure 2.37
Slides are very easy to handle because of their frames.

In the case of my Microtek ScanMaker S400, I remove the lid entirely, then attach the film holder, called the LightLid 35 Plus, to the back of the scanner using a built-in cable (see **Figure 2.38**). I slide the film into the holder and then rest it on the scanner bed. The LightLid contains a lamp that shines through the film.

When you're ready to scan, operate your scanner software the same as you generally would for photos, but with the following differences:

Figure 2.38
This MicroTek scanner requires a bit more effort to configure than the Canon.

- Select Film as your document type or source. If you are scanning negatives (this is the most likely scenario), choose Negative.

- Choose a higher scan resolution than you typically use to scan photos. You will lose a lot of detail if you do not scan using a scan resolution of at least 1200 dpi.

Taking Pictures of Pictures

While it is possible to take digital pictures of photos instead of using a scanner, I do not recommend it. Here are the reasons why:

- Even the best camera lenses distort the scenes they capture. Scanners aren't perfect, but they are designed to scan photos with more precision than a typical camera lens.

- It's far easier to set up a scanner on a desk or table by your computer and spend time scanning photos than it is to try and set up what amounts to a home photography studio to photograph them.

- Photos that curl or do not lay flat can be a problem to photograph. When scanned, they are pressed flat against the glass by the scanner lid. If you try to flatten a photo under a pane of glass, you will have to contend with reflections.

- It is harder to light a photo evenly to photograph than it is to scan it.

- You will not be able to compete with scanner resolution unless you have a 30- to 50-megapixel camera handy.

Despite these reasons, if you want to take digital pictures of your photos you should definitely try it. Quite often there is no substitute for experience. You may find a practical or artistic benefit to doing so.

There are situations where photographing photos may be the only way to preserve and restore them. For example, you may have a large photo that doesn't fit on the scanner. You may also encounter photos with such bumpy surface texture that the scanner lamp creates unsightly reflections that are impossible to remove in software. In those cases, definitely give your digital camera a try.

Chapter 2 Assignments

This chapter's assignments focus on scanning.

Do a basic scan

Scan a photo using your scanner's basic mode. Get used to launching your scanner software and physically placing a photo on the scanner bed. Decide whether you want to straighten the photo or not. If you do, compare using different edges of the scanner bed or some other technique. Experiment with different basic-mode settings.

Do an advanced scan

Scan a photo, slide, or frame of film using your scanner's advanced mode. For this assignment, get used to your scanner's advanced-mode interface. Look at the different settings and make sure you understand what they do. For extra credit, create at least one custom scan preset.

Test your scanner's resolution

You are going to test your scanner's scan resolution in this assignment. Select another photo. Make it a print that has good detail and sharpness.

Scan the photo three times. Use the same cropping frame each time so that the scans are identically framed. Use the same settings for all three scans except for resolution. For the first scan, use 300 dpi. For the second, use 600 dpi. For the third, use 1200 dpi.

Save all of the scans as .tifs and include the scan resolution in the filenames (for example, dpi_test_0300.tif).

Open the scans in Photoshop and zoom in to compare details. Can you tell a difference? Look for how large the pixels appear in each scan and whether the transition from light to dark areas of the photo appears smooth or jagged. Compare file sizes. Which one looks best? What's the most practical?

Share your results with the book's Flickr group!
Join the group here: www.flickr.com/groups/photo_restoration_fromsnapshotstogreatshots

3

Working with Photoshop

Focusing on Restoration

Adobe Photoshop is huge. It's impressive. It's like a Swiss Army Knife that's two inches thick and barely fits in your jeans pocket.

There are 11 main menus in the default menu set in Photoshop CC 2014 (Windows version; 12 on the Mac), 276 menu items accessible beneath those menus, and enough sub-submenus for me to give up counting halfway through. There are 65 tools organized into 20 categories on the Tools panel, and almost 30 other helpful panels that you can show or hide. The manual itself is a 794-page PDF file. Whew!

Photoshop can do many things, and do them well. However, that's not the point. My goal for this chapter is to draw attention to the parts of Photoshop that are important for photo restoration. There are still quite a few things to learn, but narrowing down the focus will help you manage your time and energy better.

Poring Over the Picture

There are visible blemishes throughout the photo.

Sky is not bright enough.

Details are not sharp.

Faces lack contrast and sharpness.

This area is hazy looking.

Bright areas of rock are too bright.

When I found this photo in my wife's family photo collection, I was awestruck. Taken in 1946, it's simply an amazingly cool snapshot. It makes me want to go sightseeing out in South Dakota *right now*. You can't tell from where you're sitting, but it's actually a very small print. Overall, it measures around 3.5 by 2.5 inches. I had to crop it slightly to keep George's face from being lost in the center. As a small print, it looks fine. However, when scanned at 2400 dpi, its imperfections really add up.

Poring Over the Picture

A simple Brightness/Contrast adjustment brightens the sky and adds contrast overall.

Everything is much sharper due to a High Pass Sharpen filter.

Brightness/Contrast also removes haze.

Faces appear much clearer and sharper with the help of a Shadows/Highlights adjustment.

I tamed the bright rocks with a targeted Levels adjustment.

I used the Dust & Scratches filter to remove blemishes in trees.

This photo suffers primarily from three problems: blemishes, brightness and contrast, and sharpness. Oddly enough (for an older photo), it is not plagued by a strong color cast. To restore the photo, I used all of the tools and techniques I introduce in this chapter: a combination of layers, adjustments, tools, masks, smart objects, and more.

Choose Your Own Adventure

I love choose-your-own-adventure books. As you progress through the story, you get to make decisions at important points. Should you be friendly or be wary? Take the path that leads left or the one that goes right? Call for help or continue on alone? Based on what you decide, your adventure continues along a customized path.

This book is something like that. Based on your experience (or lack thereof) with Photoshop, you are going to have your own adventure! Which adventure you have depends on where you start.

Novice

If you're just starting your Photoshop career, "Welcome aboard!" Pick up as much as you can as you read through the book, but realize that you may get lost in places and will not understand everything. If that's the case, don't panic. This chapter will introduce you to several important aspects of Photoshop that you need to know to restore photos. I have tried to balance the material between acquainting you with the most important tools (to give you a starting point for further learning) and providing practical tips.

If you feel lost, I encourage you to seek additional instruction from resources designed specifically to teach you all the ins and outs of Photoshop. Start with the Help menu and progress from there.

If you haven't made a purchase yet, consider starting with Adobe Photoshop Elements. Upgrade to Photoshop when you feel that you've gotten the hang of things. The learning curve with Elements is gentler, and there are fewer complexities to the overall application.

In addition to everything else, *practice*. Scan photos to restore and work on the craft of photo restoration. Don't give up! Set up files, use the basic photo restoration tools, make adjustments, manage layers within your files, and make final adjustments. Don't be afraid to make mistakes, and always strive to progress.

Photoshop Elements user

If you are a current Photoshop Elements user, you are in a good position to understand much of this book. Although I approach the material from the perspective of Photoshop, the two programs are similar enough that you should not get easily lost. Both programs use layers, masks, tools, and adjustments. Those are the essentials.

If you're an enthusiastic Elements user, I expect that you will be familiar with many of the tools and adjustments that I use to restore photos in this book.

Where there are fundamental differences between using Elements and Photoshop to restore photos, I point those out in the upcoming chapters.

Photoshop user

If you currently use Photoshop, you should have enough basic knowledge of how the program works that you do not need me to start at the beginning. If this is you, I suggest brushing up on the tools and adjustments I showcase early in this chapter, and then having fun exploring the tips and techniques I suggest towards the end. Get used to the perspective of restoring photos.

If you're a bit rusty, you might want to review some topics in the Photoshop manual as you follow along. You may not be familiar with the terminology or some of the features.

If you are a more experienced user, you should focus on the differences between using Photoshop to restore photos versus other types of graphic arts. It may surprise you how few tools and adjustments I use to restore photos, and how I use them. Challenge yourself in how well you can use them to produce great results.

Regardless of your experience level, this chapter should help you focus your attention on the parts of Photoshop that are most helpful when restoring photos. This chapter is but a brief introduction to Photoshop—the rest of the book will illustrate many of the tools and techniques that I give you a taste of here.

Key Restoration Concepts

When I clean and repair photos, it's like putting makeup on them. I don't really remove any dust, fix any scratches, repair any torn corners, or anything like that. What actually happens is that I take matching material from clean and undamaged areas of the photo to cover up the bad stuff (see **Figure 3.1**). My goal is to hide what I don't want you to see.

Figure 3.1 **These aren't the splotches you're looking for.**

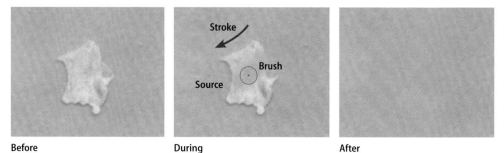

Before During After

Likewise, when I change the brightness, contrast, and color in a photo, I use special tools called *adjustment layers* that make you think you're seeing something that you're not (see **Figure 3.2**). It's like putting in colored contacts to make your blue eyes appear green.

Figure 3.2 **Photo restoration is part smoke, part mirror.**

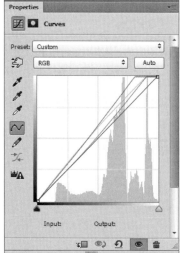

Before After

I achieve both of these effects by using multiple layers, each performing a special function, that "stack" on top of the original photo. The end result is a multilayered image that has been "made up" with foundation, blush, eye shadow, and lipstick. This is called *nondestructive* editing.

(All makeup analogies brought to you by my wonderful wife).

Conversely, I could make all the changes on the original photo layer in Photoshop. Rather than applying makeup, which can be cleaned and redone, doing everything using a single layer is more like plastic surgery. What you mess up stays messed up. There are so many drawbacks to this approach I don't feel it's worth trying.

There are exceptions to this layered approach. When I must make changes to the photo instead of covering things up or using nondestructive adjustments, I make a copy of all the layers you can see and create a new composite working layer. I call this building a new foundation.

If you look at my Photoshop files, you would see something like an archeological dig of an ancient city. There are layers upon layers, as shown in **Figure 3.3**. Some are cosmetic; others are new foundations that provide a fresh start from a new beginning.

Photoshop has all the necessary tools that you need to restore photos in layers. In fact, it was designed for you to be able to work precisely this way. Take advantage of this as you restore your photos.

Apply "makeup" on new layers when:

- Cleaning

- Repairing

- Correcting color

- Adjusting brightness and contrast

Figure 3.3 The Layers panel shows how the layers are stacked together.

When you must work with pixels, use Smart Object layers when possible, or create a new foundation layer. Use this approach when:

- Reducing noise or film grain

- Sharpening

- Dodging and burning select areas

- Softening areas with the Blur tool

- Sharpening select areas with the Sharpen tool

- Using artistic filters

As you may or may not know (yet), all layers can be blended together using layer opacity, masks, and blending modes.

A Brief Lexicon

I thought it prudent to provide this lexicon to familiarize you with some of the terms that I use throughout this chapter.

General terms:

- **Photo:** Normally, the actual physical photograph. For variety, sometimes I say "photo" instead of "image" or "image file."

- **Image:** After scanning and saving photos, they become digital images. They may be any file type (.tif and .psd are two image types). When working in Photoshop, I normally say "image" when referring to what you see on the screen.

- **Document:** A data file that you can read and sometimes edit. Documents can be image files, word processing documents, PDF files, and so forth.

- **File:** Shorthand for a document stored on your computer. In the case of photo restoration, it may be the saved scan, a Photoshop document, the final archived version of the photo, or a resized image that you want to upload to Facebook.

- **File type:** The type of file. This identifies what type of document it is (e.g., text, image), what may have created it (e.g., Photoshop), and what program has "dibs" on opening it.

 Files are identified on your system by a graphical icon so that you can distinguish them from other files at a glance. They often appear with a three-letter extension at the end of their name. Common image files are .tif (Tagged-Image File Format) and .jpg (Joint Photographic Experts Group). Photoshop files have either the .psd (standard Photoshop document) or .psb (the Photoshop large document format) extension.

continues

Photoshop terms:

• **Tool:** Tools help you accomplish tasks in Photoshop. Some make selections, others crop and slice, and still others measure, retouch, paint, draw, enter type, create shapes and paths, navigate, and work with 3D objects. Tools, which are located on the Tools panel, are often analogs of actual implements that photographers, artists, or typesetters have used in the past.

Most tools (especially those most useful for photo restoration) require some amount of hand-eye coordination to use skillfully. It is especially important to practice using them.

• **Adjustment:** Adjustments make changes to an image's color, brightness, or contrast. They do not "move" pixels around. They change their values.

There are many different possible adjustments in Photoshop. It can be confusing that a number of adjustments seem to accomplish the same task. For example, to change different aspects of a photo's brightness, you could use the Brightness/Contrast, Levels, Curves, Exposure, or Shadows/Highlights adjustment. In the end, use whichever adjustment you like best to make whatever adjustment you want to with it.

• **Canvas:** In Photoshop, the canvas is the image area. You can zoom in, zoom out, and move your view around to different parts of the image. You can also resize the canvas by adding or removing material from the borders. When restoring photos, you will rarely change the canvas. However, you will often need to select the entire canvas in order to copy material on a layer or copy a composite of merged layers.

• **Panel:** Panels in Photoshop are containers that the program interface uses to hold tools, controls, and information. You can move, modify, make visible, and hide them.

• **Layer:** Layers are, well, like a lot of stuff. I could sit here and tell you that layers are like transparencies shown on an old overhead projector, like layers of a cake, layers of clothing, layers in a sandwich, layers in the atmosphere, layers in the ocean, layers in sand art. But I'm not going to.

Layers are just layers. You'll get the hang of them. Fundamentally, you look at a photo on your screen from the top down. You look through some layers and at other layers. You organize and manage layers from the Layers panel.

When you open a scanned photo in Photoshop, it will have a single layer called Background. You will add more layers as you work on your file.

There are many types of layers. Your average, everyday layer is just called a layer. It's pixel-based, like a photo. There are also shape, type, color, adjustment, Smart Object, 3D object, and video layers.

You can show, hide, make partially transparent, blend using different techniques, group, edit independently or together, move around, reorder, link, duplicate, delete, drag between documents, select, copy, and paste layers. Layers can be full, empty, or partially empty. You can show or hide things in layers using masks, and apply layer effects and styles.

continues

- **Background layer:** The Background layer is a unique layer (each file can have only one) that has special properties. When you open a scanned image file in Photoshop, it will be the only layer you see. As you work with your photo, you can add more layers on top of the background but not beneath it. Think of this layer as the original photo.

- **Adjustment layer:** A special type of layer that makes adjustments to everything beneath it. You can edit and mask adjustment layers.

- **Color profile:** Color profiles translate the colors in the image file to your screen. Some profiles (Adobe RGB, for instance) have a greater color range than others. Others (sRGB) are more compatible across systems and devices.

Activities or processes:

- **Duplicate a layer:** Duplicating a layer makes a copy of whatever layer or layers you have currently selected in the Layers palette. I duplicate layers all the time for various purposes.

- **Duplicate an image:** Duplicating an image creates a duplicate copy (unsaved) of the currently active image. You can choose to duplicate all the layers or a merged copy of the currently visible layers. I duplicate images when I want to branch off my current restoration point and experiment. I also duplicate merged images to resize and save in different formats.

- **To create a new layer from a merged copy:** It is sometimes necessary to consolidate changes or adjustments from several layers into one new layer. To do so, select the entire canvas, perform a merged copy (choose Copy Merged from the Edit menu), and then paste the copied material as a new layer. Remember, copying layers like this not only copies pixels, but also any adjustment layers that are active.

- **To flatten:** Flattening an image merges all of the visible layers and discards any hidden layers to form a new Background layer.

Photoshop Versions

Every version of Photoshop, including Photoshop Elements, is capable of restoring photos. In addition, Adobe Photoshop Lightroom can assist you in a pinch. Lightroom excels at retouching digital photos. Here are some of the major differences between the programs:

- **Photoshop CC 2014:** Photoshop Creative Cloud (CC) 2014 is Adobe's latest version of Photoshop. With it and the other CC programs, Adobe is transitioning to a subscription service. You do not buy the software; you rent it a month at a time or by the year.

 Adobe will continually update Creative Cloud apps, so there is no need to worry about whether or not you have the latest version. If your subscription is current, so are you. However, if you let your subscription lapse, you can no longer use the software. That's going to take some getting used to.

Because Photoshop CC 2014 is the latest and greatest version of Photoshop at the time of this writing (even though it is now 2015), I use it to work on photos in this book.

- **Photoshop CS6:** Photoshop Creative Suite 6 (CS6) is the last version of Photoshop that Adobe offers in the Creative Suite line. You can still buy Photoshop CS6 as a stand-alone product or part of a Suite bundle, but it will not be updated automatically, nor will the Creative Suite paradigm be continued. At some point it will no longer be sold or supported.

 Fundamentally, Photoshop CS6 and CC 2014 are the same. They are both Photoshop. They both use the same basic interface, tools, menus, and so forth. However, if you are using CS6, you may see some minor differences between your version and the one I am using in this book.

- **Photoshop Elements 13:** Photoshop Elements 13 is the latest version of Adobe's entry-level Photoshop product. Elements is aimed at a more casual, nonprofessional audience. It has a built-in photo organizer and a lot of helpful templates for packaging your memories.

 Although it has fewer features than Photoshop CS6 or CC 2014, you can successfully restore photos using Photoshop Elements.

- **Photoshop Lightroom:** Lightroom is Adobe's digital photo editor and organizer. I use it every time I take and process digital photos. Although it is not optimized to restore photos (it doesn't suit the layered approach), Lightroom has convenient retouching, organizing, and editing features that you may want to use as you work on your projects. You can perform rudimentary retouching in Lightroom, but it is not convenient to remove hundreds of specks of dust. Aside from mentioning here that you can import photos in various stages of restoration into Lightroom to edit, I do not cover it in this book.

If you want more information on the differences, similarities, options, and features of these programs, visit Adobe's website, www.adobe.com.

Setting Up (Photo)Shop

Using Photoshop is like showing up for work. You want to know where things are at the office, will have an idea of how you want to organize your desk, and will make decisions like how you want to decorate your walls (motivational posters or Dilbert?).

And, of course, you need to know what your job is: Restoring photos. Remember, your goal should be to more effectively restore photos. If something isn't helping or is in the way, hide it, turn it off, or ignore it. (This advice can also be effective in other areas of your life.)

Color Settings

Color settings (found in the Edit menu) are confusing for many people. Once you understand a few key concepts, however, you will be able to assign or convert color profiles in Photoshop without worrying that you're making a mistake.

First, understand that color profiles translate the color data in image files so that you can view colors correctly, within the capabilities of your hardware. *Translate* is the key word.

Time for an example. Let's say you're trying to translate a document from English to Spanish. As the translator, you are the English-to-Spanish "language profile" that is able to translate from English to Spanish.

Now think of a specific word—red, for instance. English speakers think, speak, read, and write red as "red." Spanish speakers know it as "rojo." The meaning of the word is the same. It needs to be translated, though, between the two groups of people. That is what color profiles do with colors.

If you wanted to translate the English word "red" to German ("rot"), you could assign an English-German translator. The key point here is that the English word "red," in this case, does not need to be changed. The document merely needs a new translation matrix assigned that reads English and spits out German.

If you wanted, you could convert the document from English to Spanish, and then translate it to German. In this case, you would convert the English file to Spanish and then use a Spanish-German language profile to translate. English "red" would become "rojo" (Spanish) in the document. When translated to German, the output would be "rot."

If you were to assign an incompatible language translator to the English document, say from German to English, things would get all messed up. You can see that pretty easily. The language profile would be expecting to see German words and want to translate them into Spanish. It cannot read English.

Although this example is only roughly analogous to color profiles, it brings out the key differences between knowing when to assign a color profile in Photoshop and when to convert between color profiles.

When you scan a photo, the file may or may not contain a color profile. If it does, Photoshop can be set to tell you what it is, and then you can decide to convert it to another color profile of your own choosing. If it does not, you need to try and find a good match to what you think it is by assigning various color profiles and seeing what they look like. When you find one that you think correctly translates the colors, you can convert it to whatever you like.

Here's a short summary of when to use which command:

- **Assign:** Assign a color profile to images that are not color managed and have no color profile. Keep assigning different ones until you find the one that looks like the closest match to what should be displayed (yes, it's a guessing game). Quite often, sRGB is the best choice. It is the color profile that is compatible with most devices.

- **Convert:** Convert from one color profile to another so that you can work in whatever color profile you wish. I currently work in Adobe RGB because it has a larger color gamut (a fancy way of saying "more colors"). Do not use Convert when a file does not have a color profile already assigned.

To set up how Photoshop manages color:

1. From the Edit menu, select Color Settings.

 The dialog box shown in **Figure 3.4** appears.

2. In the Working Spaces area, set the RGB options to the color profile you would like to work in.

3. Under Color Management Policies, set the RGB, CMYK, and Gray values to Preserve Embedded Profiles.

4. Select the Ask When Opening check box beside both the Profile Mismatches and Missing Profiles options. This ensures that Photoshop asks what to do when you open any file that doesn't match your working space or does not have a color profile attached.

After you save a Photoshop file with a color profile, you may be asked what to do when Photoshop opens it again. If so, choose to use the embedded profile.

Figure 3.4
Set working spaces
and important
color management
policies before
you open photos
to restore.

Top Restoration Tools

Although you can make photo restoration as complicated as possible, you don't have to. The total number of tools and adjustments that you need to master is pretty small. Everything else is gravy.

If you use the tools listed in this section, you can restore (or improve to a varying degree) just about every photo you will ever work on. On the other hand, you will find it difficult, if not impossible, to restore photos without them.

Critically Important Tools

I use a small number of tools to clean and repair areas of photos that are dirty or damaged. There are other uses for these tools, of course, but they excel at these particular tasks. The shortness of this list may surprise you. Good! You don't need to use every tool on every photo—there are only a few critical tools that you will use constantly.

Clone Stamp

The Clone Stamp (S) is number one on my "Top Restoration Tools" list. It is a vital tool for photo restorers, and is so practical that I use it on every single non-digital photo that I restore. That's saying something!

The essence of the Clone Stamp tool is to cover up bad things (lint, scratches, dirt, stains, creases, spots, and so forth) with good stuff. **Figure 3.5** shows this in action. You select the good stuff from areas of the photo that are unblemished and undamaged. Quite often, the source area is right next to what you want to hide. There is a great deal of judgment required for using the Clone Stamp tool. It may take a lot of practice for you to match areas—and sometimes it's impossible.

Figure 3.5
Cloning is about covering.

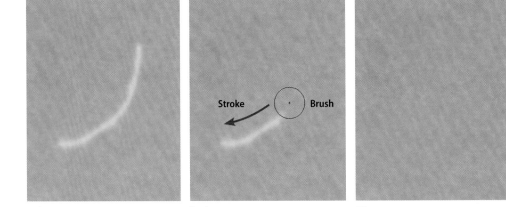

Before During After

I use the Clone Stamp to clean the surface of photos as well as repair damage. It is also useful for covering up camera straps, removing people from photos, and other photo retouching tricks.

Toggle the Clone Source panel (see **Figure 3.6**) when you have the Clone Stamp selected (it is also available when the Healing Brush is active) to access more advanced options. In particular, try using the tool with Invert selected. You can also lower the overlay opacity, which can be helpful.

Figure 3.6
The Clone Source panel controls several Clone Stamp options.

Spot Healing Brush

The Spot Healing Brush (J) is also an important part of my restoring repertoire. It is very similar to the Clone Stamp tool in that it covers up things, but the Spot Healing Brush has something going for it that the Clone Stamp lacks: It blends the spot it covers up with the surrounding area more automatically.

Unlike the Clone Stamp, you do not need to specify a source to use the Spot Healing Brush. Just set the size and go. The tool pulls in material from around the spot to cover up the center. The Spot Healing Brush excels at removing spots quickly, as shown in **Figure 3.7**.

There are drawbacks to this. If your spot isn't in the clear, or has bright or dark areas around it, you may not get a clean blend. If that is the case, you may need to switch to the Clone Stamp or the next tool, the Healing Brush.

Before

During

After

Figure 3.7
Zapping spots is not only easy—it's fun!

Healing Brush

Use the Healing Brush (also J), which is closely related to the Spot Healing Brush, instead of the Spot Healing Brush when you want additional flexibility. It heals imperfections that are more complex than spots. I like using it on scratches and creases, as shown in **Figure 3.8**. Unlike the Spot Healing Brush, you identify a source area when using the Healing Brush. In this way, it is like the Clone Stamp.

Figure 3.8
I use the Healing Brush tool to cover long scratches.

Before During After

Vital Adjustments

In the same vein as with tools, I use a short list of adjustments most of the time. Remember, these come in two flavors: adjustments applied to existing layers (in the Image > Adjustments menu) and adjustment layers that sit on top of other layers to modify them (use the Layers > New Adjustment Layer menu). I prefer using adjustment layers almost exclusively.

Levels

Levels adjustments change the *tonal range* (where shadows, midtones, and highlights sit relative to each other, and on an absolute output scale of brightness) and *color balance* (the relative strength of each of the three color channels in an RGB photo) of photos.

I use Levels for basic brightness and contrast adjustments, as shown in **Figure 3.9** (this is the non-adjustment layer version of Levels, so you can see the difference between the dialog boxes). Don't be afraid to stack Levels adjustments or make subtle changes throughout your restoration with separate adjustment layers. This takes the pressure of needing to get it perfect with one change. I often make similar adjustments using Curves and keep the one I like better.

Before

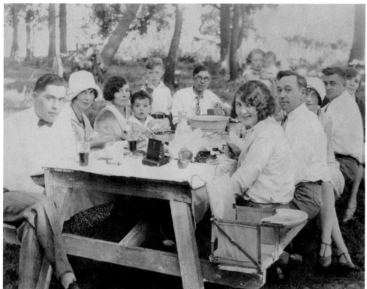

Figure 3.9
Improving brightness and contrast with Levels

After

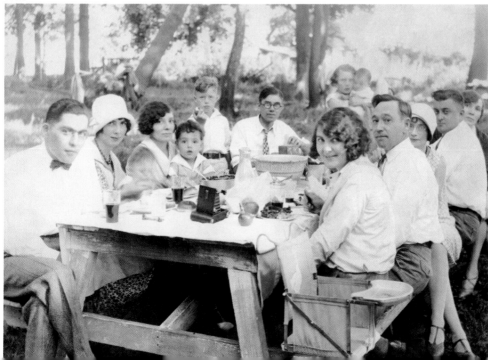

Curves

Curves is similar to Levels, only with more flexibility. While Levels enables you to adjust shadows, midtones, and highlights, Curves enables you to set and modify many more tonal points.

Curves is a tremendously powerful tone and color adjustment tool. That's good, but also bad. On the one hand, applying a Curves adjustment to your photos can fix a number of problems related to brightness, contrast, and color balance. Having so much power, on the other hand, may tempt you to micromanage photos so much that you lose sight of the big picture. In other words, you become more interested in wrangling the perfect Curves setting than in making the photo look better. It is easy to get carried away and try to do too much with Curves. Set specific goals each time you create a Curves adjustment.

I initially use Curves when restoring photos to correct color casts. I do this by clicking the Curves gray point dropper, and then clicking a neutral area in the photo. **Figure 3.10** shows the difference Curves can make when making color adjustments (again, using the non-adjustment layer version for reference). If necessary, I make more Curves adjustments after I have made other color, brightness, and contrast adjustments.

Figure 3.10 **Correcting a color cast with Curves**

Before

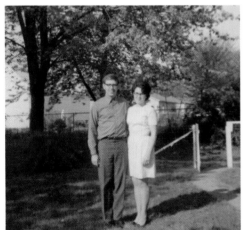

After

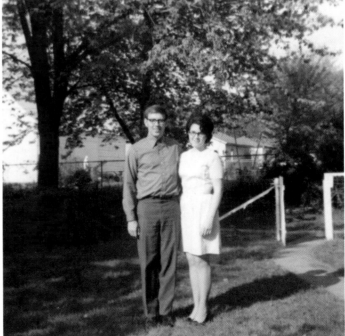

Other Significant Photoshop Features

I can't write a chapter about Photoshop without including several of its other main features. These are as essential to photo restoration as the tools and adjustments.

Layers

Layers are a critical photo restoration feature. They allow you to "stack" and organize adjustments and changes to your photos vertically, if you will, rather than on a single plane.

Graphic artists use layers to create different graphic elements that can be independently edited and moved around. You won't be doing that so much as making color, brightness, contrast, sharpness, and other changes using different layers.

It is a tremendous help to do your cleaning on separate layers. I always use a clone layer and may even separate that work into different layers. For example, I may use a separate layer to fix dust on a person's nose, the sky, the background, and so forth.

Photoshop has several different types of layers (**Figure 3.11**). You will find these to be the most useful:

Figure 3.11 **The Layers panel holds many different types of layers, each serving a different purpose.**

- **New, empty layers:** Use them to clone on and to repair damage.

- **Copies and duplicate layers:** Create duplicates of layers, or copy existing layers and paste that information to a new layer so that you can use tools like the Dodge and Burn brushes.

- **Adjustment layers:** Create adjustment layers to make nondestructive brightness, contrast, and color adjustments.

- **Smart Objects:** Create Smart Object layers from copies or duplicates of other "pixel" layers and apply filters that can be edited.

Here are some interesting tidbits about layers:

- You can control layers from the Layers panel or the Layers menu.
- Not all file types support layers. JPEGs (.jpg), for example, do not. TIFFs (.tif), on the other hand, and Photoshop files (.psd or .psb) do.
- Graphic artists and photographers can create images with hundreds or thousands of layers. You should not need anywhere near this number.
- Layers can be visible or hidden. To toggle their state, click the eyeball next to the layer thumbnail on the Layers panel.

On a final note, the Background layer is important in that it will contain the original, unrestored photo. It is my preference never to change it in any way. I do not repair it, retouch it, paint on it, or do anything to this layer directly.

Masks

Masks are wonderful tools that are very useful when restoring photos. They enable you to selectively show or hide parts of any layer by painting the mask with black to hide or white to show.

For example, let's say you want to brighten just one part of a photo (see **Figure 3.12**, where I brighten the ground but leave part of the scene that is inside the plane alone). You can create a layer with a copy of the photo on it, apply an adjustment to brighten that layer, and then mask out the areas you do not want changed. The mask enables the unchanged layers beneath to show through.

Mask ───

Figure 3.12 **Masks enable selective adjustments.**

Here are some handy notes about masks:

- Adjustment layers all come with a preinstalled mask. You can ignore it if you want (it defaults to "show all") or use it to protect certain areas of the photo from the adjustment.
- Smart Object layers can have layer masks as well as filter masks.
- You can paint masks, use the eraser, or make selections and then delete areas of the mask. Always make sure you have the mask selected on the Layers panel.

Opacity

All layers have a property called *opacity*, which is a measure of how easy it is to see through the layer. They can be opaque (100% opacity), transparent (0% opacity), or any whole percentage between those two extremes. **Figure 3.13** shows a Levels adjustment layer set to 20% opacity. That means it allows 80% of the layers beneath to show through.

Figure 3.13 **Blend with layer opacity.**

While layer opacity may not seem significant, it is one of the most important features in Photoshop that I use to blend changes together.

Here are some things you should remember about opacity:

- All layers and layer groups have an opacity.

- Set layer opacity in the Layers panel. Enter a number in the Opacity field or click the pop-up slider and drag to change the value.

- Masks have a property called *density*, which is similar to opacity, except that it controls how transparent the mask is independent of the layer's opacity.

Honorable Mention

It's not that these tools and features aren't useful. They are, given the right circumstances. However, you will find yourself using them far less than the others.

Other Features

These features deserve some mention:

- **Selections:** You select material on the canvas to copy or selectively edit. Selections can be simple or very complicated shapes. There are several different selection tools that enable you to select shapes or draw selections.

- **Transformations:** Transformations (in the Edit menu) deform and rotate layers or the entire image.

- **Noise Reduction:** Use to reduce noise and the effects of film grain. Normally the tradeoff to reducing noise is sacrificing some sharpness.

- **Sharpening:** Sharpen photos that look a little soft or blurry. While you can often sharpen digital photos quite a bit, sharpening old photos a lot without ruining them is much harder.

- **Artistic filters:** These filters (found in the Filters menu) do everything from creating mosaic effects to dry brush strokes. They're fun and amazing—not so practical for everyday photo restoration, but a must for artistic embellishment.

More Tools

The Tools panel is stocked full of relatively useful tools. You will use these at times:

- **Blur:** Use the Blur tool to soften areas of photos. This is an effective retouching tool when you want to create the illusion of a soft background.

- **Sharpen:** The Sharpen tool is useful for selectively sharpening areas of a photo. Use it instead of sharpening the entire photo, or when you don't want to sharpen the photo and mask out areas you want left alone. I use it to sharpen faces at times.

- **Red Eye (J):** The Red Eye tool is useful for taking the red out of people's eyes caused by the camera's flash.

- **Move (V):** When restoring photos, I use the Move tool to drag layers from one file to another and to reposition newly created elements (like putting together a new corner by copying and pasting an old one to a new layer).

- **Ruler (I):** Use the Ruler tool to help you straighten photos. Line up the ruler with the border or something within the scene, and it will tell you the angle. Use that information to transform the layer or photo.

- **Note (I):** The Note tool is an unheralded tool if there ever was one. Use it to keep notes about your work *within* the Photoshop file.

- **Rotate View (R):** When you want to see the photo from a different angle (to clone, for example, or work on something from a particular direction), use the Rotate View tool. This is one of my favorite newer tools.

- **Hand (H):** I don't often use the Hand tool. I prefer pressing the spacebar and then moving the image with a quick drag of the mouse. When you release the spacebar, you will return to the tool you were using.

- **Zoom:** I don't often use the Zoom tool. I prefer using the keyboard shortcuts. Zoom In/Out/Fit are Ctrl++/Ctrl+-/Ctrl+= on Windows or Cmd++/Cmd+-/Cmd+0 for Macintosh computers.

- **Dodge (O):** I use the Dodge tool quite often to lighten highlights in a photo, especially in people's faces. It makes them stand out better.

- **Burn (O):** Likewise, I use the Burn tool to give bland-looking shadows a bit more oomph.

More Adjustments

Photoshop has many more adjustments that enable you to alter a photo's color, brightness, and contrast. Over time, you should learn them all. Compared to the adjustments I showcased above, however, you may not use them as much or in every photo.

Here are some additional color-related adjustments (to find them, choose Adjust from the Image menu):

- **Vibrance:** Even thought I don't often use it, Vibrance is a fantastic restoration tool. It enables you to improve your photos by boosting color strength of muted colors but protects you from overemphasizing already strong colors. You may also reduce color intensity in the same way. The Vibrance adjustment also has an overall Saturation control.

- **Hue/Saturation:** Hue/Saturation is an important color adjustment. Using it, you can increase or decrease the color intensity of the entire photo (**Figure 3.14**) or specific color ranges. You can also alter colors by changing the hue. This lets you turn purples into blue, for instance.

Figure 3.14 **Using Hue/Saturation to desaturate a photo**

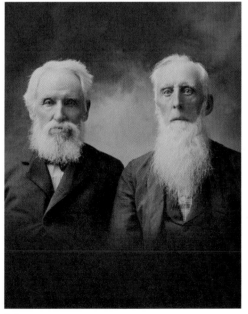

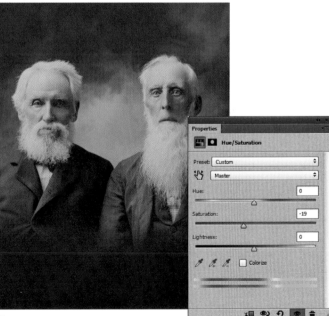

Before

After

- **Color Balance:** Color Balance enables you to make color corrections to a photo by altering the proportion of six colors in the photo. The colors are paired as opposites. You can trade cyan for red, magenta for green, or yellow for blue in three separate tonal regions: shadows, midtones, and highlights. **Figure 3.15** shows how you can use Color Balance to take reds and yellows out of a photo. Although you can see only the midtones tonal adjustment, I have also changed the values for the shadows and highlights tonal regions.

 If I can't correct a photo's white balance using a Curves adjustment, I turn to Color Balance and give it a go.

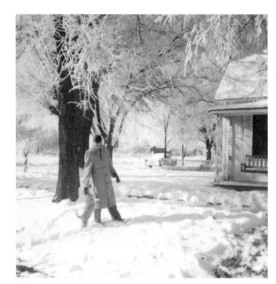

Before

Figure 3.15 **Color Balance is a handy tool to remove color casts in photos.**

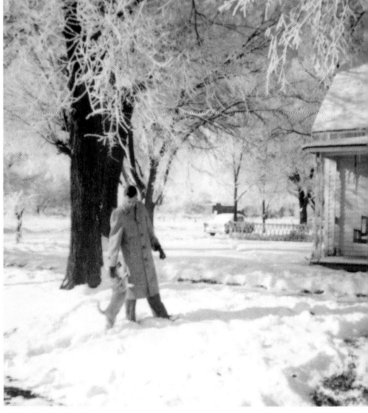

After

- **Black & White:** Use the Black & White adjustment to convert a color photo to black and white, as shown in **Figure 3.16**.

 One of my favorite tricks is to scan black-and-white photos in color, then use the Black & White adjustment to remove the color. I leave *some* toning in to preserve a sense of richness by reducing the opacity of the Black & White adjustment layer. This lets the color of the layers beneath it show through a bit.

- **Photo Filter:** Photo filters can effectively remove some unwanted color tints. For example, if a photo appears too blue, add a Warming Filter. If it's too warm, use a Cooling Filter to reduce the oranges and yellows.

- **Channel Mixer:** Use the Channel Mixer to change the balance of the three color channels (Red, Green, and Blue). Do this by selecting an output channel (for instance, Red), and then altering where the information comes from. The Channel Mixer sounds great in theory, but I find limited use for it when restoring photos.

Figure 3.16 **Converting a color photo with very strong color cast to black and white.**

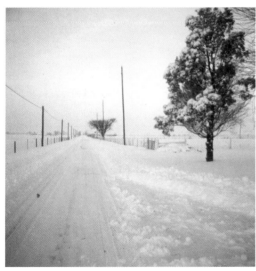

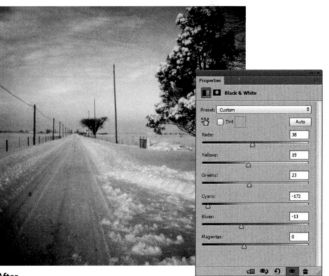

Before

After

Here are the other brightness-related adjustments:

- **Shadows/Highlights:** This adjustment enables you to brighten shadows, darken highlights, tweak midtone contrast, and make color changes to keep saturation the same. I find Shadows/Highlights useful to bring out details that may be hidden (**Figure 3.17**). Be careful: The more you brighten and saturate the photo, the more noise you may introduce.

- **Brightness/Contrast:** Increases or decreases brightness and contrast. Overall, a very useful tool that is nice and simple. I encourage you to play with it. The good thing about the Brightness control is that it compresses highlights as they get brighter, reducing the danger that you will make them so bright that they clip.

- **Exposure:** Exposure is similar to Brightness except that highlights will not be compressed. This is not the best method for adjusting brightness in old photos.

Remember, adjustments are available in two ways: as unchangeable adjustments to the currently selected layer or as adjustment layers. I always use adjustment layers, if possible. Check out the Layers panel for handy shortcuts or the New Adjustment Layer menu, found in the Layers menu.

Figure 3.17 **Brightening shadows**

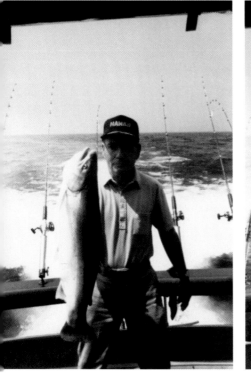

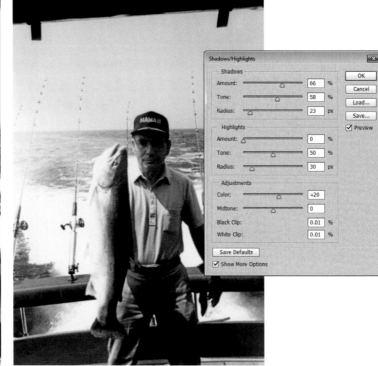

Before

After

What Didn't Make the Cut

Photoshop has so many features, bells, and whistles, it should not surprise you that I can't cover everything, especially those items that have little or nothing to do with restoring photos. If you're particularly interested in using Photoshop in a larger sense, you should look up topics like these in the Photoshop manual and experiment with them on your own:

- 3D imaging
- Texture painting
- Auto adjustments
- Content Aware Scale
- Type
- HDR
- Panoramas
- Libraries

- Effects
- Warping
- Image modes
- Lens corrections
- Extensive selection-making
- Shapes
- Proofing
- Experimental features

- Grid and guides
- Plug-ins
- Printing
- Video and animation
- Scripting
- Developing Web graphics
- Syncing and anything to do with the Cloud

Photoshop Tips and Techniques

Using Photoshop is not hard, but if you're not familiar with using it to restore photos, you may need to learn some new tricks. I use some of these every time I work on a photo. Others are handy on a case-by-case basis.

In this section I discuss working with Photoshop in general. Next I offer up some tips and techniques for restoring photos in Photoshop.

Naming Your Layers

You don't have to settle for Photoshop's default names for layers. While somewhat descriptive, you can often do better than Layer 23, as shown in **Figure 3.18**.

Figure 3.18
Make layer names work for you.

Singular adjustment layers don't cry out to be named. Levels 1, for instance, isn't that big of a deal. However, when you get to Levels 5 it can get confusing. At that point, try naming adjustment layers according to their specific purpose. For example, you might name a Levels adjustment layer Contrast or Brighten. You might name a Curves adjustment layer Color Correction.

I name some layers based on the filter I apply or the tool I use. For example, when I sharpen, I name the layer Sharpen. When I apply noise reduction, I name the layer Noise Reduction, Noise Reduction Sky, or Dust & Scratches. Feel free to abbreviate. If you want to call a layer NR (for noise reduction) or HPS (for High Pass Sharpen), go right ahead. When naming cloning layers, I may use a general name, like Clone, or be more specific, like Clone Trees.

You can name most layers when you create them from the Layers menu. If you use the Layers panel, or they already exist, rename layers by double-clicking their name in the Layers panel.

Disabling the Pixel Grid

While users who need pixel-perfect placement may benefit from leaving on the pixel grid, I prefer turning it off. When on, and the view is greatly magnified, it's very hard to see things (**Figure 3.19**), especially gradients between different tones and colors, because the grid gets in the way. Since you don't really need the grid when restoring photos, do yourself a favor and turn it off by selecting Pixel Grid from the View > Show menu. It distracts and makes using the Clone Stamp and Healing Brush tools harder.

Figure 3.19 **The pixel grid sounds great—in theory.**

On Off

Dragging Layers Between Files

Sometimes I make adjustments in one file and want to use them in another. This happens most often with adjustment layers or filters applied to Smart Objects. The trick to moving them between files is to drag the layers from the file they are in and drop them onto the canvas of the file you want them copied to.

Arrange the document windows so that you can drag and drop between them (**Figure 3.20**). Select the file that has the layers, then select the layers in the Layers panel. Drag and drop them onto the second document. You can also drag and drop layers with the Move tool.

If you are dragging layers with active masks, the masks may not be placed in the same location, especially if the images are not the same size. Try unlinking the mask from the layer before you start, then press and hold Shift as you drag the layer.

Figure 3.20 **Dragging three adjustment layers from one file to another**

Dragging Masks Between Layers

There are a few ways to copy masks, one of which is to add the mask to the selection (from the Layers panel) and then create a new mask on a different layer from the selection.

You can also duplicate the layer with the mask you want to copy, then drag and drop the mask onto the layer you want it copied to. Afterwards, delete the copied layer. I like using this method. I will often create a new, empty layer and drag a mask that I want to save onto it, then hide the layer. I prefer this method over constantly saving selections, because I like that the mask is visible in the Layers panel. Seeing it reminds me that it's there.

Documenting Your Work

Take notes or save presets as you restore photos. Note brush size and hardness, adjustment settings, opacities, and other items that might help you go back and re-create your work if needed. You can also use notes (see **Figure 3.21**) as reminders.

Your settings remain accessible if you use adjustment layers or Smart Object layers. Even so, I have realized a number of times after the fact that I needed some setting or another that I hadn't copied down. Those are the times I wish I had taken notes. In some cases you can create tool presets or save adjustment settings. Regardless of how you do it, do yourself a favor and document your work.

Notes panel ——

Note icon ——

Figure 3.21
**Notes stay with
the Photoshop file.**

If you remain skeptical, I would like to share something that just happened. I had finished working on the Mount Rushmore photo (at the beginning of this chapter) and was about ready to send the chapter to the editorial team when I realized how much I hated the photo. It was too gray, was too stark, and had too much film grain, and the shadows in the trees were too dark. I had pushed too hard. (An important lesson to learn: Give photos time to rest, and come back to them with a fresh perspective.) I went back and, without too much pain and suffering, tweaked a few things and make the photo look better. I was able to do this because I had my layered Photoshop file to work with, had used adjustment layers and Smart Objects, and had taken notes on other aspects of my edits.

Creating Tool Presets

Tool presets are a simple but effective way to re-create settings and situations. The problem is, they are notoriously (by me, anyway) underutilized. If you find that you are always using certain brush sizes or hardnesses, for example, lock them into presets.

To create a tool preset:

1. Select the tool and configure it to your liking.

2. Make sure the Tool Presets panel is open.

 Alternatively, you can click the triangle next to the tool icon on the Control panel. This opens the tool pop-up panel. Presets you create here will show here and not on the Tool Presets panel. I prefer using the panel, however.

3. Open the Tool Presets panel menu.

 There are a lot of options here. You can reset, replace, load, save, create, and manage presets.

4. Choose New Tool Preset.

5. Name the preset (**Figure 3.22**) and click OK.

 The preset appears on the Tool Presets panel with any others you have created (**Figure 3.23**).

Figure 3.22 **Name your preset.**

Figure 3.23 **Your preset is now ready to use.**

Creating Actions for Repetitive Processes

I am a huge fan of actions—recorded scripts that automate tasks, ranging from simple to very complex. I use actions for things such as:

- Duplicating the image.
- Duplicating the image as a merged copy.
- Converting a layer to a Smart Object layer.
- Creating a Smart Object from the current layer and applying a High Pass filter.
- Creating a Smart Object from the current layer and applying noise reduction.
- Creating a Smart Object from the current layer and applying a Shadows/Highlights adjustment.
- Flattening the file and saving as a TIFF.
- Selecting the canvas, using Copy Merged, then pasting the result as a new layer.
- Selecting the canvas, using Copy Merged, pasting the result as a new layer, then converting it to a Smart Object.
- Purging Photoshop.
- Resizing to common dimensions.

To create an action:

1. Open the Action panel.

2. From the panel menu, select New Action.

3. Enter a name for your action (**Figure 3.24**).

Figure 3.24
Choose an obvious name so you can easily tell what it does.

4. Choose a set to organize it with and a keyboard shortcut, if desired.

5. Press Record.

6. Perform the steps you want recorded in the exact order in which you want them.

7. Press the Stop button at the bottom of the Actions panel to finish.

 The action is updated in the panel and you will be able to see each command, as shown in **Figure 3.25**.

Figure 3.25 **Select the action and press Play to run it.**

A **Action set**
B **Action**
C **Commands**
D **Stop playing/recording**

E **Begin recording**
F **Play selection**
G **New action**

Using Adjustment Layers

Whenever possible, use adjustment layers. Once you close a normal image adjustment dialog box, the adjustment is made and you can't change it. But you can return and edit the properties of an adjustment layer as many times as you want. This is very effective when restoring photos because it is often necessary to look at the photo and ponder the effects of each adjustment you make, then change it. Adjustment layers make this process much easier.

There are many possible types of adjustment layers. I regularly use Levels, Curves, Vibrance, Hue/Saturation, Black & White, and Color Balance.

Using Smart Objects

Smart Objects are helpful because, like adjustment layers, you can edit the settings of adjustments and filters you have applied to the layer any time you like. I love to use Smart Objects for Shadows/Highlights, High Pass sharpening, noise reduction, and artistic filters.

Organizing Layers with Layer Groups

If your file is getting cluttered with layers, organize them into groups. It's an easy way to simplify the Layers panel, as shown in **Figure 3.26**.

Colorizing Layers

It might help you to colorize layers based on the adjustments you make to them. You might turn cloning and healing layers violet (**Figure 3.27**), color adjustments green, brightness adjustments blue, helper layers gray, your before layer yellow, and so forth.

Figure 3.26
Layer groups are a great way to organize numerous layers.

Figure 3.27
You can also make sense out of layers by coloring them.

Managing History

Know how the History works and that there are several options. I find the Allow Non-Linear History option the most interesting. With that selected (access the History Options choice from the History panel menu), you can selectively undo actions whether they are at the beginning, middle, or end of the current History.

As good as the History is, there are several things you will do as you restore photos that will clog the History panel, as shown in **Figure 3.28**—namely, cloning. Every single time you use the Clone Stamp tool, a new entry is created. When you're removing a thousand specks of dust, that takes over the History panel.

Figure 3.28
Repeated tool use will overwhelm the History panel.

Saving Selections

You can save selections as new alpha channels in the same image and as new alpha channels in a new image. You can update, replace, and load selections, and save them as masks. This may not be the most sophisticated method, but it's easy and a nice reminder that you have a selection.

Saving Large Files

Save large files in Photoshop's large document format (.psb). This is less of a tip than a "must do." I know. It won't feel the same, seeing the .psb extension instead of .psd. **Figure 3.29** shows them both side-by-side.

Large.psb Normal.psd

Figure 3.29 **Photoshop files for your viewing pleasure**

Restoring Photos in Photoshop

This section contains an assortment of general techniques that I often use when I restore photos. Like the Photoshop techniques that I shared previously, some of these are helpful all the time. Others are more situation-dependent.

Showing Clipping

Press and hold Alt (Windows) or Option (Mac) when changing the black-and-white points in a Levels or Curves adjustment. The photo alerts you visually when shadows or highlights clip, as shown in **Figure 3.30**. That's handy, because you don't want to lose details. You can also enable this feature from the Panel menu so that you don't have to constantly press another key.

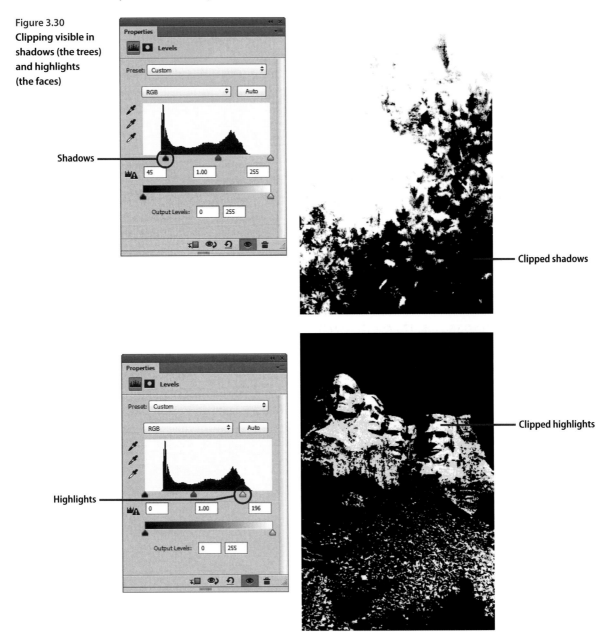

Figure 3.30
Clipping visible in shadows (the trees) and highlights (the faces)

Duplicating Open Images

Duplicate (choose Duplicate from the Image menu) the image you're working on as many times as needed to test out different restoration approaches. This keeps everything tidy in your main working file. I realize this doesn't sound necessary, but believe me, it's a great benefit to have the freedom to experiment without committing (that's also called casual dating). I am creating a duplicate file in **Figure 3.31**. When you have a winner, overwrite the original file with the version you want to keep, or drag the layers you added or modified to the open original.

Figure 3.31 **Duplicating images is an easy way to experiment and yet keep your original file safe.**

Opening Photos in Adobe Camera Raw

The Open As menu (found under File) is a hidden gem in Photoshop. Using it, you can open a photo (.tif format) and use the Adobe Camera Raw (ACR) interface to retouch it. Why do this? If you're having trouble getting the right color or exposure using Photoshop, ACR is different enough that it may be the answer to your problem. If you would rather use ACR as a Smart Object filter, turn to Chapter 6, "Correcting and Enhancing Color, Brightness, and Contrast," for further instructions.

To open a file as an ACR image:

1. If you're going to open the scanned photo, copy it and rename it to something as a reminder that you plan on opening it in ACR.

 For example, you might choose something like IMG_0192_acr_in.tif. I do this because, once opened and edited, the file will be paired with its ACR settings, and Photoshop will want to open it again using ACR whether you use the Open As menu or not.

2. If you've been working on the photo in Photoshop and want to send what you have completed so far to ACR, save (but do not close) the unflattened Photoshop file so that you don't lose your work. Next, flatten and save it as a new .tif, naming it as shown in step 1. Close the .tif.

3. In the File menu, choose Open As.

4. Change the Type box selection to Choose Camera Raw.

5. Select the file you want to open in the dialog box.

6. Press Open.

That's it. Photoshop opens the .tif in Adobe Camera Raw, and you're off and running. Make the changes you want to make. Experiment with different options. Before you're done, make sure to change the color profile to the one you want to use in Photoshop (Adobe RGB, for instance, or sRGB) and match the resolution to the scan if possible (if you can't, resize the image to match the resolution of your working Photoshop file without resampling). Do this by clicking the Open preferences icon on the toolbar or the preference line at the bottom of the screen. When finished, you can save the photo or click Open Image to open it in Photoshop. I prefer to save the file with a new name, something like IMG_0192_acr_out.tif. You, of course, do not need to be as obsessive as I am.

All you have to do now is drag the newly edited version of the image back into your original Photoshop file, or create a new one with this as the Background layer.

Comparing Before and After

Although this trick is very simple, don't underestimate the importance of being able to quickly compare your work to the original photo.

Duplicate the Background layer (this is the original photo) and always keep that copy on top of the Layer panel. As you work on your photo, keep this layer hidden. Whenever you want to see how you're doing, toggle this upmost original version on and off.

The toggling action is the secret to the success of this method. Looking at two versions of the same photo side by side is a much less effective way of comparing restoration changes. It is also a foolproof way to "sync" the view when you want to zoom in and examine microscopic details in the photo. You never have to worry about matching the zoom area, since the layers are always lined up.

Toggling Layer Groups

If you have several layers that you want to toggle on and off to compare their cumulative effect on the photo (for example, one or more cloning layers and perhaps a healing layer), put them into a layer group. Toggle the group on and off instead of the layers one at a time.

Making Channel-Specific Adjustments

If you want to make channel-specific adjustments:

1. Prepare the file by creating a merged copy of the layers you want to alter.

 You cannot make channel-specific adjustments using adjustment layers. You must make them to a layer using the Adjustments menu (found under Image).

2. From the Channels panel, select the channel you want to change.

3. Select the Adjustments menu and choose an adjustment.

 Brightness/Contrast, Levels, and Curves are just about your only options.

4. Make changes in the dialog box that appears after you've chosen an adjustment.

5. Press OK to close the dialog box and apply the changes.

6. In the Channels panel, reselect RGB to see the effect of your changes on the whole color spectrum.

Opacity Blending

Opacity blending is one of my most important techniques. The idea is to use opacity to alter the strength of certain adjustments and blend them with the rest of the photo.

For example, let's say you want to apply noise reduction. You create a merged layer to do so, then spend an hour and a half deciding how much noise reduction to use. Try this approach instead: Apply more than you need, then lower the opacity of the noise reduction layer so that the strength diminishes to the point where you're happy. It takes fewer than five minutes.

I do not hesitate to use opacity blending. It is an incredibly effective and yet simple technique. Use it on any filter or adjustment.

Using Photoshop Elements

Briefly, here are the significant similarities and differences between using Photoshop Elements and Photoshop when restoring photos.

The main application is very similar to Photoshop, but only when Elements is in Expert mode. (When you launch Elements, open the Photo Editor, then choose the Expert mode.) In this mode, Elements gives you the power you need to restore photos on your own. The interface looks something like Photoshop proper, just a bit simpler (**Figure 3.32**). Tools are on the left, the main window is in the center, panels are on the right. Unlike Photoshop, the Tool Options bar is shown at the bottom of the screen.

Figure 3.32 **Photoshop Elements has many similarities to Photoshop.**

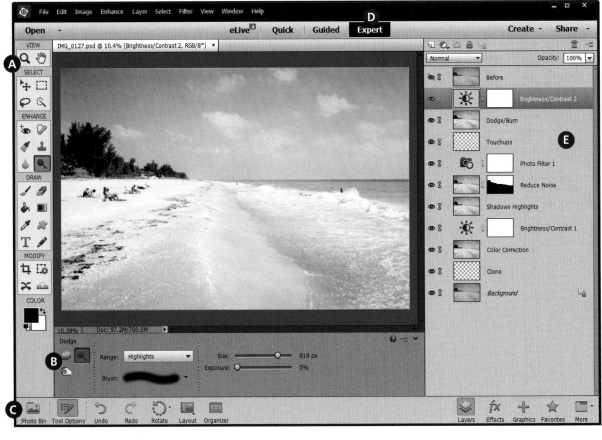

A **Toolbox**
B **Tool Options bar**
C **Taskbar**

D **Mode**
E **Panel bar**

Just like Photoshop, Elements has layers, adjustment layers, masks, different blending modes, actions, history, filters, noise reduction, sharpen filters, and a simpler version of Adobe Camera Raw. You can save and load selections, and more.

Just like Photoshop, Elements has a number of tools. The Clone Stamp, Spot Healing Brush, Red Eye Removal, Dodge, Burn, Sponge, Sharpen, and Blur are the most pertinent for restoration work.

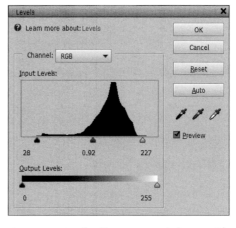

And just like Photoshop, you can make Levels (see **Figure 3.33**), Brightness/Contrast, and Shadows/Highlights adjustments. They are located in the Enhance menu. Elements has a simpler version of Curves, called Adjust Color Curves. You cannot balance color the same way or use a channel mixer. You can rotate, straighten, and transform layers, objects, or the entire image.

Figure 3.33 **Levels adjustments work the same in Elements as they do in Photoshop.**

Elements has a more rudimentary color setup (see **Figure 3.34**). Although there are more limited options, you should be able to use them effectively. You only have three choices: To ignore color management information, to use sRGB (for displaying colors on screen), or to use Adobe RGB (optimized for printing). Those are all you really need.

Elements does not feature layer groups or Smart Objects, enable you to colorize layers, support the large Photoshop file format, or have channels, paths, or embedded notes. You cannot save adjustment or customized tool presets in Elements.

Figure 3.34 **Elements has simple but reasonably effective color-management options.**

Overall, Elements is a surprisingly good application for restoring photos. While you do not have all the power of Photoshop, you can get by just fine with what you do have. I would encourage you to use more automatic adjustments and enhancements when using Elements. The thing I find most limiting (compared to using Photoshop) is that there are fewer types of adjustment layers. Most notably, you cannot create Curves, Vibrance, Color Balance, or Black & White adjustment layers. If you account for these differences, you should be able to follow along with most of the book with very little trouble.

Setting Up a Working File

I use an action to automate and speed up the process of setting up my photo restoration files. I can't tell you how much time this has saved me. It also makes my work more consistent. Here's how the process goes:

1. Scan and save the photo as a .tif image file.

2. Open the image in Photoshop without color management (**Figure 3.35**).

Figure 3.35 I leave the file as is initially so that I can run everything as an action.

My scanner does not assign a color profile, so when I open the image file in Photoshop, I tell it not to color-manage the image (I could go ahead and assign the profile I use in step 3, but I prefer this order because it seems less prone to accidentally assigning the wrong thing). This leaves the photo as is.

If your scanner attaches a color profile to the files it saves, you should not assign a new profile when you open it in Photoshop. If the existing profile is different than your current working space, you will be prompted to use the embedded profile or convert it. If you want to convert it now, do so, then skip to step 5.

Next, I run my file setup action.

3. Assign a suitable color profile to the image, as shown in **Figure 3.36**.

I choose to initially assign the sRGB profile. After extensive testing, I discovered that assigning sRGB to the scans my scanner produced resulted in the most natural looking image. I wanted them to match the physical photo, not look better or different. Other color profiles looked too saturated (Adobe RGB) or wrong.

Never assign a new profile to an image that already has one. If the image's color profile is correct, always convert from one profile to another.

Figure 3.36 I assign a color profile that makes the photo look the most like the original.

4. Convert the color profile to the desired working color profile, as shown in **Figure 3.37**.

I choose Adobe RGB. Although the difference between sRGB and Adobe RGB may not always be discernible, I prefer using the latter in order to take advantage of the wider color gamut when editing.

You do not have to use Adobe RGB. Pro Photo RGB is a viable alternative. Of course, you can work in sRGB from start to finish if you want.

Figure 3.37 Convert the color profile to whatever you like once you have one assigned.

5. Create two empty layers. Name one Clone and the other Healing, as shown in **Figure 3.38**.

I like having premade layers that are ready to use. Since I always use one or the other, it makes sense to create them with this action.

Figure 3.38 Setting up my cloning and healing working layers

6. Create three Levels adjustment layers. Name one Darken, another Lighten, and the third Contrast. Hide them until needed, as shown in **Figure 3.39**.

 These helper layers assist me when I use the Clone Stamp or Healing Brush tools. I use the Darken layer to make bright areas of the photo darker so that I can see blemishes more easily. Likewise, I make the photo brighter when I need to repair in dark areas. The Contrast layer boosts the contrast so that specks of dust and lint stand out throughout the photo. I simply toggle a layer on when I need to use it, then toggle it off when I'm done.

 I automate the creation of these layers but change the settings myself when I begin work.

7. Select the Background layer, duplicate it, hide it, and then move it (on the Layers panel) to the top, as shown in **Figure 3.40**.

 This is my "before" layer. I always have this layer on the top of the Layers panel so that I can quickly toggle it on and off to compare my work (which is beneath it) to the original photo. It is far easier to do this than it is to turn off six or seven working layers to get to the unrestored photo at the bottom of the stack.

8. Finally, I save the file as a Photoshop image file (.psd). If you expect the file to grow to a few gigabytes (common for larger photos scanned at high resolutions), save the file as a .psb file.

Figure 3.39 These temporary adjustment layers help me see things as I clone and heal.

Figure 3.40 Keep the original photo on top of the stack so you can quickly toggle it on and off to compare.

Chapter 3 Assignments

Assignment time. Since this chapter is about Photoshop, I want you to launch Photoshop and familiarize yourself with the main elements of the program. Make sure you know where the menus are and which ones you will use the most, and be able to identify the tools, panels, and other interface components.

Next, open a scanned photo and decide how you want to handle color profiles. Practice making a few layers and dragging them around. If you like, customize the workspace so that it helps you focus on restoring photos.

Practice using the top tools

With a photo open and ready (make sure to save it as a .psd before you start work so you don't accidentally overwrite your .tif), practice using these restoration tools: Clone Stamp, Spot Healing Brush, and Healing Brush. Create empty layers for each.

Find some dust or spots to clean using the Clone Stamp and Spot Healing Brush. Find a scratch or linear blemish to clean using the Healing Brush. Use the default tool presets for all three tools, with the following exceptions:

- **Clone Stamp tool:** Set Sample to Current & Below. Cloning on a separate layer requires that this be selected unless you want to constantly switch back and forth from the source layer to the destination.
- **Spot Healing Brush:** Check Sample All Layers. Healing on a separate layer requires this be selected.
- **Healing Brush:** Check Aligned and set Sample to Current & Below (just like the Clone Stamp).

Experiment with adjustments

Using the same or a different photo, create at least two adjustment layers: one Levels and one Curves. Experiment with the presets and settings. For extra credit, experiment with other adjustment layers like Brightness/Contrast, Vibrance, and Color Balance.

Create an action

Create an action. Although you can make it anything, try something you think will save you time, such as creating a merged, duplicate image. Open the Action panel, create a new action, name it, then perform the steps you want recorded. When you're finished, press Stop.

Share your results with the book's Flickr group!
Join the group here: www.flickr.com/groups/photo_restoration_fromsnapshotstogreatshots

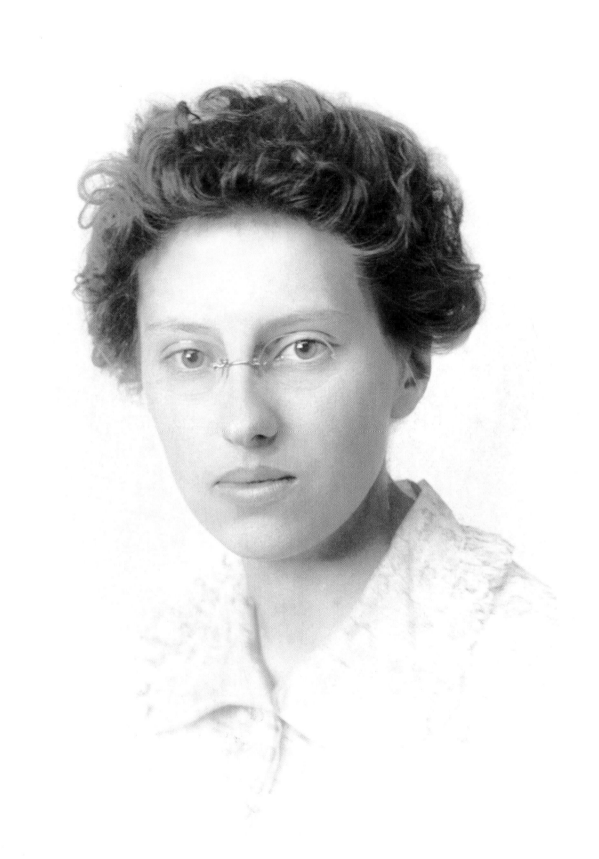

4

Cleaning the Surface

The Secrets to Cleaning

I have to admit it. I love cleaning photos. It's a practical, positive act that improves how photos look, often dramatically. The funny thing is, most people won't even know it. They'll see the end result, which is the final photo you print and frame (or post online). They won't see the specks, dust, lint, or other gobs of stuff you've laboriously covered up at a magnification level of 1000%. That's okay. We know.

To get there from here, you need to learn some of the secrets to cleaning. There is more to it than just pointing a tool at a photo and letting 'er rip. That's what this chapter is about: secrets.

WEBER'S

Details in background not clear.

Yellowed with age.

This photo of downtown Defiance, Ohio, was taken during the flood of 1913. It's an amazing shot that shows the floodwaters covering the street and sidewalk. The photo suffers from yellowing, brightness, and contrast problems. It is also covered with blemishes of many sizes and shapes. They are on the buildings, in the sky, on the boy, and throughout the water.

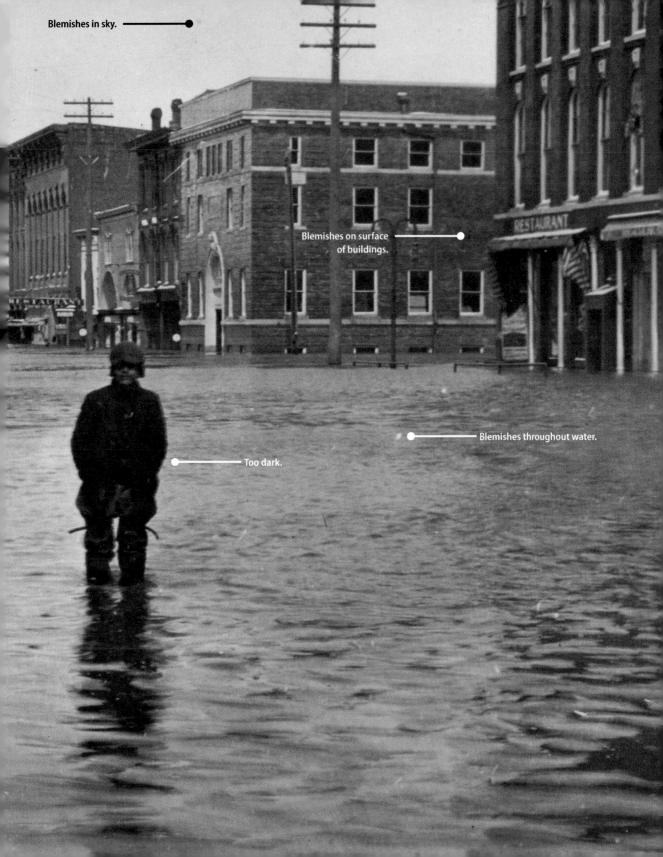

Blemishes in sky.

Blemishes on surface of buildings.

Blemishes throughout water.

Too dark.

RESTAURANT

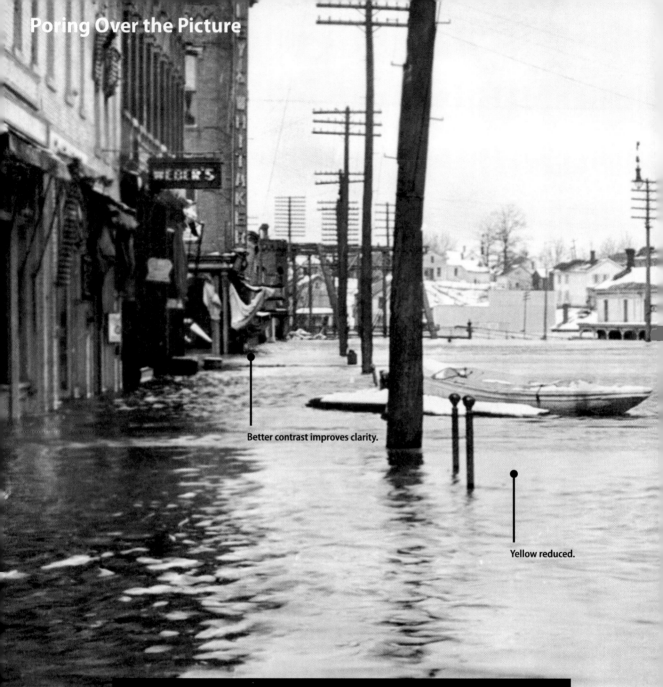

Better contrast improves clarity.

Yellow reduced.

This photo *should* look old. Therefore I have decided to perform less "restoring" than I might otherwise do. That's okay. I cleaned all the debris from the photo's surface, and improved the brightness, contrast, and color. I did not try to over-sharpen or reduce the film grain. I would rather you be captivated by the subject matter than my efforts to make it look artificially pretty.

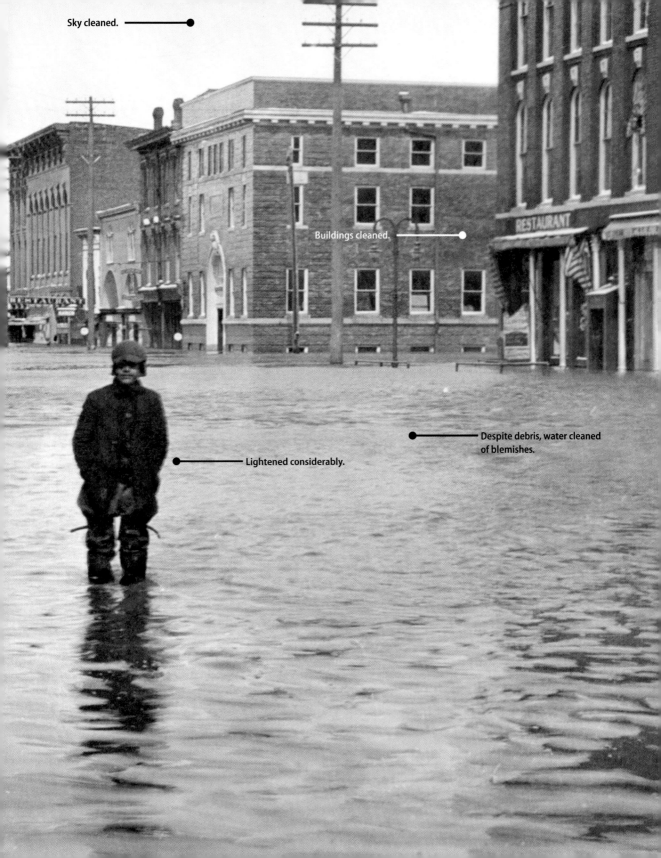

Sky cleaned.

Buildings cleaned.

Despite debris, water cleaned of blemishes.

Lightened considerably.

RESTAURANT

Surveying the Scene

Before you jump into cleaning, take a few minutes to carefully inspect the photo and see what condition it is in. Then plan your cleaning attack.

A programming note before we begin: Much of what I discuss in this chapter also applies to repairing physical damage (which is the subject of the next chapter). The concepts are very similar: You cover blemished and damaged areas of the photo with clean, undamaged material. As you read through the material on cleaning, keep that in mind.

Looking Around

Your initial goal should be to come to grips with the extent and type of blemishes in the photo. Knowing this will help you decide where—and how—to begin cleaning. In the end, you can be confident that there are no surprises waiting for you. Here are several factors you should consider.

Visibility

Some blemishes are easy to spot. They stand out because they have a different color, brightness, or texture than the surrounding area of the photo. Some actually cast shadows on the photo's surface, as shown in **Figure 4.1**. Tackle these problems first.

Figure 4.1 **Several of these larger blemishes are obvious.**

Some debris hides in shadows, highlights, or highly textured areas of the photo. Although these marks are fairly easy to clean, you may have to work to spot this type of blemish. Tackle these blemishes later.

If you haven't yet, create one or more temporary Levels adjustment layers above your empty cleaning layers. Set one to darken the image, one to lighten it, and another to improve the contrast. Toggle the darken and lighten layers so only one is on at a time. You can use the contrast layer with them or separately. Their purpose is to make blemishes easier to spot. Some spots and specks hide in bright or dark areas of the photos. Some do not contrast greatly with the surrounding pixels. Use these helpful layers to spot every blemish possible. When done, you can turn them off or delete them. They exist solely to help you see while cleaning the photo.

At times, it can be difficult to tell the difference between details in the photo and blemishes. If you find yourself unsure whether or not to cover up something, zoom out and look at the area in context. In the end, if it looks like a blemish, it probably is. If you think people will notice something wrong if you leave it in, remove it.

It is sometimes helpful to see how blemishes look in individual color channels. Select the channels one at a time from the Channel panel.

Size

Larger blemishes are easier to spot. Cleaning them should be a top priority. The size of the blemishes on your photo also affects how you clean them. In particular, you will set the magnification and size of the tools you use to match the blemish size.

Number

Knowing how many blemishes there are helps you approach the photo realistically. How much time do you have? It takes longer to clean a photo with ten thousand specks than it does to clean a photo with a hundred. This is why I typically start with the largest, most visible problems. Resolving the most obvious blemishes first enables you to accomplish something right off the bat.

Where

Pay attention to where blemishes are. Consider contrasting material around them as well as the level of detail. Blemishes in complex areas are harder to clean and take more time. You will have to magnify your view more and use smaller brushes. In **Figure 4.2**, the debris on the dog's nose is a good example of how details complicate cleaning. On the other hand, specks in the sky or other uniform areas are easier to clean quickly.

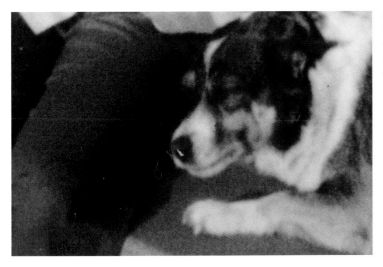

Figure 4.2
Cleaning these blemishes will be harder due to the nearby details in the photo.

Proximity

The proximity of blemishes to each other, and to clean areas of the photo, is a significant factor in how easy they are to clean. You should zoom in until you can successfully select clean source areas nearby, if possible.

Shape

The shape of each blemish affects how you use your tools and whether you use a brush stroke or dab.

What

Aside from a few exceptions, what you see covering your photos is mostly irrelevant. You will use the same approach to cleaning dust, specks, splotches, gunk, tape residue, spots, stains, or an assortment of blech. That doesn't mean it will be easy. Depending on where they are in the photo, writing, ink smudges, scuffs, fingerprints, and other discolorations can be very difficult to clean.

Planning Your Attack

Decide where you want to start. Although it can be anywhere (the sky, someone in the photo, the background, or any other area), there are certain advantages to having a consistent approach.

I prefer tackling obvious blemishes that stand out even when the photo is not magnified first. Then I move on to easy areas so that I make quick progress. When I'm ready, I move on to areas that may take more time or be harder to clean. If the photo looks pretty clean, start wherever you are drawn to.

Figure 4.3 shows how I approached a typical photo. First, I examined it for large blemishes and cleaned. I began in earnest with the easier parts: the sky and water. Next, I cleaned the poles, the water in the background, and the building on the right. I finished up by cleaning the boy, two groups of buildings, and the far background. This approach isn't an absolute rule.

I do everything I can not to get bogged down in one area. This sucks the life out of you and makes you think you'll never finish the photo. Working on different areas and moving around helps keep the work fresh. Approaching photos this way protects you from mentally checking out and throwing in the towel.

At the risk of beating a dead horse, cloning or healing on separate layers with the photo showing beneath is a very effective way to clean. Every single application of the Clone Stamp, Spot Healing Brush, and Healing Brush tools in this chapter—indeed the book—assumes that you use them on a separate layer.

Figure 4.3
Divide photos into general areas to clean.

First
Middle
Last

Making the Right Decisions

Cleaning photos doesn't have to be stupendously hard. It only has to be absurdly hard. Just kidding. You can smooth out the rough spots by making the right decisions as you start.

Selecting the Right Tool

Although it may seem a little odd to have three different "cleaning " tools that perform similar functions, each one is optimized in its own way.

- **Clone Stamp:** The Clone Stamp excels as a general-purpose cleaning and repair tool. Use it anywhere, any time.

- **Spot Healing Brush:** The Spot Healing Brush excels at removing spots. It is easier and quicker to use than the Clone Stamp because you don't have to fuss with selecting a source area. BAM! (Read that loudly with a southern accent so that it sounds like "Bey-yum!") That's it. Press it on the spot and the tool pulls in material from around the cursor and covers the center.

 You can also brush with the Spot Healing Brush. By brushing instead of BAMming, you can remove things that are more complicated than a simple spot. Lint, perhaps.

Alas, what makes the Spot Healing Brush unique also makes it more finicky to use. It does not work well in situations where the blemish you want to remove is surrounded by material of a different color, texture, or brightness.

- **Healing Brush:** The Healing Brush is a cross between the Clone Stamp and the Spot Healing Brush. Like the Clone Stamp, you must select a source. Like the Spot Healing Brush, the Healing Brush automatically blends material at the edge of the brush. I prefer using the Healing Brush on scratches in areas where the texture is pretty simple.

Selecting the Right Magnification

Select the magnification that gives you the best view of what you are trying to clean and the general area. The exact magnification depends on the size of the blemishes and the level of detail surrounding them.

It is important not to zoom in too much, as shown in **Figure 4.4**. You lose perspective, which makes it hard to see whether or not your work looks good and you are cleaning invisibly. It is also much harder to find good source material if you are zoomed in too far (this does not apply to the Spot Healing Brush, which is one of its strengths). You will constantly have to move your view to find suitable areas to select. That lengthens the process considerably.

Figure 4.4 **You can't tell what's what if you zoom in too far.**

At times, you may need to zoom in very closely to be able to use your tool very precisely. That is why smaller blemishes around areas of detail take longer to clean. On the other hand, it is also necessary to zoom out occasionally and get the big picture so that you can check blending from a distance.

Selecting the Right Brush Size

The most important thing to remember about brush size is that it's all relative. For small blemishes, zoom in and make the brush smaller. That's right, smaller. As you zoom in, reduce the size of the brush so that it stays the same size relative to the canvas. For larger blemishes, zoom out and make the brush larger, if possible (you have to take into account the surrounding material). The exact brush size you select depends on several factors:

- **Blemish size:** If possible, use large brushes on larger blemishes. Use small brushes on smaller blemishes. That makes sense. Exactly how large or small depends on the blemish itself and the surrounding area.

 For spots, I prefer setting the brush size so that it comfortably covers the blemish. For lint and other imperfections that aren't round, I set it to cover the width. In each case, I like a little extra to spare. This helps blend.

 If you set the brush size too small (relative to the blemish), it takes more work to clean each blemish. Do not be afraid to set the size of the tool larger.

- **Magnification:** The greater the magnification, the larger the tool looks on screen. For example, when viewing a 1200 dpi scan at 400%, a 40-pixel brush looks pretty large. A brush between 10 and 15 pixels looks about right to me at that magnification and resolution to cover small imperfections.

 My general rule of thumb is that I want the tool size to give me the same general "look," regardless of magnification (see **Figure 4.5** and **Figure 4.6**). In other words, the brush should take up the same amount of space on the screen. I do this by using smaller and smaller brush sizes the more I zoom in.

Figure 4.5 Working at 700% magnification with a small 10-pixel brush

Figure 4.6 Changed to 150% magnification with a larger 30-pixel brush but same relative size

- **Cleaning strategy:** It's more efficient to cover round or small imperfections with one dab or stroke. Larger brushes (relative to the size of the blemish) require fewer applications. Smaller brushes (relative to the size of the blemish) require more applications. Try this approach first.

 Large or irregularly shaped blemishes may require more than one pass, especially if they are near other imperfections or details. Size the brush smaller than the blemish, but not so small that it makes it impossible to use. You may need to use several gentle dabs or small strokes in these areas.

- **Surrounding area:** What surrounds the blemish you are trying to cover has a significant impact on the size you can set your tool to. If the area is generally clean and free of other specks, dust, lint, and other problems, you can set your tool size larger. If the area is packed with imperfections, you will have to set your brush sizes smaller to be able to stay clear of the problems.

- **Blending:** Large (relative to the blemish) brushes blend better than small ones. Keep this in mind if you are having trouble blending the edges of your brush strokes.

One quirky aspect of brush size has to do with hardness. The harder a brush is, the more distinct its edges are, much like an asteroid. Harder brushes are more difficult to blend. The softer a brush is, the fuzzier the edges are, like a comet. This makes blending soft brushes easier.

Since softer brushes have a *coma* of fuzzy pixels around a center (the coma of a comet is the halo of evaporated gas and dust that surrounds the nucleus), you may need to set them larger in order to adequately cover the center of the brush. This is normal. If you do this, watch out for "overspray" from the fuzzy edges. If it looks like you're painting material outside of where you want, erase the overspray and, if necessary, set the brush size smaller and try again.

Selecting the Right Brush Hardness

As a rule of thumb, soft brushes blend better. However, sometimes they look too soft. Harder brushes blend less effectively, but there are times you need to paint pixels with a harder edge so that they match the texture of the area you are painting in. Here are the criteria I suggest using for setting the right hardness of your brushes:

- **Soft:** I normally set the hardness to 0% and change it only if I begin to see "fuzziness" as I clean. If you sense the photo losing sharpness as you cover blemishes, that is the sign that the soft pixels are robbing the photo of detail. This happens more often than not when cleaning in areas with a rough texture.

- **Harder:** If necessary, I increase brush hardness to 10%, test it, and make adjustments up or down according to what I see. I rarely need to go above 50%. **Figure 4.7** shows an extreme example, using a 100% hard brush.

 Be careful any time you increase the hardness of any of the three main blemish-removing tools. It is easy to forget to change it back when conditions change.

Figure 4.7
Hard brushes do not blend pixels at their borders.

Remember, tool presets enable you to store and recall specific brush sizes and hardness levels.

Selecting the Right Tool Options

With one very large exception (and one moderately large, but not inconveniently so, exception), the default options for all three cleaning tools are just fine. The large exception is to set the Sample setting on the Clone Stamp and Healing Brush tools to Current & Below (see **Figure 4.8**), and to check Sample All Layers when using the Spot Healing Brush. This enables you to do your repairs on separate layers stacked above the photo layer, which should be beneath.

Figure 4.8 **Clone Stamp options**

I prefer using Current & Below because I keep all my adjustment layers *above* the clone layers. Doing so enables me to use adjustment layers to see better without affecting what I am cleaning. The Sample All Layers option for the Spot Healing Brush ignores adjustment layers.

The second exception is to select Aligned when using the Healing Brush or the Clone Stamp. When deselected, Aligned causes the tool to pick up material from the same initial sample source point with every stroke. To change the sample point, you must select a new one. Except in those rare circumstances when you want to use the same source spot over and over again, Aligned should be on.

To reset tool options, select the tool from the Tools panel, then click the small triangle beside the tool icon on the Options panel. Click the gear symbol that appears on the Tool Preset dialog, then select Reset Tool from the pop-up menu (see **Figure 4.9**).

Figure 4.9 Resetting the Clone Stamp tool

Using Your Tools

Once you have zoomed in to the magnification you want to work at, chosen your tool, selected a size, set the hardness, and configured any options you want to use, you are ready to apply new material to cover what you want hidden. This is where the magic happens.

Before you begin, make sure that the cleaning layer you want to use is selected in the Layers panel. This layer should be above the photo layer. Do not select an adjustment layer or the layer your photo is on.

Selecting the Source

When using the Clone Stamp and Healing Brush tools, you must first select a sample source. The source area contains the pixels that will be transplanted to the destination to cover up imperfections. Selecting a matching source area is essential.

(I've seen what I call the source or source area also called the sample source, sampling source, sampling point, clone source, and source sample. At least. It's all the same thing. It's where the tool looks for material to paint with. Conversely, the destination area identifies where you apply the fresh coat of paint to cover up the blemishes.)

Think *like covers like* as you look for an appropriate source area. Use dark material to cover specks in dark areas, and light material to cover blemishes in light areas. The same goes for color and texture. If you're covering up a spot on a brick building, look for good source material in nearby bricks that run the same direction. Having the same orientation and lighting makes them a perfect candidate. Likewise, cover spots in waves by looking for a clean area *on the same wave* to use as the source. Match peaks to peaks and valleys to valleys. Details make it hard to match source and destination material because you do not want to change the detail. After all, an eye has to look like an eye.

This all sounds more complicated than it is. After you get the hang of it, it is a very intuitive process. See spot. Cover spot. You get it. Your eyes and brain are magnificent instruments that often work without your direct conscious input. When you find your "zone," you will be able to quickly examine the area around most blemishes and be able to select a matching source area in no time.

To set the source area and begin brushing:

1. Press and hold the Alt (Win) or Option (Mac) key. The cursor will change to indicate that you are in the sampling, not painting, mode.

2. With the Alt or Option key held down, left-click the spot you want to sample on the canvas, as shown in **Figure 4.10**. This loads it into Photoshop. Although I keep things simple with just a single source, you can select and have Photoshop remember up to five different areas using the Close Source panel (open it from the Window menu).

3. Release the Alt (Win) or Option (Mac) key.

 The cursor changes back to normal.

4. Position your brush where you want to begin your stroke, as shown in **Figure 4.11**.

5. Brush (see **Figure 4.12**) or dab with the tool to cover the blemish.

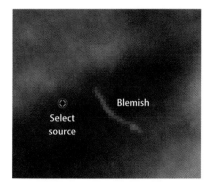

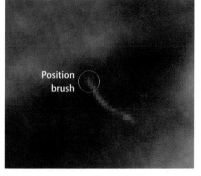

Figure 4.10
Select a source that matches the area surrounding the blemish.

Figure 4.11
Remember, you will paint with "borrowed" material.

Figure 4.12
Stroke to match the contour.

Mechanically, this is a relatively simple operation. What complicates it is the necessity of matching the area of the photo surrounding what you want to cover with the source. If you are off just a little bit, it will be obvious. The keys to matching the source and destination are based on how well you observe and account for the color, brightness, texture, and detail.

Brushing

Having a good brush technique is vital to cleaning your photos invisibly. Remember, you want to cover up bad things with good things without anyone knowing. I have some advice to help you accomplish this.

First, try to keep your strokes shorter rather than longer. Do what needs to be done to cover the blemish and then end the action. Do not linger unnecessarily. If necessary, touch up the edges of your first strokes with more material to make them blend better. Do not be afraid to undo or erase your additions entirely and start over. Using relatively short strokes means each mismatch costs less time and effort to fix.

Second, the direction you stroke in can make a difference in how the new material blends in. Think like a skier skiing or a snowboarder snowboarding downhill. Follow the "lay of the land" as you navigate the ups, downs, and twisty turns of each gradient.

At times, it will feel like you're erasing things (see **Figures 4.13–15**). That's good. This feeling is an indication that what you're painting is blending in so well you think you're doing the opposite of what you are. At other times, you'll feel like Pac-Man or the Cookie Monster, eating away lint, dust, or grime. That's a good sign too!

Figure 4.13 **Before** Figure 4.14 **During** Figure 4.15 **Erased**

Dabbing

At times, all that you need to do is gently tap the tool directly onto the spot you want to cover. If you need to reapply, dab again. Do not overdo it. If necessary, wiggle the brush a little when you press it down. It should feel like you're trying to press paint onto a rough surface. While dabbing is a viable strategy to use with any of the three cleaning tools, it is especially effective with the Spot Healing Brush.

If you don't cover the blemish with one or two dabs, make the tool larger. If you can't (due to the surrounding material), make the tool smaller and switch to a brushing technique.

Selecting New Source Areas

Do not cover long blemishes in a single stroke using a single source area. More often than not, it will look like you simply copied and pasted material over the blemish. It will be apparent that something is up. Vary your strokes and dabs, and constantly select new source areas.

While you do not have to reselect a new source area every time you brush or dab smaller specks in homogenous areas, doing so periodically keeps you from painting a recognizable pattern on top of the photo. We have the amazing ability to spot things that should not be there! One of my favorite activities as a child was spotting hidden shovels, ice cream cones, and seals in *Highlights* books.

When working in complex areas, you should select a new source area to cover each blemish. In **Figure 4.16**, I am working on a brown shirt. Each blemish has a slightly different shade around it, which requires that I select a new source for each one.

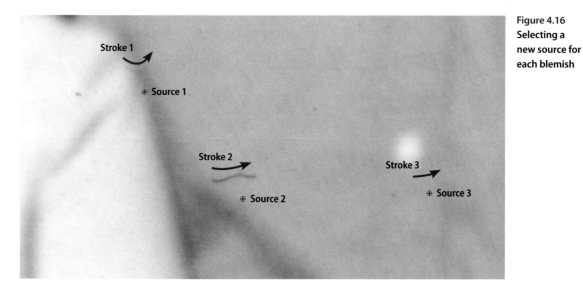

Figure 4.16
Selecting a
new source for
each blemish

At times, you may need to "eat away" at a blemish from all sides. You'll find yourself selecting several new source areas to cover one blemish. **Figure 4.17** shows a strategy for selecting four source areas surrounding this rather large piece of tape stuck on a photo.

Figure 4.17
Select source areas around the blemish and brush inwards, making sure the strokes blend together.

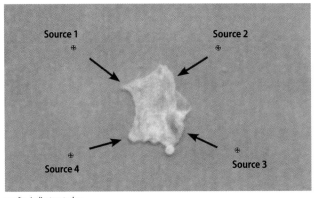

→ indicates strokes

Evaluating Your Work

You should continually evaluate your work to make sure you are cleaning the photo effectively and not creating more problems. Ultimately, your work should be invisible and the photo should be believable. I tell myself this all the time when covering blemishes. The material I use to cover things up has to look like it was always there.

One secret to evaluating your work is to toggle the cleaning layers on and off. Doing so enables you to quickly compare before versus after. This helps you see how effectively you covered the blemishes and whether your work is obvious or not. Do this occasionally while you work. Over time, you

will have inspected the entire photo using several different zoomed-in magnifications.

Figure 4.18 shows a magnified portion of a photo with the cleaning layer off. **Figure 4.19** shows it on. The most obvious differences are in her hair, but if you look closely you can spot disappearing blemishes on his shirt and in the background.

Periodically, take a break from the close-in work (your eyes will thank you) and zoom out. This enables you to take in the photo from a fresh perspective. Look for telltale spots or any signs of repeating details or textures.

Figure 4.18 Blemishes on

Figure 4.19 Toggle off and on quickly to see the difference.

Not Settling for "Meh"

The point of this section is to make sure that you realize mistakes are part of this process. As I've said before, restoring photos involves guessing, taking chances, and a degree of trial and error. When something doesn't work out, undo it and try again.

Create new layers to clean on as your work progresses. I separate my work into general cleaning and healing layers, then use new layers for retouching faces, people, and other difficult areas. **Figure 4.20** illustrates how you might create layers to clean different areas of a photo. Name them so that you do not forget what is on each layer, and pay attention to the layer order in the Layers panel as you clean. If your strokes seem like they are disappearing, you may be cleaning beneath something you've already brushed on.

Figure 4.20
Layered cleaning helps you succeed.

Doing the Dance

I enjoy working quickly while I clean photos. My fingers fly between setting the source with the Alt key, brushing or dabbing with the mouse, pressing the spacebar with my thumb to move the view around, and, if necessary, quickly pressing Alt+Ctrl+Z to undo actions. I call this "The Dance of the Clone Stamp." (My wife just burst out laughing.)

Figure 4.21 shows how I position my left hand on the keyboard. I like to curl my left ring and pinky fingers around the side to provide a firm anchor for my hand. **Figure 4.22** shows how my thumb is free; it does quite a bit of work.

Like any skill that requires hand-eye coordination, you will get better and faster the more you do it. Keep practicing. Focus on relaxing your fingers as you provide good support with your forearms. Keep your movements smooth and sure. Not having to look at the keyboard helps tremendously.

Avoid actions that break this flow. I don't zoom in and out or change brushes constantly. I prefer sticking with a single brush size and magnification for as long as I can. I make several sequential passes over the photo, cleaning differently sized blemishes.

I slow down in more difficult areas or save them for later. A multilayered cleaning approach helps accomplish this as well. I can keep simple cover-ups on one layer and use any number of new layers for sticky situations.

Figure 4.21 I grip the keyboard with my left pinky finger.

Figure 4.22 Your thumb gets a real workout from moving and selecting new source areas.

Undoing Mistakes

Photoshop is quirky about undoing things. Pressing Ctrl+Z (Win) or Cmd+Z (Mac) undoes one action. Fine, we all get that. Here's where it gets weird. When you press the shortcut again, you don't continue to undo action after action. Photoshop converts the second undo into a redo. Instead of undoing, you just toggle back and forth between two different states.

- To undo more than one sequential action, press Alt+Ctrl+Z (Win) or Option+Cmd+Z (Mac). This is called Step Backward.

- To redo more than one sequential action, press Shift+Ctrl+Z (Win) or Shift+Cmd+Z (Mac). This is called Step Forward.

If things get completely out of hand, switch to the History panel and retrace your work steps to where you want to start over. You can also switch to the Eraser and—if you're following my advice about cleaning on separate layers—partially or completely erase what you've done. If you want to take more dramatic action, delete the cleaning layer and create a new one.

Trying Again

After you undo an action or sequence of actions, start over. There is no need to feel bad or embarrassed. This is not a spectator sport where people are watching over your shoulder. No one can tell how many times you've had to start over or how many mistakes you made along the way to restore a photo. Think about what is causing the problem and how you can overcome it. It might be the tool, the hardness, the magnification you're working at, or a number of other things. If you reach a point where you realize you don't have the skills to do something, don't be afraid to leave it there.

Location, Location, Location

Specks, dust, dirt, and other blemishes don't exist in a vacuum. If they did, there wouldn't be anything to clean. Ba-dum bum. They are located somewhere on the photo, which means that they are somewhere *in* the photo.

Use this part of the chapter to familiarize yourself with some of the peculiarities of different locations in photos. Understanding how they differ from each other, and how they are alike, will help you clean them more effectively.

Remember, cleaning requires you to choose a source area (unless using the Spot Healing Brush) and brush new material over blemishes. Both require a degree of trial and error. Do not be afraid to undo mismatches. Keep trying until you're satisfied with the result.

Skies

Skies that are evenly toned and free of clouds are very easy to clean. It is not difficult to find matching material to cover imperfections. This is a good time to try out the Spot Healing Brush.

However, sometimes skies can be a real challenge to clean. Gradients that transition from one shade of blue to another (or gray, as in the case of black-and-white photos) are often difficult to match. This situation can make using the Spot Healing Brush impossible. If so, switch to the Clone Stamp tool and select source material from the same "slope" on the gradient as the destination, as shown in **Figure 4.23**. Notice how the area at the top of the blemish is a different shade of blue than at the bottom. While I have illustrated a vertical stroke, you could also use a series of smaller horizontal strokes to eat away at the blemish. Color and brightness gradients can make even smaller spots difficult to clean. You must select a source area that undergoes the same changes from top to bottom or left to right.

Match brightness instead of color when working with black-and-white photos.

Photos often have blown-out skies. This means that details that may have been present in the sky were overexposed, recorded as white, and are lost. Blemishes in blown-out skies are very easy to repair. Make sure that you investigate the area with a dark adjustment layer to catch hidden details.

It is especially important to zoom out at times when cleaning skies so that you can see the big picture. This helps you detect subtle mismatches between old and new material.

Figure 4.23
Note the gradient when you brush.

Clouds

Clouds typically have brightness and color gradients in abundance. Select source areas very close to blemishes, as shown in **Figure 4.24**. This ensures that the material you paint with has the same brightness and color characteristics as the destination.

Pay attention to the edges of the clouds as well as how the clouds change from light to dark. Always stroke along those lines. Although it can seem complicated, when you get the hang of "reading" clouds, cleaning in clouds is actually easy and fairly forgiving. Clouds do not restrict your work as much as areas with details of people or buildings. No one will notice a little extra puffiness.

Tip: Light blemishes can hide in bright clouds. Turn on a darker adjustment layer to help spot them.

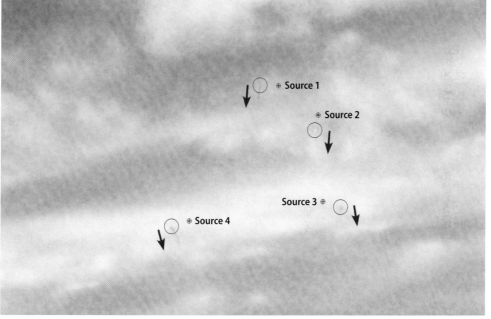

Figure 4.24
Clouds are full of layers and folds.

→ indicates strokes

Water

When full of waves, water has undulating bright and dark areas. Rough water reminds me of clouds with smaller, more intense areas of detail. Clean crests with crests and troughs with troughs. Pay attention to these shapes when you select your source areas and choose a direction to brush in, as shown in **Figure 4.25**. You should not have much trouble finding clean areas close to blemishes. When calm, water is much like the sky.

Figure 4.25
Although this looks very busy, the texture is actually very repetitive (which makes cleaning easier).

Trees

When the leaves of trees blend in with each other, they can be cleaned very easily. You don't need to worry too much about matching. Don't obsess over each leaf in these cases.

When you can easily see individual leaves and branches, as shown in **Figure 4.26**, zoom in and pay more attention to each stroke. Try not to break the lines that large branches form. That will be apparent. However, you do not have to worry about every void (where the sky shows through) or small branches. As long as they are evenly distributed, no one will notice where you've cleaned.

At times, you will notice that an area is so varied and complex that you are overwhelmed with details. This is true among tree branches and some other locations. The funny thing is, the more details there are, the more individual differences seem to disappear. When cleaning in these areas, it is impossible to match every detail. If you get frustrated, select a larger brush, then select a source area nearby that matches the general color and tone of the blemished area. Cover the blemish without worrying about lining everything up. If you can spot repeating shapes, undo and start over.

Figure 4.26
Preserve larger tree branches when cleaning.

Grass

In some photos, grass is well defined and highly detailed. Be on the lookout for "fuzzy brush syndrome" when cleaning blemishes in these photos. The effect of changing color and brightness from grass blade to grass blade presents a very choppy texture. It's important to match that with a harder brush. It is often easy to find clean source material because grass is so prevalent. Watch out for anything that might make a pattern as you clean, especially leaves, bare spots, and different grass lengths and mixtures.

Quite often, grass is an indistinct field composed of several shades of green. When cleaning these photos, as shown in **Figure 4.27**, pay more attention to shades of color and brightness instead of conventional details. In effect, clean this type of grass just like you would clouds or skies.

Figure 4.27
Grass is not always sharply focused and distinct.

Rocks

Large, smooth rocks are fairly easy to clean. It's not difficult to find matching source material. Clean these surfaces like you would the siding of a house (which is shown in the Buildings section, below).

Some rocks have rough textures. Treat them like bricks. Pay attention to texture and orientation when selecting a source. You may need to increase the hardness of your brush, especially when working in areas of small rocks and gravel. Otherwise, the tool looks like it slightly blurs an otherwise sharp scene.

Figure 4.28 shows an area on Mount Rushmore where the rocks to the side of the faces have a lot of lines and subtle undulations. Pay attention to these details when you select a source area and make your strokes. Although they are rocks, they can be cleaned just like waves or clouds.

Sand

Sand is often very uniform, making it easy to clean, as shown in **Figure 4.29**. Like a plain sky or quiet water, sand is a good place to tackle early. You'll get a lot done for very little effort.

Be careful of footprints, rocks, and color or brightness differences caused by wet areas. The challenge with sand is matching the transitions between sand and water or sand and grass.

Figure 4.28 Cleaning blemishes in rocky areas with small strokes.

Figure 4.29 Except for the color, sand reminds me of a clear sky.

Snow

It is difficult to spot many blemishes, especially light-colored ones, in snow. Use an adjustment layer to darken the scene and make them easier to spot. I have done just that to make the blemishes stand out better in **Figure 4.30**.

At times, transitions between snow "dunes" present more difficult challenges because the lighting changes. In addition, you may run across shadows and other features that make cleaning snow more difficult.

Buildings

Old buildings often contain a myriad of tiny details. Pay careful attention to lines and transitions between materials as you clean them. **Figure 4.31** shows the side of a brick building with tall windows. The great thing about buildings is that details often repeat themselves. This makes finding a clean source area very easy. Just look at the next brick over. The direction in which you make your brush strokes is very important when cleaning buildings. Always go with the lines of the feature you're covering.

Figure 4.30 Use different source areas for differently shaded areas of snow.

Figure 4.31 Cleaning buildings is easy when you can match similar details.

Faces

Eyes, nostrils, and lips are often the hardest parts of faces to clean because the gradients in these areas are more complex and there may be little clean material to use as a source area. In **Figure 4.32**, I have highlighted four blemishes and source areas. Although close together, each blemish occupies a differently shaded area. When working in such close quarters, it is especially important to have room to make your strokes. This applies to the source area as much as to the destination.

It is important to hide your work here. You can completely change how a person looks if you mess up their nose, mouth, or eyes. Or ears, eyebrows, cheeks, chin, lips. Or teeth. You get the idea. It's complicated because a face is full of rounded shapes that catch light differently. Faces remind me of rolling hills or sand dunes when magnified.

Figure 4.32
When working
with faces, it is
important that you
match shading and
undulations.

indicates strokes

Hair

Like choppy water or cloudy skies, hair often has a number of gradients that alternate between light and dark or different colors. Although it might seem hard, hair can be easy to work with because there is normally a clean patch of matching hair very close by any blemish you need to cover.

Clean hair either by "matching lock to lock" or along the same line of hair (as shown in **Figure 4.33**). When cleaning around the head, use edge material to cover edge material. In this way, cleaning hair is like covering blemishes in tree branches or bushes.

Figure 4.33 **You could also use a number of smaller, vertical strokes here.**

Clothing

Matching textures, patterns, brightness, and color is very important when cleaning clothes because mismatches are easily noticed. Some clothing can be highly detailed, as shown in **Figure 4.34**. The pattern makes aligning the source with the destination very important. The bottom blemish is easier to clean, but you should still note the folds in the fabric. Approach highly patterned clothes like you would a building full of different architectural details. They both have a plethora of repeating features.

Clothes conform to our shape, which can make brushing more difficult. Clothes that lie flat and are made of a solid color are the easiest to clean. They are similar to clear skies, smooth water, and sand.

Figure 4.34
When cleaning very detailed fabrics, zoom in, and keep strokes short and to the point.

Portrait Backgrounds

Some portrait backgrounds have random changes between colors, tones, and details. You may need to zoom in very closely to match material. On the other hand, simple backgrounds are fairly uniform and act like a clear sky. Pay attention to the surface texture of portraits. They can have a leathery look when highly magnified, as shown in **Figure 4.35**. Inspect your work to ensure that you don't accidentally repeat details and that the brush isn't too soft.

Figure 4.35 **Match texture as well as color when cleaning portrait backgrounds.**

Cleaning with Photoshop Elements

The techniques and tools that I present in this chapter transfer almost identically between Photoshop Elements and Photoshop. The three main cleaning tools have fewer options in Elements, but that should not make much of a difference when restoring photos. The tools work the same way. Create a new layer to clone or heal on, enable the Sample All Layers option, set brush size and hardness, and you're good to go.

You will not, however, be able to clone or heal on individual color channels. This includes the standard Red, Green, or Blue channels as well as the more esoteric HSB/HSL filter. You really aren't missing much.

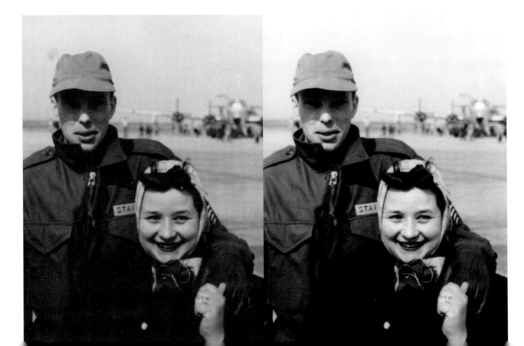

Chapter 4 Assignments

This chapter's assignments involve using the cleaning tools to clean one or more photos. To prepare, make sure you can use the Clone Stamp, Spot Healing Brush, and Healing Brush tools. Acquaint yourself with the options for each tool. Know how to select source material (except for the Spot Healing Brush) and be familiar with different brushing techniques. Create new layers in the files you work on to practice.

Clean a Sky

Find a photo with specks of dust or debris in the sky. Your assignment is to clean this part of the photo. Focus on setting the right brush size and hardness, and matching the color or brightness of the source area and destination. Compare using all three tools.

Clean Trees and Grass

Select a photo with trees and grass that could use cleaning. Clean these areas, and compare how you did versus the sky. Note the different textures involved and how your technique changed.

Clean a Person

Choose a photo with a person in it who needs cleaning. Zoom in and focus on the face, hair, and clothes. Note the different magnifications and tool sizes you use. Compare how hard this was (and how long it took) versus cleaning the sky and grass, and how easily you were able to select a clean source area or not.

Share your results with the book's Flickr group!
Join the group here: www.flickr.com/groups/photo_restoration_fromsnapshotstogreatshots

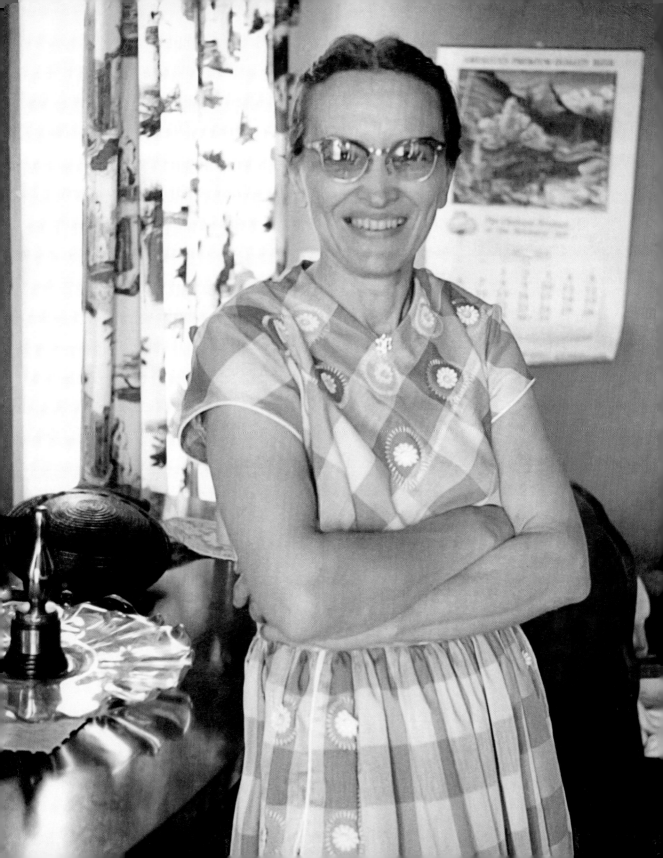

5
Repairing Physical Damage

Building on Success

Don't let the prospect of trying to repair physical damage scare you. Although it can be more challenging than covering lint or removing a few specks of dust from the surface of a photo, the principles are largely the same. Find clean, undamaged material that matches the area that has been damaged, then use the good stuff to hide the damage. At times, you'll use undamaged material to re-create missing elements of the photo. Build on the skills you learned in the last chapter as you attempt to repair damaged photos.

Poring Over the Picture

This photo of my wife's grandmother, taken in the mid-1920s, is a cute snapshot. Unfortunately, it has yellowed with age and been damaged. It actually looks worse in person than it does in this scanned image. Thankfully, it is not terribly difficult to repair photos such as this using the techniques I show in this chapter. You will learn to cover most types of damage as you would lint and dust.

These dimples are another type of damage.

These large cracks ruin the print.

Scratches and scuffs are hiding in more complex areas of the photo.

Limited details in these
areas make repairs easier.

Use the Clone Stamp to
cover cracks and dimples.

Do your best not to repeat
details when cloning.

Poring Over the Picture

Use the repeating bricks to repair most of this crack.

This charming photo was taken in 1941. It suffers from many of the same problems as the last photo. Cracks, creases, and scuff marks have damaged the print's surface. I was able to repair most of the damage, but not all. That illustrates an ever-present truth of photo restoration: It is not always possible to repair everything. When this happens, I would rather do less and live with the damage as opposed to trying too hard and ruining the character of the photo.

The main subject needs to be cleaned, repaired, and sharpened.

These scuff marks show up best in dark areas.

Large scratches are
successfully repaired.

This area was sharpened,
with blemishes and
damage covered.

It was impossible to remove all
the scuff marks without ruining
the photo.

Primary Repair Techniques

This section summarizes the general techniques that I use to repair most damaged photos. Later in the chapter I address how to approach specific types of damage.

As a reminder, not counting some brainstorming, I clean photos before repairing them. If you repair a dirty photo, then clean it, and then change your mind about the repairs later (maybe you want to tweak something minor), you have to roll back the cleaning and the repairs to start over. By cleaning first, you lose only the repairs. While this doesn't happen with every photo, once or twice was enough for me to create the workflow I follow. I also don't worry about making final brightness, contrast, and color adjustments until after all repairs are complete. I may create temporary adjustment layers to see better, or to give my eyes a break from having to constantly look at a yellowing photo, but I do not spend any time poring over these. That goes for the figures in this chapter too. I have not attempted to fully restore the photos to show you how to repair a corner, for example. What you see is basically what I saw when working on them.

Cloning and Healing

The Clone Stamp and Healing Brush are very effective tools that can repair most damage. Use them the same way you would when cleaning a photo. Instead of covering dust or lint, though, you will use them to cover scratches and other types of damage with undamaged material. You can also use them to re-create lost areas of the photo.

Remember, you should make every effort to hide your work. Constantly evaluate your repairs to see if they look natural or should be redone. Do so using different magnification levels. You might miss something close up that becomes apparent when you relax the magnification. Use multiple layers to repair different areas of the photo.

Cropping and Masking

Sometimes you have no choice but to crop the photo or mask out damaged areas. Although this may feel a bit like cheating, it's not. Don't fall into the temptation of making everything a competition. Even if you can partially rescue an otherwise ruined photo, you've accomplished something.

The first image in **Figure 5.1** shows a photo that has serious damage to one side. Although catastrophic, the missing area is limited. The rest of the photo looks great. I encourage you to try and repair damage like this, but have a backup plan if you can't. I first tried using the Clone Stamp to paint existing fabric over the missing shoulder. I also tried copying and pasting the good shoulder over the damaged area, flipping it horizontally, transforming it, and blending it in with the existing material of the coat jacket. Neither of these approaches worked to my satisfaction.

Therefore, I decided to crop out the damage. Notice from the second image in Figure 5.1 that I have placed the Crop tool so that it eliminates most of the damage, but not all. I've left a damaged area in the photo that I know I can repair. The final image of Figure 5.1 shows the repaired photo. It's ready for color, brightness, contrast, and other restorative steps.

Figure 5.1 **Rescue what you can when cropping.**

Before Cropping After

If you don't want to crop photos, consider masking out the damage. This allows you to keep the entire photo in your Photoshop file but hide the damage, as shown in **Figure 5.2**. If you want to print or post a copy of this photo, crop the photo to the visible area and save a flattened image as a new file. You could also perform a merged copy of the visible photo and paste that into a new image file.

Figure 5.2 **You can also mask out the damage before restoring it.**

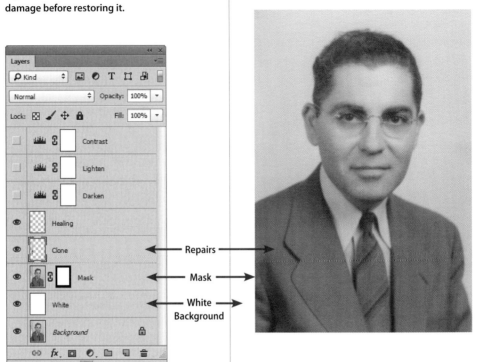

Copy and Paste

I'm a problem-solving kind of guy. If a technique works, it works. And copying and pasting often works. It doesn't matter how long your repairs take or how many steps you need to accomplish them. In fact, easy solutions give you more time to attempt more difficult tasks or work on more photos.

To perform repairs using this technique, copy and paste material out of the same photo to cover up damage (think damaged borders) or reconstruct missing elements (think corners that have been torn off). I've used an imaginative copy and paste technique to illustrate how effective it can be in **Figure 5.3**. The first photo is the center of a card-mounted photo that has been cut out. The photo is just fine, but it's missing the mount!

Because the photo itself is oval and has so little background, it's impossible to crop without losing too much of the girl. I did, however, have another card-mounted oval photo that was roughly the same age and style. I decided to copy and paste the damaged photo onto the photo that had the border intact. To finish the transformation, I masked out the extra border from the damaged photo. It's basically impossible to tell that I did anything, as you can see from the second image in Figure 5.3.

Figure 5.3 Yes, sometimes copying and pasting is a valuable technique.

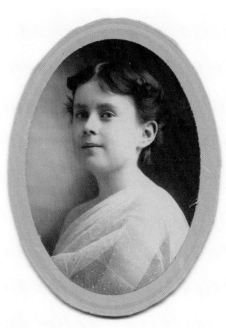

Cut photo

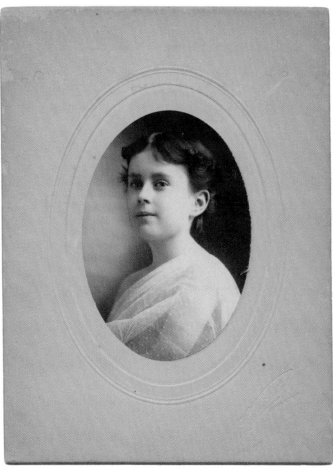

Composite

Preservation

There may be cases where you want to scan and work with a photo, even if you can't fully restore it. For example, you could have a damaged heirloom that you want to display but don't want the actual photo handled.

If you find yourself in this situation, treat the photo as if you were a conservator engaged in historical preservation. Scan and preserve the photo digitally. If possible, clean and do what you can to retouch it. You may be able to improve the color, contrast, and brightness.

I have done just that with the photo in **Figure** 5.4. It is an old tintype portrait from my wife's family, shot sometime around 1875. It has a lot of damage as well as snipped corners. I have absolutely no desire to create new material to retouch this photo. It's simply too cool for that.

Therefore, after I scanned the photo and created a working Photoshop file, I duplicated the background layer, created a white layer beneath the copy, and masked the damaged tintype (exactly as I did for the photo in Figure 5.2) so that it would appear nicely over the background.

It's ready to clean further and retouch. If I want to print a copy, I can print it as is, then have it professionally matted and framed, hiding most if not all of the irregular shape. Conversely, I could crop out the damage and print a rectangular or square photo and frame it myself.

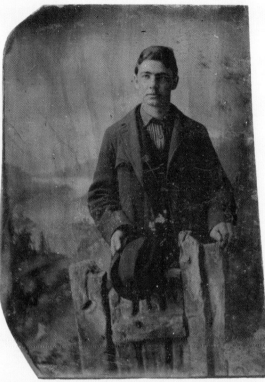

Figure 5.4 **Preserve photos that you can't or shouldn't repair.**

Handy Repair Tools

If you haven't yet, please read or quickly review Chapter 4, "Cleaning the Surface." I cover a lot of information about how to use the Clone Stamp, Spot Healing Brush, and Healing Brush tools there. Much of it, such as choosing a brush size and hardness, is applicable to repairing damage as well as cleaning. The section in that chapter entitled "Making the Right Decisions" is especially important in terms of basic tool information. I won't belabor those points here.

Here, then, are the three main tools you can use to repair damage (they should look very familiar; that is a strength of Photoshop):

- **Clone Stamp:** When I repair damaged photos, I use the Clone Stamp almost exclusively. It is very powerful and does exactly what you want without adding in things that you don't want (as in automatic blending). As with cleaning, use it when you need to cover things up. You'll also be able to create new material where none exists. This makes it possible to re-create missing elements of photos.

- **Spot Healing Brush:** The Spot Healing Brush is less useful for repairing damage than it is for cleaning. However, be prepared to use it if you run across damage that is similar to surface blemishes.

- **Healing Brush:** The Healing Brush can be used to repair some scratches and tears. I prefer using the Clone Stamp, but the Healing Brush can be effective at covering some scratches that need more blending to look invisible.

You will also make use of the Crop and Select tools and the Eraser.

If you aren't familiar with how to use any of these tools, review Chapter 3, "Working with Photoshop," and Chapter 4. You should also consult the Photoshop manual for basic instruction.

Repairing Damaged Corners and Borders

Old photos that have been handled a lot, even carefully, often have bent or damaged corners and borders. It doesn't have to be much to make a difference. **Figure 5.5** shows a typical bent corner. Because the photo has a border, you could just crop and be done with it. If you want to repair the corner, use the Clone Stamp tool. Select source material near the corner to match the tone of the surrounding area. Select a large enough brush to blend the gradients from both sides of the bend together. If the light is such that you end up with a dark side and a light side (as was the case here), clone the whole corner so that the tone matches throughout.

Figure 5.5
Clone to cover the crease and match the tone of the border.

Before During After

Figure 5.6 shows another photo with slight damage to a corner. In this case, there is no border: The damage is to the photo itself. The remedy is the same, however. Clone to cover the bends (cropping might be too drastic, depending on the photo). You can conduct repairs like this as you would cleaning or repairing scratches or other linear damage to the surface of the photo. Match details in your source and destination areas, and cover the bend. Make sure not to stray off the side of the photo.

Figure 5.6
Match details when repairing damaged corners without borders.

Before

During

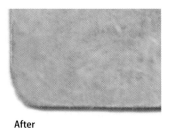
After

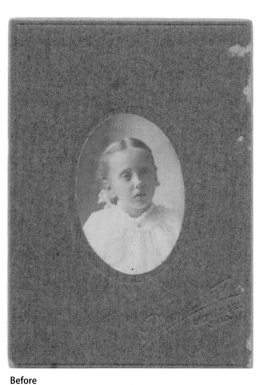
Before

Figure 5.7 shows an old mounted print. The photo was glued onto nicely detailed card stock in the style of the day (it's a card-mounted photo taken sometime around 1905). Unfortunately, the border has been rubbed away in places. The trick here is to use the Clone Stamp to cover the damage using a slightly harder brush than normal. A soft brush will appear to soften the edges of the fibers.

Figure 5.7 Damaged borders can have complex textures or details.

During

After

Figure 5.8 is an example of a *carte de visite* (visiting or calling card) photo. The name comes from the fact that the photograph is mounted on a small card that measures 2½ by 4 inches. As you can see, the corners of the photo (not the backing card) have been damaged, and in some cases, torn off. Believe it or not, this is a simple fix. Use the Clone Stamp, as shown in **Figure 5.9**, to re-create the missing area. I prefer starting along an edge, framing the corner, and then filling it in. Use edges along the same side as source material. Be very careful to make everything line up correctly or your repairs will stand out like a sore thumb. I place the center of the brush squarely on the border I want to copy to select the source, then I reposition the brush along the same horizontal or vertical line to make my stroke.

Finally, **Figure 5.10** illustrates a photo with a bit more damage to one corner. The good thing about corners is that they are often devoid of complicated details. This makes them easy to clone. To repair this corner, I extended the wood siding up along with the edge of the photo. The top edge was a bit trickier to finish because there was no dark horizontal line to copy. Therefore I cloned the top edge using lighter wood and then filled it in with dark wood.

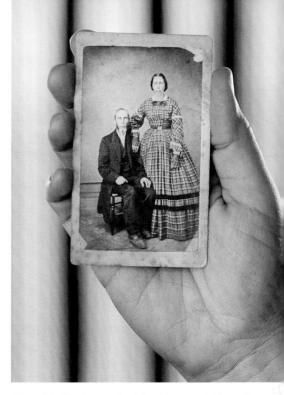

Figure 5.8 Classic carte de visite photos are fairly small.

Before
During
After

Figure 5.9 Rebuild the corner starting with the edges.

Before
During
After

Figure 5.10 In this case, you must re-create detail that has been lost.

Covering Creases, Cracks, and Scratches

Creases look like small furrows (if indented) or ridges (when they stick out) in the surface of a photo. They are caused by bending or holding photos without proper support. Creases can be singular and can also appear in packs.

Cracks are more severe than creases. Cracks can start out life as a bend in a photo and get worse over time. They can also be caused by other factors. For example, damage to the photographic emulsion of the print may appear as cracks.

Scratches share similarities with creases and cracks. They can be small, with fairly limited damage, or large.

Although they have different causes, repairing creases, cracks, and scratches tends to be variations on a theme. When small or limited in number, approach them with either the handy Clone Stamp or Healing Brush.

If they are large or cover much of the photo, however (and this is a big however), you may be in for trouble. You may not be able to find enough undamaged material to make your repairs.

Figure 5.11 shows a crease in the background of a portrait. It's an easy fix. Use the Clone Stamp or Healing Brush to cover creases like this. Select source material from the nearby area to match the tone or color. The trick with creases and cracks like this is to select a brush size that extends well beyond both sides of the damage. This helps blend in repairs with the original material and hide them.

Figure 5.11
When you can, choose brushes that are a good deal wider than the crease or scratch you are repairing.

Before

During

After

Figure 5.12 is a close-up of the first Poring Over the Picture photo in this chapter. It has cracks and creases in multiple areas. Thankfully, the siding and the border are simple and have little detail. This allowed me to select a large brush (160 pixels). When repairing creases like this, I start by repairing them as they cross lines or other detailed features. Here, I selected a source area for the Clone Stamp that aligned with the siding and kept my brush strokes horizontal. After that, I repaired between the lines. For touch-ups, switch to a small brush.

Before During After

Figure 5.12
Repair details like lines first, then fill in between them.

Repairing the cracks in the grass and plants is more difficult because it can be hard to copy material without duplicating obvious features. Chances are, you will not be able to copy details precisely. That's okay. No one will notice an out-of-place blade of grass or two. They will see repeating patterns, however, and places where you may need to make the brush harder. This is a situation where you don't always want to use source material from right next to a stalk to cover a crease, because it will be apparent. Select sources far enough away that you can't tell they have been used. Use smaller brushes for touch-ups on branches, leaves, and dark areas between the foliage.

Figure 5.13 shows significant damage in a very detailed area of a photo of the Leaning Tower of Pisa. When repairing buildings, always try to use source material from parts of the structure that aren't damaged. To repair this photo, I used undamaged columns as source material to repair damaged ones. I also took care to match the stone joints and shadows on the building. It's certainly not easy, and you may be able to spot your work in these cases. While I try to avoid seeing my work, it is not always possible with this amount of damage. As long as you can't see the repairs themselves at the magnification you'll be printing or viewing the photo, they'll be fine.

Before During After

Figure 5.13
Although heavily damaged, this photo has enough undamaged building details to be repaired.

Figure 5.14 is an example of more severe cracking. Repair damage like this just as you would smaller scratches. Pay attention to details on each side of the defect. When there are features such as these tree branches, make sure to line up your source and destination areas, and brush along the branch. I like starting at the photo border and then working inward.

Figure 5.14
Repair cracks like you would a crease or bend, paying attention to details.

Before

During

After

Figure 5.15 shows a portion of a photo (I'm receiving my college diploma) that has a large number of scratches all over it. Something was placed on top of the photo that scratched it repeatedly over time. While some of the scratches may be difficult to repair, they won't all be. If you become discouraged as you work, give the photo a rest and come back when your batteries are recharged. In the figure, I'm repairing the scratch from top to bottom, making my brush strokes line up with the light and dark areas on my pants.

Figure 5.15
Try to brush with the contours of light and dark areas.

Before

During

After

Filling Holes and Other Surface Damage

Holes and other surface damage often require you to make up for lost material. Don't panic. Use the same techniques that you have learned to clean photos and repair other damage. You've been covering blemishes and damage with clean material all along, albeit different shapes and sizes.

Figure 5.16 shows how simple repairing this type of damage can be. This photo has been pinned to a wall or a bulletin board. There are three holes along the top edge and one in the bottom center. Repair them as you would a circular blemish, by covering them with undamaged material. When repairing damage this close to the top or bottom borders, I keep my brush strokes horizontal. I also make sure to watch the brush size. If it is too large, you'll see overspray outside of the edges of the photo. Because this hole is close to the border, you could also choose to crop it out of the photo.

Figure 5.16
While severe-looking, this hole was very easy to fix.

Before During After

Figure 5.17 has a hole that is a bit tougher to tackle. This repair requires delicate work with the Clone Stamp and careful attention to the clothing and shadows. The largest challenge with this repair was selecting good source material to cover the missing areas. The tones and shading all had to match.

I started cloning along the photo's edge, then worked my way inward, toward the other details. I find that getting details like lines fixed first works well. When they were done, I filled in the easier areas. Don't be afraid to create more than one layer to handle repairs like this.

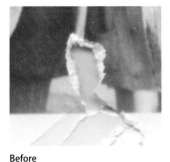

Figure 5.17
To make repairs like this, you must be able to pull source material from nearby areas of the photo.

Before During After

The photo in **Figure 5.18** has a large area in the center that has been badly damaged. To make this repair, I used the Clone Stamp, paying attention to the changing light and shadowy areas on the wall. There was plenty of good source material close by to pull from.

The damaged area on my sister's hair was more challenging. I tried cloning first, but it didn't look right. So I switched to the copy and paste technique. I selected an area to copy (shown in the first image of **Figure 5.19**), copied, then pasted and flipped it horizontally. Following that transformation, I placed it over the damaged area. Next, I masked out part of it and cloned material to complete the blending.

Figure 5.18
I repaired the large
area by cloning.

Before

Cloning

Figure 5.19 **The key to this repair was copying, pasting, and then flipping hair from another area.**

Selecting

Pasting

Blending

The result is a repair that used existing material as a foundation to clone around and over. **Figure 5.20** shows both areas finished.

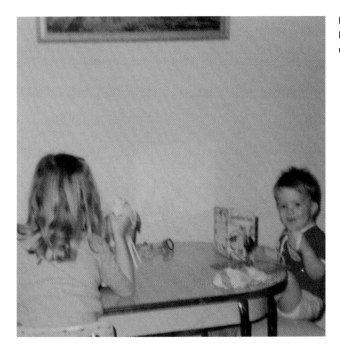

Figure 5.20
Both areas were repaired using different techniques.

Reconstructing Torn or Cut Photos

While creases, cracks, and scratches often damage the photo's surface, tears and cuts typically leave you with a clean edge, even if ragged. You can fix most tears with the Clone Stamp tool. Pull in undamaged material to bring the two edges of the tear together.

Photos that are more or less torn apart (either in half, into pieces, or partially torn and left dangling) are a bit more complicated. When repairing them, you should copy one section of the photo, paste it as a new layer, position it as if it were not torn, then use the Clone Stamp tool to stitch the two sides together.

Figure 5.21 shows a minor tear along one side of a photo. Damage like this is fairly easy to handle. Use the Clone Stamp tool to repair it like a small crease. Don't turn up your nose at easy fixes. Appreciate them whenever you can, because you will also have your fair share of impossible problems.

Figure 5.21
Treat small tears like
creases or bends.

Before During After

Figure 5.22 shows a photo that has been nearly torn in half. Notice the edges of the tear. They are ragged, but the material is still there. In some ways, this makes repairing tears easier than large scratches. You just have to put the two edges together. To do that, use the Clone Stamp tool. As with other repairs in detailed areas, I brush with details like suspenders and folds in the shirt, not across them. Most of my strokes for this repair were essentially vertical. Some were from the top down, others were from the bottom up.

Figure 5.22
Treat larger tears like
cracks or scratches.

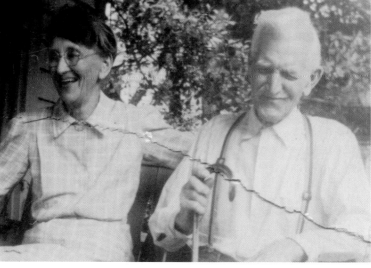

Before

During After

Figure 5.23 is a more challenging repair. Rather than being partially torn, it has been torn completely in half and taped together. Photos like this require a bit more effort to get started. Once you position both sides, however, the repair is relatively straightforward.

Here's a general outline of how to approach tears of this magnitude:

1. Copy one side of the photo, as shown in Figure 5.23.

2. Paste that as a new layer on top of the existing photo.

3. Position and rotate, if necessary, as shown in the first image of **Figure 5.24**.

 This part feels like you're working on a puzzle. Notice that the white border has torn edges that should obviously fit together. Use areas like this to help you position the upper layer as perfectly as possible. If necessary, reduce that layer's opacity so that you can partially see the material underneath and be able to tell when details line up. Don't worry about making the tear invisible at this point, however. You will still have to fix it, even if you position the layers well.

4. Erase or mask out material on the top layer that extends too far over the bottom layer, as shown in the second image of Figure 5.24. You may not need to mask out much. Look for torn paper that covers the other side of the tear.

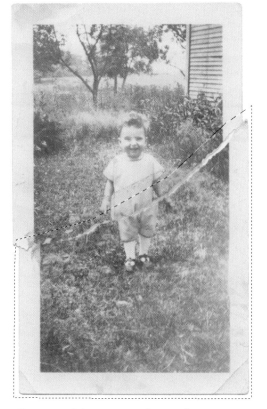

Figure 5.23 **Select one area of a torn photo to move into the proper place.**

Positioning

Mask overlap

Figure 5.24
Match details and position the top layer precisely, then blend.

5. Finally, switch to the Clone Stamp, and on a new layer (above both photo layers), cover the tear with matching material from either side. Your goal is to "erase" it, as shown in the first image of **Figure 5.25**. The second image of Figure 5.25 shows a small portion of the completed repair.

Figure 5.25
Use the Clone Stamp to cover the remaining damage.

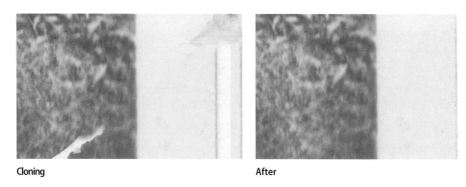

Cloning After

Figure 5.26 is a photo of my dad sitting in his 1955 Thunderbird. The photo was cut across the bottom in order to fit it in an album. This is a perfect photo to illustrate how you can use very simple techniques (copy and paste) to restore photos and make them look new. It's far easier to copy and paste an undamaged side to create the bottom border than it is to try and re-create it using the Clone Stamp.

Figure 5.26
The bottom border and some photo area were cut off of this print.

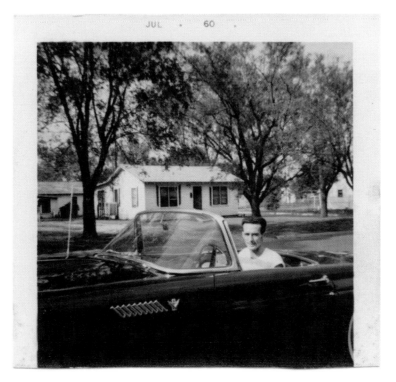

Here's how to approach repairs like this:

1. Enlarge the canvas, as shown in **Figure 5.27**, so that you can size and fit the border properly.

2. Select a border that isn't missing.

3. Copy and paste it as a new layer.

4. Rotate it to the proper orientation, then position it, as shown in **Figure 5.28**.

 As you can tell from the date, I used the top border of the photo. It's the one side that has both corners. Cloning out the text was an easy thing to do at the end. What you can't see is that I copied, pasted, and rotated the top border two other times and placed those copies along the sides so that I would know where all four good corners were supposed to be. That gave me all the information I needed to position the new bottom piece in place.

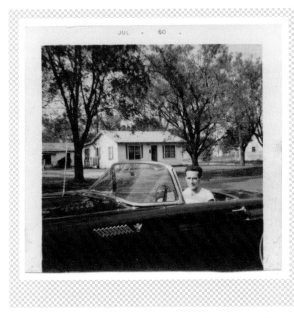

Figure 5.27 **Having a larger canvas gives you room to position copied and pasted elements.**

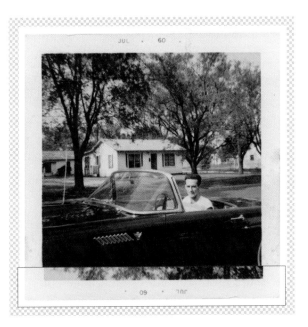

Figure 5.28 **Line up the new bottom border.**

5. Use the Eraser or mask out areas that should be hidden.

6. Use the Clone Stamp tool to blend the new piece with the other borders, as shown in **Figure 5.29**.

7. To finish the repair, I chose to copy a square selection in the center of the photo and paste it as a new layer. I then enlarged it using the Edit, Free Transform menu (see **Figure 5.30**) so that it fit the new border.

Figure 5.29 **Clone over areas to blend new and old together.**

Figure 5.30
This photo is repaired and ready for more restoration work.

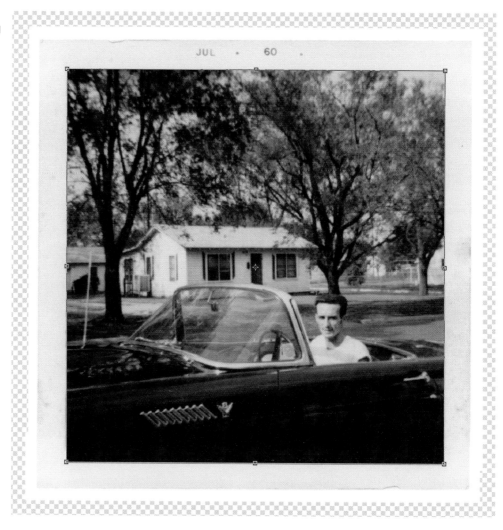

What the wut?

You may have noticed that I have basically used a single tool throughout this chapter: the Clone Stamp tool. I have done so because it's the most consistently versatile photo restoration tool in Photoshop (as well as Elements). It does exactly what you want it to with very few side effects. You don't often have to fix something and then make repairs to your repairs. What you fix stays fixed, and I like that. I like being able to use the tool and not worry about it.

There is also some benefit to a single-minded approach. Namely, I have gotten really good at using this tool because I've spent so much time with it. I have been able to develop a mindset where the tool recedes into the background of my consciousness. I don't have to worry about using it—I simply use it. Attention I would otherwise devote to the tool is freed to focus on the photo, where it is most needed.

When you think about it, that should encourage you. Photo restoration isn't necessarily about learning how to use a thousand tools—it's about mastering a few tools and being able to use them in a variety of circumstances.

You may prefer using a combination of the Clone Stamp, Spot Healing Brush, and Healing Brush tools. That's okay too.

Using Photoshop Elements

Once again, the Photoshop tools that I use to repair physical damage are essentially identical to those now found in Photoshop Elements. Likewise, the techniques carry over from program to program very well.

I prefer working in Photoshop, but if need be, I could make virtually every repair using the same basic tools in Elements. That means you can too. Master the Clone Stamp tool, layers, copying and pasting, positioning, and in some cases, making transformations. That's it. These are classic restoration tools, and for a good reason: They work quite well.

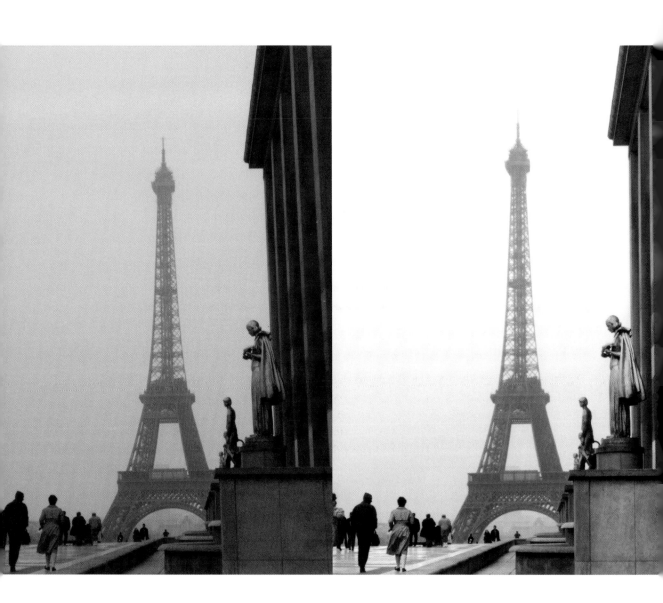

Chapter 5 Assignments

Use these assignments to practice the repair techniques in this chapter. They aren't hard in theory, but it's funny how theory isn't always easy to implement.

Don't forget that everything works together. Scan and save the photo. Create your Photoshop file with different helper layers. Use adjustment layers to help you see details better as you work. You might want to clean the photo using a different layer than the one (or more than one) that you plan on repairing damage with. Focus on *using Photoshop* as much as the techniques.

Repair Something Easy

Begin by repairing something easy. Corners and some creases are a good place to start. Get used to seeing damage and not being intimidated by it. Don't forget that, like cleaning photos, it is very important to critically evaluate your work as you go along.

Find and Mend More Damage

Now, stretch your legs a bit. Find something a little harder to repair. Large creases and more serious cracks present more of a challenge than bent corners, especially if they are numerous or fall in detailed areas of the photo.

Reconstruct a More Heavily Damaged Photo

Finally, see if you can repair a more heavily damaged photo. It doesn't matter if the photo you choose is torn, is cracked, has missing corners, or is new, old, in color, or black and white. Evaluate how long it takes and how successful you think you were in repairing the photo. Were you able to keep your work hidden? Does it look like the original photo? Depending on the damage and the photo, successful repairs can sometimes be very hard or impossible. Know when to quit and don't blame yourself. Use this assignment to help you set expectations for the future.

Share your results with the book's Flickr group!
Join the group here: www.flickr.com/groups/photo_restoration_fromsnapshotstogreatshots

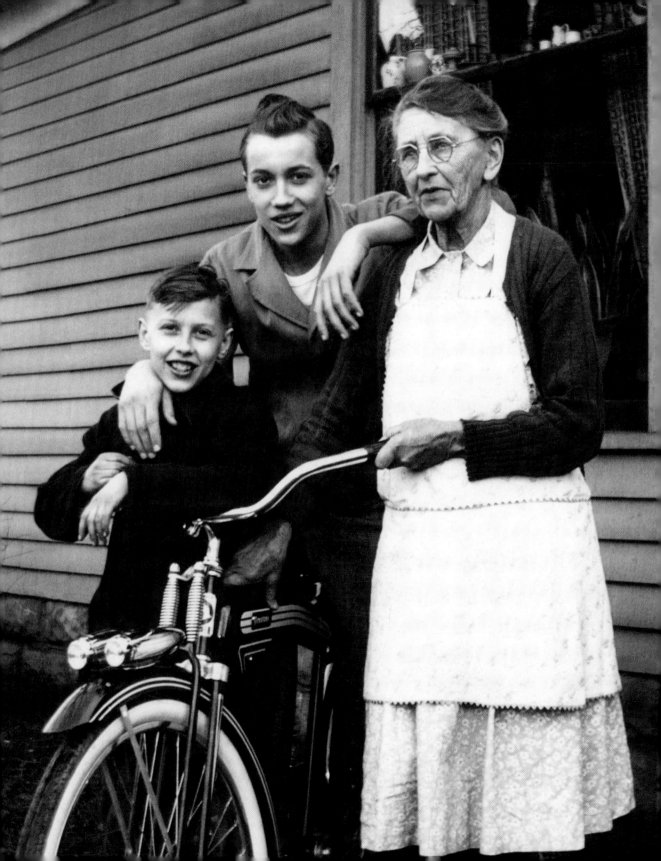

6

Correcting and Enhancing Color, Brightness, and Contrast

A New Paradigm

Prior restoration chapters focused largely on moving pixels around to cover up blemishes and hide or repair damage. This chapter relies on a different approach to improving and adjusting color, brightness, and contrast: using adjustment layers and Smart Objects.

Chapter 3, "Working with Photoshop," has a lot of good basic information on the tools you will see in this chapter. If you need to, please go back and review the sections on adjustments and layers. What I would like to do in this chapter is quickly walk you through how to create and use adjustment layers, and how to use the Camera Raw Filter, and then show a few examples.

Poring Over the Picture

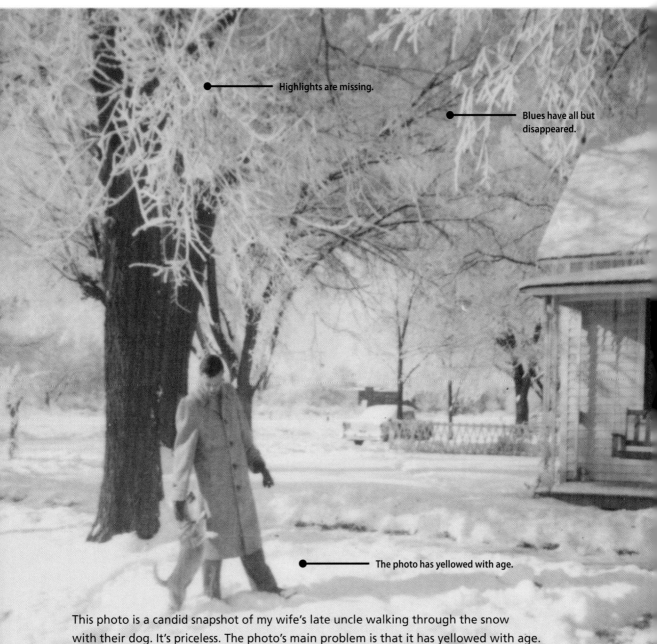

Highlights are missing.

Blues have all but disappeared.

The photo has yellowed with age.

This photo is a candid snapshot of my wife's late uncle walking through the snow with their dog. It's priceless. The photo's main problem is that it has yellowed with age. Don't despair! Sometimes problems like this can be very easy to overcome. To achieve the end result, I cleaned the photo, then adjusted the color using a Color Balance adjustment layer, then fixed the brightness and contrast with Levels.

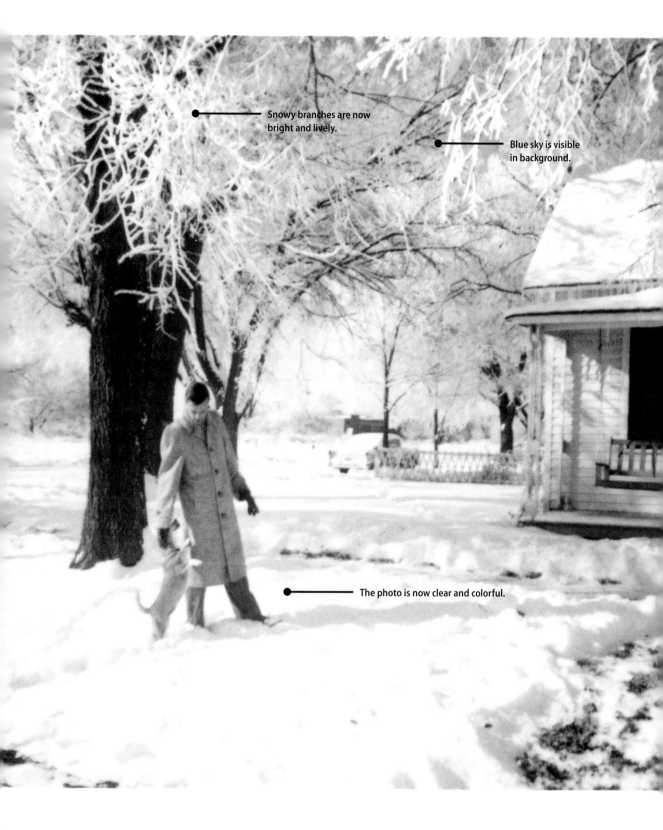

Snowy branches are now bright and lively.

Blue sky is visible in background.

The photo is now clear and colorful.

Poring Over the Picture

This photo commemorates the occasion of my wife's grandfather catching the fish that *didn't* get away. It was taken on the spur of the moment, without a flash, and has faded over time. To improve it, I made four adjustment layers: Curves to correct the slight yellowing, Levels to improve brightness and contrast, Vibrance to increase saturation, and Color Balance to boost the blues in the final shot.

Subject is in shadow.

Sky and water are colorless.

There are specks and dust throughout.

Brighter subject with good contrast brings photo to life.

Color correction results in nice, blue sky and water.

Good cleaning is paramount when brightening photos.

Easy There, Pardner

Before you jump in to increase the saturation and brightness of your old photos, I want to give you a word of caution: Try to do as little as possible. Yes. Your efforts to clean and repair the photo should have already made the photo look better. Your goal at this stage is to help the photo along, not ruin it with a heavy hand.

I've tried to call attention to photos throughout the book that really *should* look old. They don't need to look new. They weren't taken with a 24-MP digital camera and processed through Adobe Lightroom. They don't need to look perfectly exposed. You don't need to "rescue" blown highlights as if you were presenting the photo for an award. This isn't about perfecting things or correcting bad techniques. Photo restoration, by and large, is about preserving and improving, where possible.

Many old black-and-white photos will look worse if you strip them of all coloring. There's a reason every graphics program has a "colorize" button somewhere or a preset to apply "sepia toning." It's because it looks good! Don't completely remove the real thing in your zeal to correct the photo. Leave some character in there.

Technically speaking, Photoshop has all the tools you need to effectively handle virtually every color, brightness, and contrast adjustment you will likely need. The tools aren't the problem. What is much harder is knowing how much of an adjustment you need to make. It's critically important that you develop the ability to back off when it starts to look like you're pushing it.

Likewise, I do not recommend using every single possible tool, trick, tip, and technique that Photoshop has to offer on every photo. I use a very small number of tools to perform most of my work. As I've said before, that enables me to think more about the photo and less about the program.

Making Adjustments

Here's the approach that I recommend when making color, brightness, and contrast adjustments:

1. Finish cleaning and repairing your photo.

2. Evaluate the photo for signs of color, brightness, and contrast problems. They fall into a few simple categories:

 - **Color:** Some photos have too much color, too little color, or the wrong color. Old color photos have a habit of fading and losing their punch. When black-and-white photos age, they can turn sepia-toned. Both color and black-and-white photos can take on odd color casts.

- **Brightness:** Photos can be too dark or too bright. Sometimes they are both at the same time, depending on the area of the photo you're looking at. Quite often, these problems were in the original photograph. You may not be able to overcome them. Beware that brightening can make all the photo's imperfections more noticeable.

- **Contrast:** When photos age, they tend to lose contrast. Poor contrast is often the result of fading. Blacks appear less black, and whites aren't as bright. These photos look like a dull overlay has been placed on them. Other photos may have too much contrast. Like exposure problems, having too much contrast was a problem captured when the photo was taken—you may not be able to make the photo look better. However, if you know there is too much contrast going in, you know not to add any more. Note that increasing contrast can accentuate debris you might have missed, film grain, and noise because edges stand out more.

3. Create an adjustment layer to correct color issues. See the next section if you need help creating adjustment layers.

 As you create new layers, typically you will work from the bottom up. However, you see the canvas from the top down. Adjustment layers that you create stack on top of each other in the Layers panel and modify layers beneath them but not above. Therefore, make sure to create them on top of your cleaning and repair layers.

 For photos that have too much or too little color, try one of these adjustments:

 - **Vibrance:** This is a great adjustment if you want to boost colors without pushing some already strong ones over the edge.

 - **Hue/Saturation:** Use to uniformly strengthen faded colors, or to target specific hues to saturate or desaturate.

 - **Black & White:** This adjustment takes color out of photos, even black-and-white shots scanned in color.

 - **Photo Filter:** Use this adjustment to enhance photos by adding a bit of a color tint on top, or boosting blues or yellows.

 For photos that have the wrong color, try correcting it with one of these adjustments:

 - **Curves:** The key to using Curves to correct colors in a photo is to activate the gray point dropper and then click on something in the photo that should be neutral.

 - **Color Balance:** I regularly use Color Balance to add or remove tones from shadows, midtones, and highlights if correcting with Curves doesn't work. It takes a bit more work but is reliable.

 - **Hue/Saturation:** Use the Hue control to modify some or all of the hues in the photo.

- **Photo Filter:** This adjustment can help correct color tints by adding some of the "opposite" color. For example, you can add blue to correct yellow or yellow to correct blue.

- **Channel Mixer:** You can use the Channel Mixer instead of the Black & White adjustment to convert color photos to black and white. You can also use it to correct imbalances between the color channels (say, for example, the green channel is too bright). You can also use it to isolate one of the color channels for diagnostic purposes. I tend to use this adjustment as a last resort to rescue something out of a photo that appears hopeless.

4. Create an adjustment layer to improve brightness and contrast, using any of these adjustments:

- **Brightness/Contrast:** What could be simpler? Despite being simple (or perhaps because of it), please feel free to use this tool to adjust a photo's brightness and contrast.

- **Levels:** Adjust the white (highlights) and black (shadows) Input Levels sliders to set the overall tonal range of the photo, then adjust brightness using the middle (midtones) Input Levels slider. Check out the presets or click Auto and see what happens.

- **Curves:** Manually creating your own tone curves is something of an art form and takes a bit of practice. I encourage you to select a preset to see what it does, then experiment. If you want to jump in, click on the curve line to create a point, and then drag it to make adjustments. Dragging above the initial line lightens; dragging below darkens. Each point affects how the others are connected. You can also click the On-image adjustment tool, and click and drag on the photo to create and modify points on your curve.

- **Exposure:** I don't recommend using the Exposure adjustment. There's not much to it that you can't do elsewhere. It sounds very "photographic" and professional (and when working with 32-bit HDR images, it is), but it's not the best tool to adjust brightness and contrast when restoring photos.

5. If nothing seems to work, keep trying. You may need to change settings. Sometimes you should try another approach. You may need to use one of these Smart Filters instead of an adjustment layer:

- **Shadows/Highlights:** Brightens shadows and tones down highlights. You cannot use Shadows/Highlights as an adjustment layer; I suggest applying it to a Smart Object as a Smart Filter.

- **Camera Raw Filter:** This useful filter allows you to use the features of Adobe Camera Raw on your photo. This includes making changes to properties like Exposure, Contrast, Highlights, Shadows, and so forth. The filter is more convenient than saving a copy of the photo as a .tif, opening it as a Camera Raw file, making adjustments, saving the result, and then placing that file into your working Photoshop file as a new layer. It is located in the Filter menu. I have more on the Camera Raw Filter in the section "Using the Camera Raw Filter," later in this chapter.

6. After you've made your adjustments, take a step back and reevaluate the photo. Make sure your efforts have helped, not hurt. In particular, look at these areas:

- **Age:** The photo should look right for its age. It should not look too new or fake.

- **Color:** Most often, the color should look natural. There should not be any green or magenta tints. Make sure you don't take out too much color from black-and-white shots—they can look too cold and gray as a result. And don't oversaturate colors. Sometimes your photos need to be what they are: old photos.

- **Grain/Noise:** Any time you brighten areas of old photos, you run the risk of making film grain stand out. If it looks unattractive, you may want to back off. Likewise, you may elevate digital noise created during the scanning and digitizing process.

- **Contrast:** Photos with too little contrast look dull and lifeless. However, it's possible to add too much contrast as you correct it. When that happens, the photo will look overdone and unnatural. It will sort of hurt your eyes to look at it.

7. Make changes to your original settings or add additional adjustment layers to finish the job.

Don't fall prey to the notion that you have to do everything with a single adjustment. Photo restoration is a process. With each adjustment, take the time to look at the photo and consider whether the change is good, is bad, goes far enough, goes too far, addresses the problem you are trying to overcome, or needs to be deleted, edited, or added to. It really helps to take breaks and come back to the photo after a rest. You will see things with a new, fresh perspective. Problems that you got used to seeing (that's when your brain starts to silently ignore things it shouldn't) will stand out now. The more time you can rest between evaluations, the better.

Using Adjustment Layers

Adjustment layers are not difficult to set up and use. You will spend more time deciding on what settings to use than you will creating them.

Creating Adjustment Layers

To create an adjustment layer, follow these steps:

1. Click the Create New Fill or Adjustment Layer button at the bottom of the Layers panel. It will expand and show you the available options, as shown in **Figure 6.1**. Notice that they are divided into four groups. We're interested in the second and third.

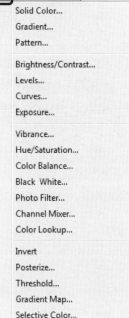

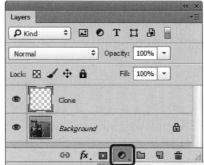

Figure 6.1
Get used to seeing the adjustment layer menu.

2. Click the name of the type of adjustment layer that you want to create. Photoshop will create the layer (see **Figure 6.2**) and update or open the Properties panel.

This panel shows you the specific settings that apply to the type of adjustment layer you've just created.

New adjustment layer

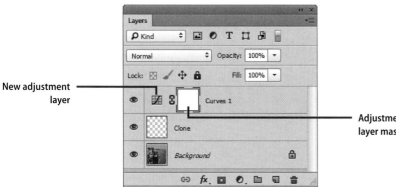

Adjustment layer mask

Figure 6.2 **When creating adjustment layers, the mask is initially selected.**

3. Use the Properties panel (**Figure 6.3**) to change the settings and make your adjustments.

 Some adjustment layers have presets that you can choose from. Levels, Curves, and Black & White are examples. Others, such as Color Balance, do not. In those cases, it's all up to you.

That's it. You don't have to press Enter or OK or anything. When you make the changes, they are applied instantly. I love this aspect of using adjustment layers because it lets me experiment with settings by "scrubbing" sliders and other moveable controls back and forth. This type of immediate feedback makes the process feel very intuitive.

You can also create adjustment layers using the Layer menu. Navigate to the Layer > New Adjustment Layer menu, and then choose the specific type you want to create.

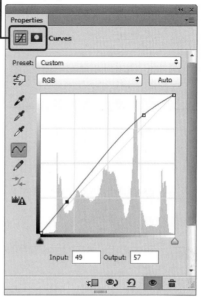

Click the adjustment or mask icon to switch properties.

Figure 6.3
Each type of adjustment has a different-looking Properties panel with unique settings.

Some adjustments should be applied to the entire photo. For example, removing a photo's green tint will make everything look more natural. Likewise, many brightness and contrast enhancements look best when applied globally. When you make these types of adjustments, you don't need to bother with the adjustment layer mask. If you need to control the strength, make changes to the settings or lower the adjustment layer's opacity.

Don't Even...

You may have noticed that I do not use normal adjustments. Right. Whenever possible (which is all the time), I use adjustment layers. It's not that the adjustments are different, it's that adjustment layers are far superior. So superior, in fact, that normal, non-adjustment-layer adjustments are just not worth it. You can't edit them after the fact, can't easily come back to make changes, and end up using more pixel layers than you would with adjustment layers. The last bit makes your files either much larger (more layers) or impossible to reconstruct (say, a single layer with all of your adjustments done to it).

If I find myself in a position where I can't get what I want out of the existing adjustment layers, I create a Smart Object and use the Highlights/Shadows adjustment or the Camera Raw Filter.

Editing Adjustment Layer Properties

To modify an existing adjustment layer, follow these steps:

1. Select the adjustment layer you want to edit from the Layers panel, as shown in **Figure 6.4**. The Properties panel updates or opens.

 If you click the layer mask in the Layers panel, the Properties panel will display the settings for the layer mask instead of the adjustment. You will see the Density and Feather settings plus a few other options.

 Click the adjustment icon on the Layers panel (the currently selected item is enclosed in a broken box) to switch away from the mask settings. There are also clickable icons on the Properties panel that correspond to the adjustment and mask. Click them to switch the Properties panel view between the adjustment and mask settings.

2. Make changes to the settings using the Properties panel, as shown in **Figure 6.5**.

3. Click a new layer, switch to a new tool, or create another layer to move on.

The adjustment
layer is selected.

Figure 6.4 **Click squarely on the adjustment icon to select it instead of the mask.**

Figure 6.5 **The strength of using adjustment layers is that you can easily change them later.**

Locking In Adjustments

Adjustment layers are ephemeral things. They don't really exist as photo layers—they modify those layers beneath. To combine one or more adjustment layers, Smart Objects, visible photo layers, cleaning layers, and repair layers into a single, normal layer, follow these steps:

1. Make all the layers you want to consolidate visible. Toggle the rest off.

2. Press Ctrl+A (Windows) or Cmd+A (Mac) to select the entire canvas.

3. Select Copy Merged from the Edit menu.

4. Press Ctrl+V (Windows) or Cmd+V (Mac) to paste the merged copy as a new layer in the Layers panel. You can also use the Paste or Paste Special commands from the Edit menu.

5. Rename the layer if you wish, as I have done in **Figure 6.6**.

Figure 6.6
The layer I named Merged is a merged copy of everything beneath it.

Adjustment Layer Tips and Tricks

- Don't be afraid to stack adjustment layers.

- Make incremental adjustments. You do not have to do everything at once!

- An adjustment layer's best friend is its mask. Use masks to target adjustments exactly where you need them applied. Make other adjustments for other areas of the photo.

- Use layer opacity to alter the adjustment strength. I use this trick to blend adjustments all the time.

- Store adjustment layers in layer groups to organize them. You can create alternate versions and compare them.

- When you start getting a lot of adjustment layers of the same type, name them. Doing so enables you to quickly see what their purpose is by looking at the name on the Layers panel.

Using the Camera Raw Filter

If you're an avid digital photographer with experience using Adobe Lightroom or Adobe Camera Raw, you may prefer to use the Camera Raw Filter to perform some of your color, brightness, and contrast adjustments.

I prefer to use other adjustments for most tasks, but there are times when the Camera Raw Filter provides a great alternative. Here's how to set it up:

1. Clean and repair your photo.

2. Make color, brightness, and contrast changes using adjustment layers if you wish.

 This is the approach I typically take. I rely on my standard set of adjustment layers and turn to the Camera Raw Filter if I can't quite get what I want otherwise. You may want to use the Camera Raw Filter first, or use it without any other adjustments. Either is fine.

3. If you have created cleaning, repair, or adjustment layers, make sure those layers are visible (turn off other, temporary helper layers), then create a merged copy (select the entire canvas, then Copy Merged).

 If you have no other layers, you can simply duplicate the Background layer and skip the next step.

4. Paste the copy as a new layer. This consolidates the changes and builds a new foundation for you to build on. I like to rename this layer in anticipation of applying the Camera Raw Filter to it, as shown in **Figure 6.7**.

Figure 6.7 **Consolidate changes into a normal layer before attempting to convert it.**

5. Right-click this layer in the Layers panel and select Convert to Smart Object from the pop-up menu.

The layer is now a Smart Object. The thumbnail changes to show that the layer is no longer a standard layer, but an Embedded Smart Object (see **Figure 6.8**).

For more information on Smart Objects, please turn to Chapter 3, "Working with Photoshop," and Chapter 7, "Creating Great Shots."

6. Select the Filter menu and choose Camera Raw Filter.

This opens the Camera Raw interface in filter mode. The image controls are the same (with a few small exceptions—there is no Profile tab in Lens Corrections, and you cannot create

Figure 6.8
Notice that the thumbnail has changed to reflect its new status.

Smart Object thumbnail

snapshots), but the preferences and some of the tools are gone. There are no options to make changes to the color profile, resolution, and so forth. That doesn't matter, because all of these options are controlled by the current Photoshop file you are working in. Likewise, you cannot crop, straighten, or rotate the image using the filter.

7. Make basic adjustments on the Basic tab (the tabs are shown in **Figure 6.9** on the following page). Focus on making color, brightness, and contrast changes first.

- **Color:** To make color adjustments, use the Temperature (compensate for lighting by cooling or warming the photo), Tint (counter green or magenta tints), Vibrance, or Saturation controls. Slide them back and forth to see what they do.

- **Brightness:** To make brightness adjustments, use Exposure (overall brightness), Highlights (bright areas), Shadows (dark areas), Whites (the brightest brights), or Blacks (the darkest darks) controls.

- **Contrast:** To make direct contrast adjustments, use the Contrast control. You can indirectly change contrast by manipulating shadows and highlights (or the white and black points) so they are closer to or farther away from each other. You can alter local contrast with the Clarity control.

Figure 6.9
Change tabs by
clicking the appro-
priate icon.

Basic
Tone Curve
HSL/Grayscale
Split Toning
Effects

Basic

Current Tab

8. If desired, make other color, brightness, and contrast adjustments using the other tabs:

- **Tone Curve:** This tab contains two types of tone curves: parametric and point. You can use either, or both, to brighten or darken tones in the image. The Parametric curve splits tones into four adjustable areas: Highlights, Lights, Darks, and Shadows. The Point curve is just like working with a Curves adjustment. Click and drag to position a point on the chart in the tonal region you want to modify.

- **HSL/Grayscale:** This tab is split into three parts. One controls image hues, the other saturation, and the last luminance. They all work the same way, but have different effects. Hue changes color values, saturation affects color purity (from gray to pure color), and luminance modifies how bright the colors are (from black through the color to white). You can also convert the photo to black and white by checking the Convert to Grayscale box.

- **Split Toning:** Change color hues and saturation between highlights and shadows. Use the Balance control to fine-tune where the split between highlights and shadows occurs.

- **Effects:** Use the Post Crop Vignetting area of the Effects tab to counteract vignetting—when the outer edges of a photo are darker than the center—in photos. The edges didn't get the same amount of light because of the characteristics of the particular lens used when the photo was taken. Increase the Amount control to brighten the edges.

 There are many other types of adjustments possible using the Camera Raw Filter. I cover those that may be useful but aren't directly related to color, brightness, and contrast in Chapter 7.

9. When finished, click OK.

One limitation to using the Camera Raw Filter is that you can't continue to selectively blend each different adjustment later using layer opacity or masks. They all go together in the filter.

Using Masks to Limit Adjustments

At times, you may need to limit adjustments to certain areas. Quite often, this means brightening areas of the photo that are dark without brightening the already bright areas.

When you need to selectively apply adjustments, use masks. Masks can be applied to adjustment layers, Smart Objects, and Smart Filters. That makes them really versatile.

I often use masks to isolate skies from the rest of the photo. This enables me to darken the sky (or perhaps increase its vibrance) without affecting everything else.

Creating Masks

When you create an adjustment layer, you don't need to do anything special to get the mask. It's automatically created. To create a mask on other layers, or if you've deleted the mask on an adjustment layer and want to re-create it, follow these steps:

1. Select the layer or Smart Object you want to create the mask on, as I have done in **Figure 6.10**.

2. Click the Add Layer Mask icon on the Layers panel.

 Photoshop quickly creates the mask and links it to the layer you selected in Step 1, as shown in **Figure 6.11**. If you had a selection active, everything but the selection will be masked out. Otherwise, the entire mask should default to white, which allows the layer to do its job (whether as an adjustment layer, Smart Object, or Smart Filter).

Figure 6.10 **In this case, I have selected a Smart Object layer to mask.**

Figure 6.11 **The linked mask appears next to the layer thumbnail.**

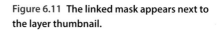

The new mask is currently clear.

One quick note about another type of mask: the *clipping mask*. I don't use clipping masks when restoring photos. They work differently than normal layer masks. Rather than show or hide layers beneath the mask, they "clip" layers above the mask, allowing what's beneath to show through one or more layers. This is great when working on logos, text art, and other types of graphics, but they are not needed to restore photos.

Editing Masks

Follow these steps to edit masks (on any type of layer):

1. Select the mask icon next to the layer on the Layers panel. In **Figure 6.12**, I've selected the mask attached to the Curves 1 adjustment layer. The mask thumbnail will be surrounded by a dashed rectangle, indicating that it has the focus. Check and double-check that you have selected the mask and not the layer.

2. Select a tool from the Tools panel with which to apply the mask. Most people use the Brush. I am a complete oddity in that I prefer using the Eraser and applying masks using the background color. However, I have written these steps from the perspective of using the Brush.

3. Set the foreground color to black. When painted on the mask, black blocks or hides the layer or adjustment.

4. Customize the size, hardness, and opacity of the brush to suit your needs.

 Use a soft brush to create edges to the mask that blend well. Lower the opacity to create a partially transparent mask.

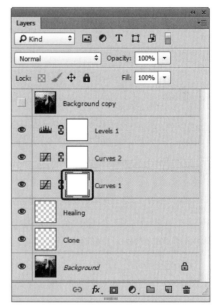

Figure 6.12 **Always double-check to make sure that you have the mask—not the filter—selected.**

5. Paint the area you want to mask, or block, with black. I have masked the bottom area of the photo in **Figure 6.13**. This lets me make an adjustment to the sky with Curves without affecting any other area of the photo.

6. If you need to tweak the shape or undo any mistakes, set the foreground color to white and paint over any black areas of the mask that you want set to erase. You may also want to adjust the mask's properties. You can lower the density to make it more or less transparent, feather the edges to improve blending, invert the mask, and apply other filters (like Gaussian Blur) to it.

7. If you want to start over, select the mask on the Layers panel, press Ctrl+A (Windows) or Cmd+A (Mac) to select the entire canvas, set white as the background color, and then select Clear from the Edit menu, or press the Delete or Backspace key.

Figure 6.13
Masked areas appear black on the thumbnail.

Clear white

Masked black

Mask Options

The list of things you can do with or to masks is tremendous. Right-click a mask on the Layers panel and take a look at the pop-up menu, which is shown in **Figure 6.14**.

- **Disable or Enable Layer Mask:** Choosing Disable Layer Mask temporarily turns off the mask. A large, red X appears on the mask thumbnail as a visual cue. This is most helpful when the mask's effects are subtle and you can't easily tell from looking at the photo whether the mask is on or off. In addition, the menu option changes to Enable Layer Mask. To turn the mask back on, right-click the mask and select Enable Layer Mask.

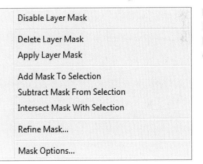

Figure 6.14
Right-click a mask to bring up the Mask Options menu.

- **Delete Layer Mask:** This option deletes the mask. Poof! It's gone.

- **Apply Layer Mask:** Apply Layer Mask applies the mask to the layer and replaces masked pixels with transparent pixels. I do not recommend this, because one of the super strengths of masks is being able to edit, improve, copy, move, or delete them as required.

- **Add Mask to Selection:** This option adds unmasked pixels to the current selection.

 If nothing is currently selected, this and the following two options have the same effect: They create a selection based on the pixels that aren't masked. In other words, pixels that are beneath white areas of the mask are selected. Those that are masked, which is to say that they are beneath black pixels, are ignored. I find this a very useful feature.

- **Subtract Mask from Selection:** This option subtracts unmasked pixels from the current selection.

- **Intersect Mask with Selection**: This option selects those pixels that meet both requirements: They are unmasked (white) and in the current selection.

- **Refine Mask:** You must have a selection active for this option to be enabled. When you select it, the Refine Edge dialog box opens and enables you to tweak the edges of the mask based on several different criteria and methods. The four options in the Adjust Edge area are particularly useful.

- **Mask Options:** This option opens the Layer Mask Display Options dialog box. With it, you can change the layer mask's Rubylith color and opacity. I will explain this shortly.

Super-Secret Mask Tricks

Here are some tips you may want to keep in mind when working with masks:

- To view the mask on the canvas in black and white, press Alt (Windows) or Ctrl (Mac) and click the mask in the Layers panel. This hides everything but the mask. Although you can edit the mask in this mode, you won't be able to see the photo.

- To view masks as a Rubylith, select either the layer or the layer mask and press Backslash. Rubylith is a type of masking film invented by the Ulano Corporation whose name has become synonymous with what it does: create masks. In the physical world, Rubylith is ruby red.

 Figure 6.15 masks the opposite area as the one shown in Figure 6.13. After masking the wrecked train cars to make an adjustment to the sky, I masked the sky to make a different adjustment to the cars. This shows the canvas with the Rubylith turned on. I encourage you to turn on the Rubylith to help you keep track of areas you've masked and whether or not you've missed anything. It's an amazingly cool (and relatively hidden) feature.

Rubyliths do not work with Smart Filter masks. However, they do work with masks on Smart Object layers. Go figure.

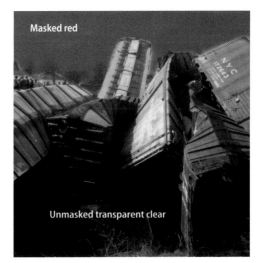

Masked red

Unmasked transparent clear

- To move a mask independently of the layer it is attached to, click the link icon between the mask and the layer thumbnail. This unlinks the mask from the layer. This is less practical for adjustment layers, but is still a helpful trick to know.

- You may like working with the thumbnails off in the Layers panel. If you have trouble telling where the masks are or what they are doing, turn layer thumbnails back on when working with masks. Either that or show the Rubylith when you've selected the mask.

Using Layer Comps

Using layer comps is one way of comparing two or more different versions of your work. Each time you create a layer comp, you take a snapshot of the Layers panel. That sounds promising. There are, however, significant limitations that prevent me from endorsing them in most situations.

First, the good news: You can save select layer properties into layout compositions (called "layer comps"). After you create them (use the Layer Comps panel, which is under the Windows menu), you can quickly toggle between different comps to compare them. Based on what you see, select your favorite and use that as the basis of any further work.

You are limited to preserving three states or properties: layer visibility, position, and appearance (including styles and blending mode). This applies to all layers within your file. You can adjust whether or not these states are saved from the Layer Comp Options menu on the Layer Comps panel.

Now for the bad news: Layer comps do not save adjustment layer or Smart Object filter settings. If you make a change to a Levels adjustment layer, for example, it will be applied across all layer comps. This prevents you from comparing different approaches using the same adjustment layer. To do that with layer comps, you would have to create multiple adjustment layers, show one set while hiding the other, create a layer comp, then create a new set of adjustment layers that are visible (while hiding the original) to create an alternate layer comp. It is certainly possible, but it seems like a lot of work.

If you plan on using layer comps and have a lot of layers, try collecting the adjustment layers you want to experiment with into layer groups. Make your layer comps based on the groups instead of individual layers.

Tackling Specific Problems

I want to use this section of the chapter to walk through several different photos and show you the adjustments I would make to them and explain why. It's not complicated stuff, but it will help you see how the settings of my favorite adjustments translate from theory to practice. Let's go.

Correcting a Color Problem

The photo shown in **Figure 6.16**, of my wife sitting on a porch when she was a young girl, has developed a distinctly orange-red tone over time. The challenge is to convert the offending colors into something more natural looking. It looks impossible, but it's actually very easy to do.

Figure 6.16
Correcting color
can be as easy as a
single click.

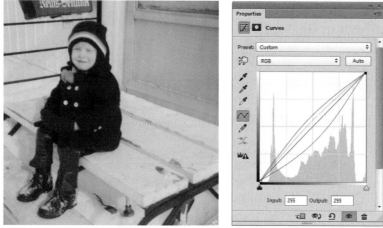

Before

Settings

After

My first choice when correcting color tints is to use a Curves adjustment layer. I create it, click the gray point dropper (it's the center dropper), then click something in the photo that should be neutral. In this case, I clicked on the top right button on her coat. If this doesn't work, I delete the Curves layer (or undo it) and try a Color Balance adjustment. From this point I would continue to make brightness, contrast, and other adjustments to fully restore the photo. However, I left this for you to see an isolated color correction.

Reducing Age-Related Yellowing

Figure 6.17 shows a black-and-white photo of my father-in-law (he's about the same age as his daughter when the photo in the last figure was taken) that has also aged over time.

When working with black-and-white photos that have yellowed with age, you can remove color tinting in one of several different ways. You could:

- Use a Curves or a Color Balance adjustment.
- Reduce the image's saturation using a Vibrance or Hue/Saturation adjustment layer.
- Fully convert the photo to black and white.

In the end, I wanted to show you something simple: I merely removed some color by lowering the Vibrance setting. Sometimes it's really just that easy. You don't need to fuss over what adjustment to make and pore over the settings for hours.

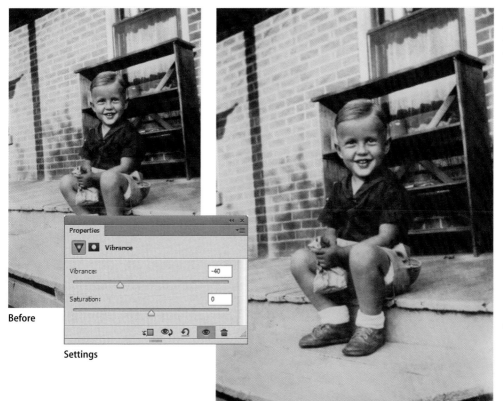

Figure 6.17
Gently reducing the yellow with a Vibrance adjustment

Before

Settings

After

Removing a Green Tint

A Polaroid photo taken of my grandmother in the 1970s has an awful green tint to it (see **Figure 6.18**). She is holding some radishes from our garden. This is a good photo to show the Color Balance dialog in action. I have moved the sliders in all three tonal regions away from green and towards blue. I have brightened the photo so that you can see the result of the color correction. There's still work to do, but the photo looks really promising now.

Figure 6.18
Color Balance is a bit more complicated but very effective.

Before Settings

After

Improving Color, Brightness, and Contrast

The photo in **Figure 6.19** is a cute snapshot of my mother-in-law taken some time ago that has faded and dulled a bit over time. This is a great example of taking snapshots and turning them into great shots. To improve this photo, I made a color correction using a Curves adjustment layer. I used the gray point dropper and clicked on the sidewalk in the photo. The concrete should be a nice, neutral gray. Then I increased both the brightness and the contrast using a Brightness/Contrast adjustment. The combination of making a minor color correction, plus a good deal of brightening and additional contrast, has turned the photo into a real gem.

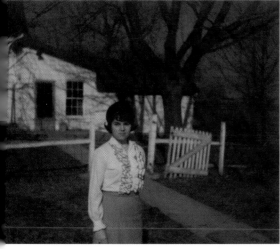

Before

Color settings

Brightness/Contrast settings

Figure 6.19 Even simple color, brightness, and contrast adjustments can have a profound effect.

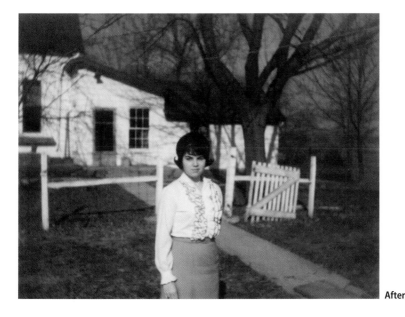

After

Old color photos can fade and lose some of their color strength. It's also possible that they never had much punch to them. After correcting the colors, try strengthening faded or muted colors with a Vibrance adjustment layer. If you want more, increase the color strength across the board with the Saturation control.

To strengthen a limited range of colors (blue, for instance), use a Hue/Saturation adjustment layer. Select the color range you want to work with from the drop-down list initially labeled Master. Increase the saturation until you like what you see.

If you aren't sure which range the color you want to adjust falls into, you can click and drag on the photo to increase or decrease its saturation. First, click the On-image adjustment button (it looks like a right hand with an outstretched index finger between arrows), then click the color in the photo and drag the mouse. Drag right to increase saturation and left to decrease it.

To alter the color range that you are adjusting, use the adjustment sliders near the bottom of the Properties panel. Click and drag the middle slider to change the hue. Click and drag the vertical white bars on each side to increase or decrease the hues that comprise it. Click and drag the triangle sliders to adjust the fall-off range, which controls how much feathering occurs between hues that are on the edges of the adjustment range.

Making a Levels Adjustment

You might be surprised at how seemingly decent photos can look better with just a nudge of a brightness and contrast adjustment. The photo in **Figure 6.20** is such a case. Notice that the apron my wife's great-grandmother has on is already very bright. Brightening the photo without regards to this fact may push the apron over the edge and render it (and their faces) a featureless white. This is where making a Levels adjustment can be more effective than using a Brightness/Contrast adjustment.

Notice the end result. The whites are nice and clear but not overpowering. The darks are rich but not artificially black—they match the rest of the photo. The midpoint slider has made the overall photo brighter. Fantastic.

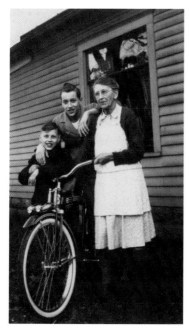
Before

Settings

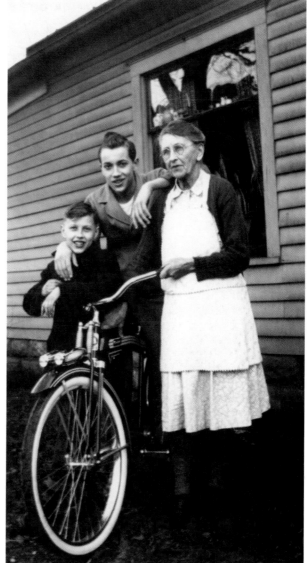
After

Figure 6.20
Making a Levels
adjustment to
brighten without
overdoing it

Correcting Color, Brightness, and Contrast

The photo in **Figure 6.21** is a lighthearted shot of some kids playing around at a park. It has color, brightness, and contrast problems. I could tackle them all separately using different adjustment layers, but this is a good time to show another example of the Camera Raw Filter in action. I used the controls on the Basic tab to cool the photo, remove a slight green tint, boost the brightness by elevating the Exposure and Whites controls, deepen the darker areas of the photo, and enhance the color a bit. I also *decreased* the contrast. This was a case where too much contrast made the photo look too harsh. I didn't want that at all.

Figure 6.21
The Camera Raw Filter enables you to correct several things at once.

Before

Settings

After

Taming Highlights

My wife took the photo in **Figure 6.22** of us on our honeymoon. It's a selfie before selfies were cool. As you can tell, the flash was very bright and overpowers our faces in the photo. The challenge is to try to tone down the highlights without ruining the beautiful sunset in the background.

This example illustrates why masks are so handy. I created a Levels adjustment layer and used it to darken our faces, then masked out the background. As you can see, the mask kept the rest of the photo from being altered. Using masks can increase the effectiveness of your work tremendously.

Figure 6.22 **Masks enable you to apply different adjustments to different areas of the photo.**

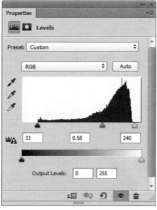

Before Settings Mask

After

Rescuing Details

I found the photo shown in **Figure 6.23** in a collection of slides from my wife's family. It's a guy standing beside his Ford truck, which is parked on the street in mounds of snow. At first I thought I could bring up the brightness and make the photo look better. I couldn't.

After investigating, I discovered that I could use the Channel Mixer adjustment layer to basically ignore the Green color channel and pull information only from the Red and Blue channels. I set the adjustment to Monochrome and then lowered the opacity of the layer to 64% to let some color through. The photo looked too harsh in pure black and white. Finally, I used a Levels adjustment layer to brighten the mid-range tones of the photo. The result is a nice-looking shot.

Figure 6.23
Rescue as much detail as you can from photos like this.

Mask

Correction

Brightening

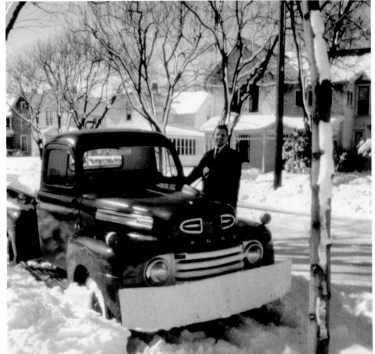

After

Using Photoshop Elements

We have finally arrived at a chapter that will require Adobe Photoshop Elements users to make a few adjustments. Not all of the tools and techniques that I use to make color, brightness, and contrast adjustments in this chapter are available in Elements. That's the bad news. The not-so-bad news is that Elements does not leave you high and dry. You will merely have to substitute some features found in there for those in Adobe Photoshop.

In general, adjustment layers and masks work the same in both programs. Likewise, there are a number of adjustment layers that are present in Elements and Photoshop:

- Hue/Saturation

- Photo Filter

- Brightness/Contrast

- Levels

You can also use Shadows/Highlights in Elements, but you will have to use it on a standard layer. It cannot be used as a Smart Filter.

You will have to substitute an Elements feature for these general Photoshop features:

- **Smart Objects and Filters:** There is no feature in Elements that provides you the option of applying a nondestructive filter to a layer. You will have to commit to any non-adjustment layer adjustments when you make them.

 My advice is to create a duplicate or merged copy layer for each adjustment you plan on making, then renaming the layer so you know what you did to it. Take notes on the settings you used (with specific numbers or a description of what you may have clicked on, for example) so that you can alter them if you change your mind.

- **Vibrance adjustment layer:** There is no Vibrance feature in Elements. You will have to make do with a Hue/Saturation adjustment layer.

- **Color Balance adjustment layer:** You cannot adjust the color balance directly in Elements. Use Remove Color Cast instead (shown in **Figure 6.24**). You'll find it under the Enhance > Adjust Color menu.

Figure 6.24 **To correct color, click somewhere in the photo on a spot that should be free of color.**

- **Black & White adjustment layer:** While there is no adjustment layer, you can use the Convert to Black and White feature, which is located in the Enhance menu. In **Figure 6.25** I am using it to desaturate a yellow photo.

- **Channel Mixer adjustment layer:** If you need to adjust the brightness and contrast of individual color channels, use a Levels adjustment layer. Change the Channel to Red, Green, or Blue for each change. You can also play with the channels using Convert to Black and White. If you center the strengths of two channels and adjust the third, you can create an approximate grayscale version of that channel.
- **Curves adjustment layer:** Curves works differently in Elements and is not available as an adjustment layer. Use the Adjust Color Curves feature instead. You can find it under the Enhance > Adjust Color menu. I am using it to darken highlights in **Figure 6.26**.

Figure 6.26
This seems familiar: Select a style from the left and adjust using the sliders.

- **Exposure adjustment layer:** There is no exposure control in Elements. Use a Brightness/Contrast adjustment layer instead.

- **Camera Raw Filter:** You will not be able to embed Camera Raw in a Smart Object in Elements. I suggest using the Open in Camera Raw command (see **Figure 6.27**), as described in Chapter 3.

Figure 6.27
Use Camera Raw to access a slightly different set of adjustments than Elements proper.

If you're interested in trying them out, Elements has a bevy of automatic adjustments:

- Auto Smart Tone

- Auto Smart Fix

- Auto Levels

- Auto Contrast

- Auto Color Correction

Automatic adjustments can be very nice, especially if you're just starting out. Use them as
a diagnostic tool to see what Elements thinks will make the photo look better. Sometimes
it's spot on. Sometimes not. Either way, you've learned something.

Chapter 6 Assignments

The theme of this chapter's assignments is to *play.* Have fun experimenting with different adjustments and filters. Find out which ones you like, which ones you don't like, how they work, what presets (if any) are available, how the controls work, how they interact with each other, and whatever else you can dream up.

Create a new Photoshop file from a scanned photo. It will help if the photo has some type of color cast or imbalance (just don't make it a hard one). Name the file something that will help you remember that this is an experimental/learning file. It is not meant to be a serious restoration attempt. Do not mess with cleaning or repairing—get right to adjusting. Feel free to use the same file for all three assignments.

Play with color

Make color corrections using all of the color tools in this chapter. Create at least one of the following adjustment layers: Vibrance, Hue/Saturation, Color Balance, Black & White, Photo Filter, Levels, and Curves. Create at least one Smart Object using a copy of the background layer. Apply the Camera Raw Filter to it and experiment with the color controls.

Experiment with brightness

Make brightness adjustments using all of the brightness tools in this chapter. Create at least one of the following adjustment layers: Brightness/Contrast, Exposure, Levels, and Curves. Create a Smart Object for the Shadows/Highlights filter and the Camera Raw Filter, and play with the brightness controls. Use masks to see how you can make changes to different areas of the photo.

Fiddle with contrast

Tweak the contrast using all of the contrast tools in this chapter. Create at least one of the following adjustment layers: Brightness/Contrast, Exposure, Levels, and Curves. Create a Smart Object for the Shadows/Highlights filter and the Camera Raw Filter, and play with the brightness controls.

Share your results with the book's Flickr group!
Join the group here: www.flickr.com/groups/photo_restoration_fromsnapshotstogreatshots

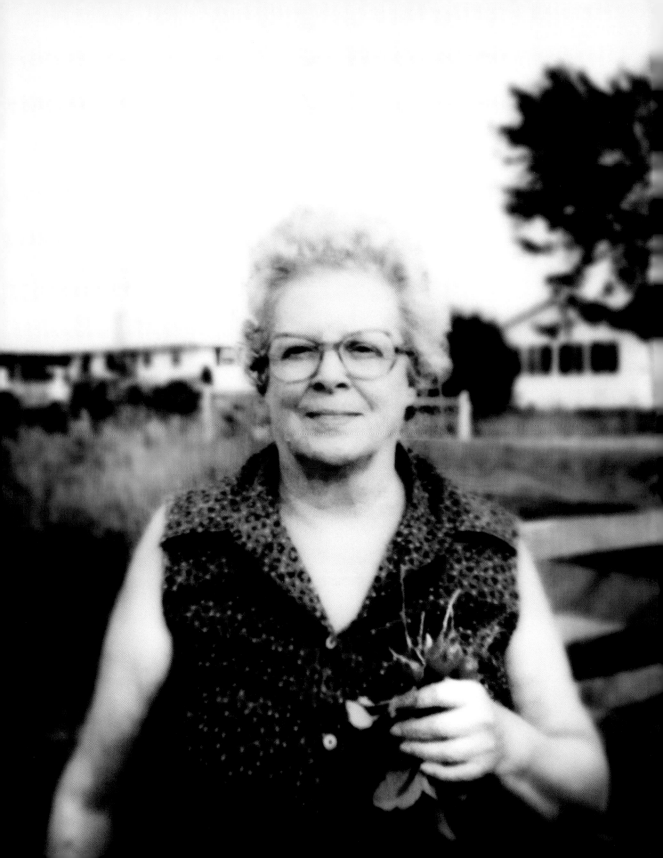

7

Creating Great Shots

Adding Greatness

This chapter is about ending with great shots. To help you cross the finish line, I have included a number of different techniques that you can use to make final corrections to your photos. They are as-needed improvements that you do not need to perform with every photo. Be selective with them. Along the way, I will help you develop your ability to recognize when, where, and how to add these extra touches.

Poring Over the Picture

I took this photo from inside the Diamond Head crater in Honolulu, Hawaii. I was looking up from the bottom of the second long stairway (it is the longest, with 99 steps) that is part of the trail that leads from the crater floor to the rim. At the top is a great view. After cleaning the photo, correcting the color, and improving the exposure, I used the Dodge tool to brighten the steps to draw your attention to them. I also sharpened the photo to reinforce the linear details. All of these improvements combine to make it a much better photo.

Bland with poor contrast.

Stairs need more pop.

Distracting box and cooler.

Color and contrast enhanced.

Stairs accentuated with Dodge tool.

Distractions removed with Clone Stamp tool.

Poring Over the Picture

The entrance needs to stand out more.

Overall, the photo is unremarkable.

Large regions of light and dark suitable for filter.

This photo of a front door and part of a house is not that big of a deal, really. It's meaningful to my wife's family, and it has a certain charm, but the photo itself is not a prizewinner. When restored artistically, however, it turns into something that anyone could enjoy. I used the Pointillize filter to create the effect, which works because the photo is fairly simple, has come good color, and has a nice range of light and dark areas.

Entrance transformed into attention-grabbing centerpiece.

Photo now has a gingerbread-house feel.

Effect created with Pointillize filter.

Using Smart Objects and Smart Filters

I use Smart Objects and Smart Filters to put a lot of finishing touches on photos. In fact, I created many (but not all) of the examples in this chapter using these tools. They enable you to apply practical and creative filters nondestructively. That means you can return to the filter dialog box later and change the settings.

There are a million-and-one other uses for Smart Objects, but they go well beyond the scope of photo restoration. This section addresses their general use. I covered using the Camera Raw Filter specifically in Chapter 6, "Correcting and Enhancing Color, Brightness, and Contrast."

Creating Smart Objects

Creating a Smart Object is very easy. All you need to do is this:

1. Create a normal layer that you will use to convert into a Smart Object. Rename it if desired.

 Most often, this means creating a merged copy that consolidates several adjustment layers, cloning and other cleaning/repair layers, and the photo itself. At times, you will simply need to duplicate a layer. Although you can convert adjustment layers to Smart Objects, I don't think that feature is practical for photo restoration.

2. Right-click in the space beside the layer thumbnail on the Layer panel and choose Convert to Smart Object from the pop-up menu, as shown in **Figure 7.1**.

 The layer thumbnail will update to indicate the new status. You are now ready to apply filters or other changes to the newly created Smart Object.

Figure 7.1 This option turns the layer into a special type of layer that you can edit nondestructively.

I have created an action to automate the process of copying layers and then creating a Smart Object. I use it most often when I want to combine the background photo layer with my clone or healing layers and several intervening adjustment layers. The action, as shown in **Figure 7.2**, selects the entire canvas, creates a merged copy, pastes the merged copy as a new layer, then converts that layer to a Smart Object. Bam.

Figure 7.2 Always be on the lookout to automate repetitive and yet simple tasks.

There are two other ways to convert a layer to a Smart Object. You can:

- Select the layer in the Layers panel, then choose Convert for Smart Filters from the Filter menu.
- Choose Convert to Smart Object from the Layer, Smart Objects menu.

Applying Smart Filters

To apply a Smart Filter, perform the following steps:

1. Select the Smart Object layer in the Layers panel.
2. Select the Filter menu to open up the list of filters you have on your system.

 You can also apply the Shadows/Highlights adjustment to Smart Objects. This is located in the Image, Adjustments menu.

3. Find the filter you want to apply and select it.

 Select the Filter Gallery (see **Figure 7.3**) if you want to apply a filter from the Artistic, Brush Strokes, Distort, Sketch, Stylize, or Texture categories. Noise reduction, sharpening, distortion, and many other types of filters do not appear in the Filter Gallery.

Figure 7.3
What makes Smart Filters so awesome is that you can edit them later.

My favorite nonartistic filters to use are the Camera Raw Filter, High Pass (found under Other), Reduce Noise, Lens Correction, and sometimes Shadows/Highlights (which is located under the Image menu, not the Filter menu). I also really like the Blur and Blur Gallery filters.

4. Adjust the filter's properties.

 In this case I have chosen to preview the Poster Edges filter to see what it will look like applied to a photo I took of the road that ran in front of my mom's home years ago.

5. Apply the filter by pressing OK.

 Photoshop applies the filter to the Smart Object, which becomes a Smart Filter. You can see the change in the Layers panel. **Figure 7.4** shows the Smart Object expanded to show the filter in place. Notice that the Smart Object, like any other normal layer, does not have a mask. If you want a mask on that layer, you will have to create it yourself. However, the Smart Filter, like an adjustment layer, comes with a preinstalled mask. Use it to mask the effects of the filter or filters.

Figure 7.4
Smart Filters are attached to Smart Object layers.

Smart Object Features

Smart Objects are fairly straightforward, but there are a number of features that you should become familiar with as you use them:

- Smart Object layers act like most other layers. You can drag them up or down in the Layers panel to reorder them, delete them, rename them, lock them, link them, color them, adjust their overall Opacity and Blend Mode, apply Layer Styles, and add a mask.

- Notice that Smart Filters have their own mask that is different from the overall Smart Object layer. You can enable and disable each mask independently.

- You can stack and reorder Smart Filters.

- You can enable or disable Smart Filters individually as a group by clicking the appropriate eye.

- To delete all the Smart Filters in one fell swoop, right-click Smart Filters and choose Clear Smart Filters.

- To blend filters, right-click their name and select Edit Smart Filter Blending Options.

- To edit a filter's settings, double-click the name, or right-click and select Edit Smart Filter.

- To lock in changes to the Smart Object layer and convert it back to normal, right-click it and select Rasterize. This removes your ability to edit any Smart Filter settings, but it also reduces the memory footprint of the layer.

Dodging and Burning

Dodging and burning are two fantastically easy tricks that, when done right, help bring out the best in your photos. The Dodge and Burn tools are based on actual darkroom techniques that photographers use to brighten or darken areas of prints without changing the overall exposure. They expose areas more to brighten (burning) or block light from the enlarger (dodging) in order to darken areas relative to the rest of the print.

To dodge, use the Dodge tool. To burn, use the Burn tool. Use them on merged layers that consolidate the changes you've made to your photo. I tend to dodge and burn near the end of my work on a photo, after all my cleaning, repairs, color, and overall exposure changes are locked into a new layer.

My key to using the Dodge tool is that I use it to add sparkle to a photo. In other words, I try to accentuate what is already good. For the most part, that means I concentrate on brightening highlights in order to draw people's attention to a specific person or place in the photo.

Figure 7.5 shows an example of this approach. I used a light application of the Dodge tool (Exposure was below 10%) to subtly brighten the hand and face of my wife's Aunt Liz. The effect is to make those areas stand out a bit more. I set the tool to brighten highlights—but made sure not to brighten them too much.

Figure 7.5 Accentuate highlights with the Dodge tool.

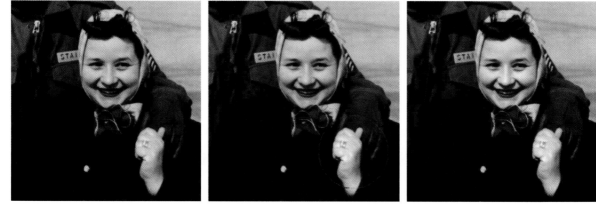

Before During After

Tweaking Is Encouraged

As you restore your photos, I encourage you to tweak things that you think can be improved, even if you're not at the right "step" in the process. For example, let's say that you have finished cleaning, repairing, and correcting the color of a photo, and have moved on to the Camera Raw Filter. However, perhaps only now do you notice something that you missed when cleaning. You don't always have to go back to the beginning to fix it (I do at times, but only when it's not too inconvenient). Simply create a new layer above the Smart Object, and use the Clone Stamp tool just like you did at the beginning of the restoration process. Your work will be incorporated into the next merged copy. The same goes for brightness, contrast, and other adjustments. If you think the contrast could be boosted, create a new Levels or Brightness/Contrast adjustment layer, make your change, and keep moving on.

You need to go back to the beginning (or back to the last merged copy) only if it's obvious that the changes you want to make need to be applied before others. Imagine making a Clarity change using the Camera Raw Filter, then reducing noise on a later Smart Object layer. If you wanted to change the Clarity setting, you would have to go back and make changes to the Camera Raw Filter, then re-create the steps that brought you to the noise reduction layer. That's why I take such great pains to be able to re-create my work. It's important at times like that to know what you did, and in what order.

It helps to hold off on making some changes (rotating a working layer, for instance), until you're sure that you are happy with the photo. This protects you from having to continually go back in order to go forward.

Use the Burn tool the same way—but instead of brightening midtones or highlights, darken midtones or shadows. **Figure 7.6** illustrates what I mean. The contrast on this part of the mountain in this photo wasn't very good, so I used the Burn tool and set the Range to Shadows. I lowered the Exposure to 3% (a little goes a long way) and darkened a patch of rocks and trees.

Remember, be selective. Draw the viewer's attention to the spot you want to emphasize, but do not make it obvious that you are doing so.

Figure 7.6 **In this case, Burning helped increase the contrast of a bland area of the mountain.**

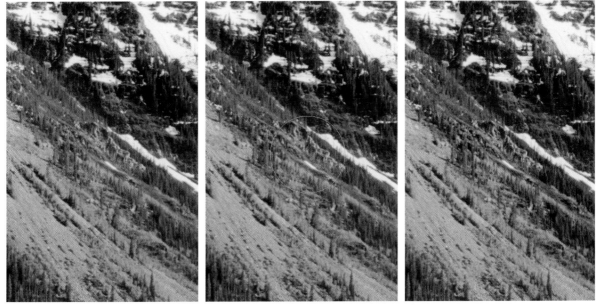

Before During After

Straightening Photos

I don't typically straighten photos, but I want to provide some guidance for you if you do. First of all, don't bother straightening them unless they are particularly out of whack. My test is that if I look at the photo and am uncomfortable about the angle and can't stop thinking about it, I correct it. If it doesn't seem to bother me, I will not correct it.

The main reason I take a hands-off approach is that, generally speaking, when you straighten a photo, you lose part of it. The exceptions are rare: when you were going to crop out unnecessary background material anyway, or if you were going to change the aspect ratio so much that the crop won't be noticeable.

Figure 7.7 is a photo of my wife standing in front of the Eiffel Tower. Unfortunately, the camera was held at a slight angle. It's pretty noticeable when something like the Eiffel Tower is crooked, so I decided to use the Ruler tool and rotate a composite layer (not the entire image) to straighten it up. I ran the ruler down through the center of the tower, rotated the layer, and then masked the photo to make it rectangular once again. You can see that in this case, I lost only a small portion of the photo around the edges.

Figure 7.7 **Oui oui, ma chère.**

Before During After

Cropping Images

Much like straightening, I try not to crop restored photos (beyond cleaning up their edges) unless necessary. The benefits of recomposing should clearly outweigh the value of the material that you lose.

Figure 7.8 shows an instance where cropping improves the photo's composition and does not sacrifice anything important. This photo is of my mom saying hello to a camel at a zoo at Christmas. I find it hilarious that the camel is looking directly at the camera with what looks like a smile.

Note that I do not advocate cropping your working Photoshop files. I suggest using the Rectangular Marquee tool to make a selection on a composite layer, then masking the area outside the selection (press the Add a Mask button on the Layers panel when the selection is active). If you want to preview the crop, create a new layer beneath the masked layer and fill it with white. When you want to save a final, flattened version of

the photo (complete with crop), first select the unmasked area, choose Crop from the Image menu, flatten the file, then choose Save As from the File menu.

Figure 7.8 Sometimes extra space is unnecessary.

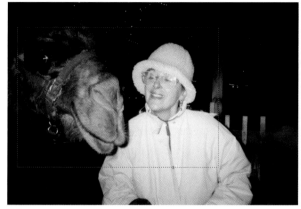 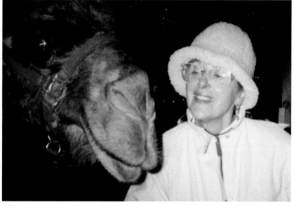

Before After

Blurring the Background

The photo of my grandmother that I used on the opening page of this chapter started out as a run-of-the-mill-Polaroid. It holds a great deal of meaning for me, though. As I was restoring it, I came to the point where I knew I had to do something about the background—not so much to hide it, but to smooth it out and make Grandma the undisputed center of attention. Therefore, I decided to blur the background as if the photo were taken with a nice camera and lens capable of producing a creamy bokeh effect. I used a combination of filters for this, including Field Blur (which is part of the Blur Gallery). All effects were done on Smart Object layers. **Figure 7.9** shows what the photo looked like before and after the transformation.

Figure 7.9 Blurring the background makes the subject stand out.

Changing the Aspect Ratio

It is possible to effectively change the aspect ratio of a photo in order to recompose it. **Figure 7.10** is a photo of my wife and me at sunset the night before our wedding. While there is nothing tragically wrong with this photo oriented as it is, there is quite a bit of wasted space. If it weren't so dark, I might be tempted to keep it. However, this photo makes a good case to show how to change a photo's aspect ratio.

Mechanically, I perform this task just like I crop photos. I use the Rectangular Marquee and select the area of the photo I want to keep. Then I create a mask that shows the selection and hides the rest (again, you can see the effect better by creating a white layer beneath the masked photo layer). When creating selections based on a particular ratio, set the tool's Style setting to Fixed Ratio. This locks in the aspect ratio, which in this case was 4 wide by 6 tall.

Figure 7.10 **A tighter composition in this case means changing the aspect ratio.**

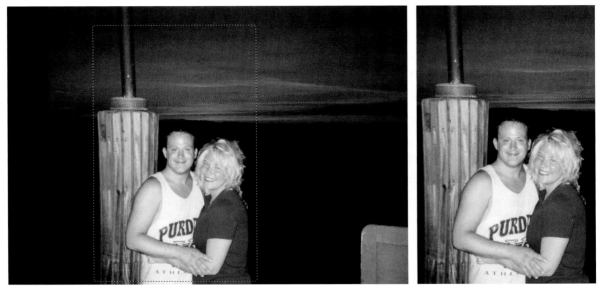

Before After

Sharpening Photos

Sharpening restored photos can make them look much better than they were originally. The key is knowing when to sharpen and applying the right amount. The danger of over-sharpening is that you also boost a photo's imperfections, which can include film grain, noise, dust, or blemishes that you missed when cleaning.

Photoshop has several different sharpening filters. Most are located in the Filter menu's Sharpen section. If you want to use them, they are all pretty straightforward. In the past, I used Unsharp Mask and Smart Sharpen. You can also use the Camera Raw Filter's Sharpen feature.

Now, though, I use the High Pass filter almost exclusively for sharpening. It's super effective and amazingly easy. Here's how to use it:

1. Create a merged copy that consolidates all your changes into a single layer.

2. Select the merged layer in the Layers panel and convert it into a Smart Object.

3. Now change the layer's Blend Mode to Overlay (see **Figure 7.11**).

 You can wait to perform this action until after you've applied the filter. However, I find it most helpful to change the Blend Mode now because it lets me preview the effects of sharpening on the main canvas.

4. Next, select the High Pass filter, which is in the Filter menu's Other section.

5. Enter a radius.

 I use 5.0 as a starting point, as shown in **Figure 7.12**, then change as desired. This results in noticeable but not outrageous sharpening for images based on the size and resolution of my typical scans. You may need to adjust this, depending on the settings you used when scanning your photos.

Figure 7.11
This sharpening technique depends on the Overlay Blend Mode to work.

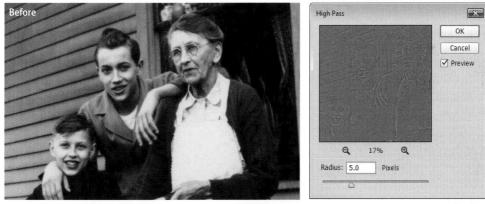

Settings

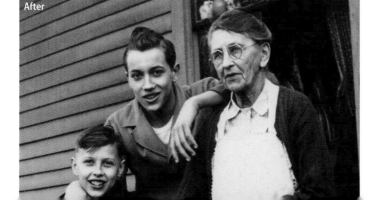

Figure 7.12
Subtle sharpening can accentuate details without elevating noise.

6. Click OK to close the dialog box.

 Figure 7.12 shows the effect of a moderate amount of sharpening using the High Pass filter. Everyone looks clearer and better defined. This photo of my father-in-law (the youngster), his grandmother, and his brother has gone from being slightly soft to pleasantly sharp.

7. To blend even further (aside from going back in and lowering the radius), alter the layer's opacity or mask areas that you do not want sharpened using the Smart Filter mask.

Reducing Film Grain and Noise

The world has lived with film grain for many, many years. It's not your job to eliminate all of it when restoring photos. Therefore, do yourself a favor: Do not obsess over film grain (noise is a slightly different matter)! You will be tempted to take the Noise Reduction Hammer to your photos and ruin them.

When reducing film grain or digital noise (produced by the scanner), the dilemma is that you sacrifice detail in order to smooth out noise. This is the opposite of sharpening, which trades smoothness for sharpness.

When you must remove some noise, do so gently. Many people use the Reduce Noise filter, located in the Filter menu's Noise section. I prefer using the Camera Raw Filter. Either way, consolidate your work into a merged copy layer and convert it to a Smart Object first. Then apply whichever filter you would like to use.

There are a few differences between the filters:

- **Reduce Noise:** This filter has four sliders and an option to remove JPEG artifacts. The sliders are: Strength, Preserve Details, Reduce Color Noise, and Sharpen Details. Click the Advanced button to control how much noise to reduce per channel. If there is a lot of noise in a single color channel, it is nice to be able to target it and leave the others alone.

- **Noise Reduction (part of the Camera Raw Filter):** This filter has six sliders (see **Figure 7.13**): Luminance, Luminance Detail, Luminance Contrast, Color, Color Detail, and Color Smoothness. You cannot reduce noise in specific color channels, and there is no option to remove JPEG artifacts. All-in-all, I prefer this filter and find it effective at reducing noise yet keeping some detail.

When working with a photo like that in Figure 7.13, remember that removing film grain and noise should be less important to you than preserving the photo. If you look closely, you can tell that I did not completely remove the film grain in my hair or on my face and uniform. Reducing the severity of the grain was all I was after.

Figure 7.13 **When restoring photos, learn to live with some level of film grain.**

Before Settings After

I encourage you to experiment with these two different types of noise reduction and see what you think. Here are some tips to keep in mind:

* Film grain is often very aesthetically pleasing. If it looks nice in your photo, don't mess with it.

* Film grain tends to look better in black-and-white photos than color. If you have a grainy color photo, consider converting it to black and white.

* Remember that when you reduce noise, you remove varying degrees of sharpness from your photo. If necessary, sharpen afterwards to try and recover details.

* Reducing film grain and noise in uniform areas of the photo, such as the sky or evenly toned buildings, can be effective.

* Noise in detail-rich textures, such as gravel or grass, is often hidden.

* Consider masking areas of the photo that lose too much detail when reducing noise. However, take care that you don't create an imbalanced photo that has some noisy areas and some oddly clean ones. People may notice the mismatch. In cases like this, I always err on the side of keeping the noise.

Reducing Red-Eye

Thankfully, red-eye is not a particularly common problem in old photos. However, when you run across particularly red eyes, you can zap them in a number of ways.

First (and possibly the easiest) is to use the Red Eye tool, which is hidden under the Spot Healing Brush on the Tools panel:

1. As usual, create a merged copy of the photo and any adjustment layers you've made.

2. Select the tool, then click and drag to make a rectangular selection around an eye, as shown in **Figure 7.14**. Undo if necessary and try again.

3. Increase or decrease the size of your selection to see what effect it has on the eye. You can also adjust the tool's settings: Pupil Size and Darken Amount.

This tool is also available in the Camera Raw Filter, which means you can use it when making other adjustments using Camera Raw on a Smart Object layer.

There are other techniques for reducing or removing red-eye. I will not go into detail, but I have had success with desaturating offending eyes, using the Channel Mixer, and even using Hue/Saturation. When you use different adjustment layers, mask everything but the eyes.

Figure 7.14 If the tool doesn't seem to work, make a larger selection.

Before After

Removing Glare on Eyeglasses

Removing glare on glasses is a hit or miss proposition. I don't suggest trying to fix this problem until late in the restoration process. If the glare is so bad that restoring the photo is not worth it unless you can remove the glare, then you should experiment first to see if you can. By and large, though, you should work with good photos that can be made better, but won't be ruined if you can't successfully eliminate the glare.

There are several reasons glare is so hard to fix:

- You're dealing with one of the most distinguishing features a person has. When cloning on the face and around the eyes, it is vital that you do not change how they look. This ruins the photo.

- The area is small and you often have very little room to select matching source areas to use when cloning.

- Glare and the undulating surface around the eyes create gradients that are sometimes impossible to match. Yikes!!

The photo of my mom in **Figure 7.15** was possible to fix because the glare was limited to one lens of her glasses and does not cover her eye—it is restricted to her eyelid and moves up towards her brow. I used a fresh layer to clone on and then used good material from her eyelid and beneath her eye as my sources.

Figure 7.15 **Removing glare is a tricky business indeed.**

Before After

Reducing Lens Distortion

If you run across a photo that looks distorted, try running it through the Lens Correction filter. Here's how to do it:

1. Create a merged copy that consolidates all your changes into a single layer.

2. Select the layer in the Layers panel and convert it to a Smart Object.

3. Select Lens Correction, which is found under the Filter menu.

4. Select the Custom tab (as shown in **Figure 7.16**).

5. Slide the Remove Distortion sider left or right to remove pincushion (pushed in) or barrel (bulging out) distortion.

6. If necessary, use the Vertical or Horizontal Perspective sliders to transform the image and correct perspective problems.

 Lens distortion is a different animal than perspective problems. The lens causes the former; the latter is caused by how the camera was held. You'll see another method of correcting perspective in the next section.

7. Likewise, use the Angle and Scale to tweak the image.

 If necessary, use the Straighten tool (on the toolbar to the left of the dialog box) and draw a line identifying what should be vertical or horizontal in the image. Photoshop will calculate the proper angle to use to straighten the image.

8. Click OK to finish.

I took the photo of a sunrise in Figure 7.16 while I was a cadet at the U.S. Air Force Academy. The F-104 on static display is the subject, but the sunrise, sky, grass, and buildings frame the scene beautifully. There is a touch of barrel distortion in this photo: The center feels like it is bulging out a bit. Aside from the distortion, I corrected the perspective a bit and straightened the photo a tad.

Before

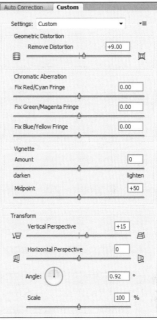

Settings

Figure 7.16
Correcting a slight
amount of distortion
in this photo
is possible using
Lens Correction.

After

Transforming Photos

At times, you may run across a photo that doesn't look right. You may not be able to put your finger on why, but lines that should be straight aren't. Often, this indicates that the photo has a perspective problem.

For example, the photo my wife took of the Eiffel Tower, shown in **Figure 7.17**, leans uncomfortably to the left. The building on the right is leaning toward the center of the photo. Although it's not the end of the world, I would prefer to see everything straight (or nearly so).

The solution is to transform the photo. Here's how:

1. After cleaning and repairing your photo, create a merged copy that consolidates all of your changes into a single layer and select it in the Layers panel. This is what you will transform.

2. Select Edit from the Free Transform menu.

3. Zoom out so that you can see the entire canvas.

4. If you need some visual assistance determining what is true vertical, show the rulers, and then drag one or more vertical and horizontal guides onto the canvas. You can also turn on the Grid. I often use the side of the photo for help.

5. Press and hold Ctrl (Win) or Cmd (Mac) and drag a corner handle up and outward. Do this for each handle so that the lines of the photo are basically straight.

 It takes practice to know where to drag the handles so that you can achieve the effect you're after. In this case, I dragged the top handles outward and up. I then dragged the top-center handle upward to give the photo a bit more height.

6. Click the Commit button to accept the transformation.

Figure 7.17 At times, it is necessary to transform photos to fix them.

Before During After

Using Clarity

Clarity can be a great tool to add or remove local contrast to your photos. When reduced, this has the effect of making the photo look like it was shot with a soft focus. It looks dreamy. When increased, the photo will look grittier and have a hyper-detailed (and often artificial, but hey, this is a special effect) look to it.

Experiment with clarity to see what effects you can create. I like reducing clarity a smidge when I want to make people look better. Conversely, increasing clarity will make most people look very unattractive.

The only way to use Clarity is from the Camera Raw Filter, which is in the Filters menu. I always apply the filter to a Smart Object layer.

My father-in-law took the photo shown in **Figure 7.18** when he was in the Air Force, assigned to a base in Canada in the 1950s. I love the repetitive nature of the trees and the stark sky; the hills in the background hint at the scale of the photo.

To show you the effect of Clarity, I have used three different settings on this photo. The first shows settings well into the negative numbers. The second shows the photo with a Clarity setting of zero. The last shows Clarity increased. Notice the first has a wispy look and the last has a definition that borders on harshness.

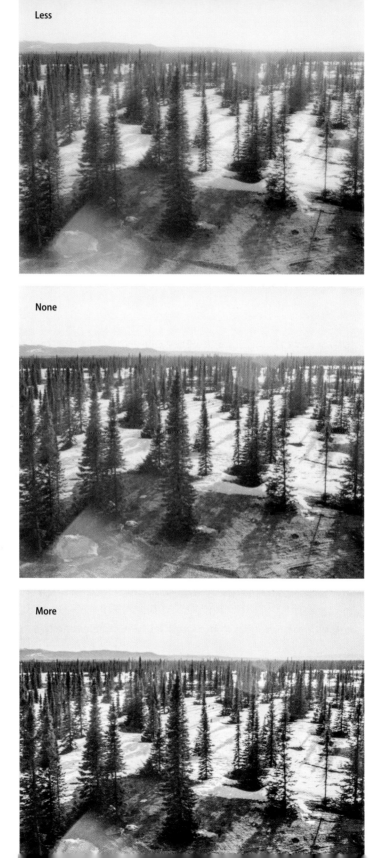

Figure 7.18 **Three different Clarity settings applied to one scene**

Less

None

More

Creating Duotones

Duotones enjoy a long history as a printing technique that uses two different colored inks (often shades of black and another color, such as blue) to print what is effectively a colored grayscale image. You get a wider range of possible tones out of using two inks than one. Tritones are printed with three inks; quadtones use four inks.

You can mimic this real-world process using the Duotone feature in Photoshop. It's a great way to tone black-and-white photos that have color imbalances or add luster to photos that are too bland.

Regardless of whether you use this as an interim step or save it for last, I suggest creating a copy of your working restoration file (Image, Duplicate), flattening it, and saving it with a new file name to start. The changes made to the file by the Duotone process make continued restoration impossible.

When you're ready, follow these steps:

1. Convert the photo to grayscale using the Grayscale option, which you can find in the Image, Mode menu.

 If you want more control over the conversion process, try creating a Black and White adjustment layer as the top layer in your file, then tweak the settings to achieve the look you prefer. Then convert the photo to grayscale.

2. If prompted, go ahead and flatten the image. This makes the file use fewer resources.

 Again, I prefer starting with a flattened copy of my working file, so I am ahead of the game.

3. Confirm that you want to discard color information.

4. Select Duotone from the Image, Mode menu.

5. Select a Preset from the drop-down list (see **Figure 7.19**) and preview it.

 The presets are generally named for the colors used. For example, "mauve 4655 bl 3" is the third combination of mauve and black. This is a trial-and-error process, so select as many presets as it takes to find something that looks interesting to you.

 In Figure 7.19 I am previewing the mauve preset on a photo shot at, you guessed it, the same general location in Canada as the last figure. Rather than a serene landscape, this time my father-in-law captured the fierce action of a plow cutting through the snow.

Figure 7.19
The duotone gives the photo a pleasing tone.

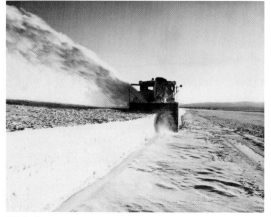

Original

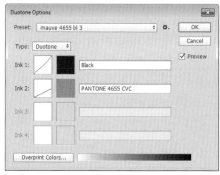

Preset

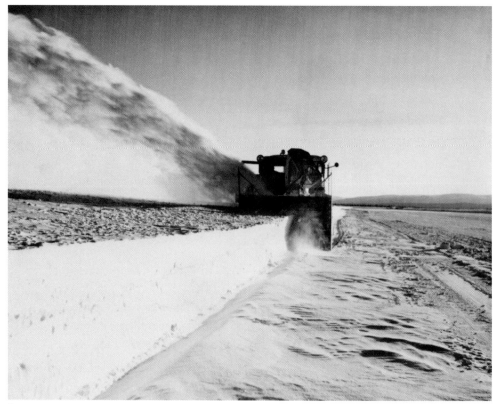

Duotone

6. Select OK to close the dialog box.

7. If you like, save your duotone image.

 As long as you perform the next step, you don't need to preserve this file.

8. Drag the duotone into your photo restoration file as a new layer, as shown in **Figure 7.20**.

 This may seem odd, but I like converting the 8-bit grayscale duotone back into a 24-bit RGB image for further restoration. This way I am also able to use the duotone to blend creatively with the original photo. It always pays to experiment.

9. Continue working.

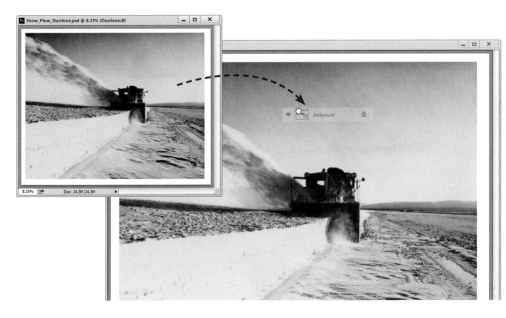

Figure 7.20
Drag the duotone into your restoration file.

The one caveat I would mention about duotones is that they are limited to an 8-bit color space. Converting to grayscale doesn't sound all that bad, but what happens is that you convert three 8-bit color channels to a single 8-bit grayscale channel. It doesn't look as bleak at it sounds, but you do lose a smidgen of quality along the way. If you notice the difference (I'm not sure that I ever have), consider creating your own type of duotones using color fill layers with Blend Mode set to Color. To blend each color layer:

1. Double-click the layer in the Layers panel to open up the Layer Style dialog.

2. In the Blending Options section, adjust the Underlying Layer slider to assign the color to a specific tonal region. For example, if you want purples to "stick" to dark tones, slide the white slider down until the sliders encompass only those tones you want the color to blend with.

3. Set the color layer's Opacity to blend further.

Using Creative Masks

Masks are powerful, are flexible, and help you solve problems like targeting adjustments and limiting changes to a specific area of a photo. They are so helpful to the photo restoration process that I've made sure to cover them whenever possible. It should be no surprise, then, that I've found a way to squeeze them into this chapter.

My wife took the photo shown in **Figure 7.21** of the Royal Gorge Bridge in Colorado. I reached a point in the restoration where I was unhappy with the tone of the distant background. I decided to apply a Photo Filter (as a Smart Filter) to cool the color but did not want the entire photo changed. Therefore, I used the Gradient Fill tool to mask out the foreground. The gradient provides a nice blend between the two areas of the scene.

Be on the lookout for ways to create and use masks imaginatively. If you can't paint them on, try using selections. If that doesn't match what you need, consider the different gradient fill options. Being able to create masks in a number of ways opens up many more possibilities for you to target and blend adjustments.

Before

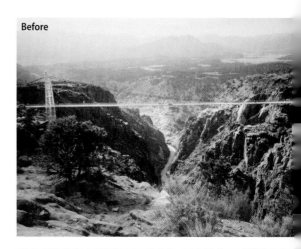

Gradient Mask

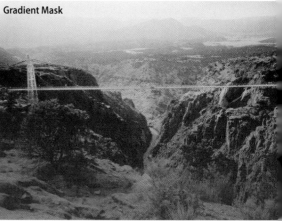

After

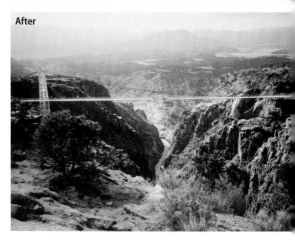

Figure 7.21 The mask helps make the colors look "gorge-ous."

Being Artistic

In previous chapters, I've suggested doing as little to photos as possible so that your work remains hidden. This changes when you are restoring a photo artistically. You can let your hair down, get crazy, and do what you want. The end result is whatever you want it to be.

I can hear you asking, "When should I perform an artistic restoration?" My short answer is "When a photo asks you to." My long answer is that, with time and experience, your ability to see potential in photos will grow. You won't be able to go on without trying something artistic with some shots. You may not always be able to bring out whatever it is you're feeling, or successfully pull off every technique or attempt, but you will sense that you need to try.

Here are some tips to help you develop your artistic side:

- Experiment all the time.

- Don't limit yourself to a single type of technique. In other words, resist using the same filter with the same setting on every photo you restore.

- Analyze why some techniques look good on certain photos and some do not. The differences may involve people (or the lack thereof), simplicity, color, detail, or any number of factors.

- If something doesn't work, don't give up. Take a break and return when you're fresh.

- Create alternative expressions of the same photo using different techniques or settings and evaluate them.

- Get a second opinion. It drives her crazy when she's busy, but I call my wife into my office time and time again to ask her what she thinks of my photos. She knows that I want an honest, often gut reaction. If it hits her one way or another, I need to know. Then we figure it out and go from there. Sometimes that means I move on to something else. Sometimes I refine what I am doing or tweak a few things. When I get a "Wow!" from her, I know I've nailed it.

Now it's time for some examples to show you some fun things I've come up with. Fun is the key word here. It's not what I would call serious art, and I didn't have to suffer that much to achieve it. Quite simply, these types of photos make me happy and look great printed, framed, and hung around the house.

As you look through my examples, keep in mind that your artistic sensibilities may be different than mine. You may want to try painting over your photos, using the Liquify filter, or distorting them. Go for it!

Lady Liberty Comes Alive

I've used the photo shown in **Figure 7.22** a few times in this book. I really love it. It's an odd shot of people looking at the Statue of Liberty. All you can see is the backs of their heads.

One rule I have when using Photoshop is to try the Lens Flare filter (located in the Render section of the Filter menu) on lots of photos. It's so much fun I don't really care if it's over-used. I blurred the background with an Iris Blur (this protects the statue without having to mask it) and centered the flare on Liberty's torch. I stacked two Smart Filters together to accomplish this using a single Smart Object layer. The end result is really captivating.

Figure 7.22
She is radiant,
isn't she?

Before

After

Blending Possibilities

The photo shown in **Figure 7.23** is of the tree that used to stand in my in-laws' front yard—until the city came through and cut down all the trees that were within 50 feet of the power lines, that is. I was experimenting with different blend modes when I came across this nice combination. To achieve it, I duplicated the background layer and set the Blend Mode to Hard Mix. Experiment with different modes and opacities, and you will be surprised at what happens.

Figure 7.23 **Look up for wow!**

Before

After

Overcoming Noise with Color

My wife (shown on the left in **Figure 7.24**) took this selfie with a close friend on her last night as a single woman. We were married the next day. It's a cute shot of both of them. Unfortunately, the photo is dark and has a tremendous amount of film grain.

Sometimes the only way to get around film grain or noise is to do something creative with the photo. I tried converting it to black and white but that didn't look much better, so I experimented with other approaches. In the end, I used a blue Color Fill layer and set the Blend Mode to Divide. Bam: yellow. So unexpected and yet so simple.

Figure 7.24 **Color Fill layers expand the artistic possibilities tremendously.**

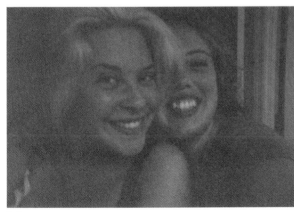

Before

After

Sometimes It's Good to Be Bad

I find this photo (see **Figure 7.25**) of my wife's grandfather hysterically bad, but also brilliant. It's a shot of him sitting on the couch one Christmas with a look on his face that is hard to interpret. The composition is poor. The wall takes up most of the photo. Despite that, there is something about the balance that I find oddly pleasing.

As I thought about how to discuss my approach to this photo, I was reminded of the character Ralph from the movie *Wreck-It Ralph*. He realizes that he's bad (actually he's not; he's got a good heart and eventually transforms into a selfless hero) as he dives down into Diet Cola Mountain to save the Sugar Rush world. But he's okay with that.

Some photos are bad, and that's okay. But they can be transformed. That's okay too.

In this case I was messing around with different filters to see what effect they would have, and I stumbled upon Note Paper with a particular color combination that turned this photo into an artistic drawing. I love it because it transforms an otherwise unimpressive photo into something that really draws your attention. Perfect for a quirky display.

Figure 7.25
Creative filters can transform photos into drawings.

Before

After

Using Photoshop Elements

If you use Photoshop Elements, you will be able to use most of the techniques that I show in this chapter to make final corrections to your photos, embellishments, and even artistic statements.

The two largest limitations you will face are Elements' lack of support for duotones and Smart Objects. You can work around this with some additional effort.

To create duo-and-more-tones, use a Hue/Saturation adjustment layer (select Colorize) or Color Fill layers. With the latter, after creating the layer, set the Blend Mode to Color (see **Figure 7.26**), lower the opacity, and mask areas you want to remain untouched. You have to use masks because Elements does not have layer styles that have variable blend options based on the tone of the layer underneath.

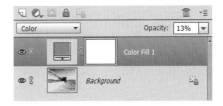

Figure 7.26 **Use Color Fill layers in Elements to tone photos.**

You will not be able to use Smart Objects at all. This does not prevent you from using filters (with the exception of the Camera Raw Filter), but it does prevent you from using filters nondestructively. Create a merged copy layer, then apply the filter of your choice to it. You will not be able to change the settings or even call them up to remind yourself what they are.

If you use multiple pixel layers and apply adjustments and changes directly to them (often by necessity), your computer may balk at the huge file sizes you end up with. If this is a problem, I recommend separating your work into two or more different files. Begin with a cleaning file. When finished cleaning, save that file, then make a flattened copy to save as a new file for repair work (skip this if repairs are not needed). When done repairing, do the same thing and create a color/brightness/contrast file. When you are finished with these tasks, save that file and create a merged duplicate to use as a finishing file. Always keep a copy of the original photo in each file as the top layer so that you can quickly compare your progress to the original. In the end, you may have a few extra files, but working with them will be less frustrating than trying to wrangle a single gigantic file.

Most of the tools—such as the Dodge and Burn, Red Eye Removal, Straighten (use in place of the Ruler), Crop (you can also try Recompose), and others—work largely the same. Just be sure to uncheck Rotate All Layers when using Straighten (see **Figure 7.27**). Otherwise you will rotate the entire photo, which is not something I recommend.

Figure 7.27 Straighten works like the Ruler in Photoshop.

You also have access to most of the same filters as Photoshop:

- High Pass and Reduce Noise (without the advanced channel-specific feature) are the same.

- The artistic filters are the same, although you do not have the Blur Gallery filters like Tile Shift and Field Blur.

- You will need to use Correct Camera Distortion instead of Lens Correction.

- If you want to sharpen using Unsharp Mask, it is located under the Enhance menu instead of with the other filters.

- You should check out Adjust Sharpness as well. It's in the Enhance menu.

You will also be able to use creative masks and transform layers to correct perspective distortion.

Chapter 7 Assignments

Use these assignments to finish on a strong note. You should be familiar with all of the restoration techniques I've shown in the book and be in the mood to put the final touches on your photos. Think about the things you can do to complement the work you've put in so far and take your photos over the top.

Dodge and Burn

Pick out a few photos that will benefit from dodging and burning. Remember to emphasize important details and make those areas stand out. Dodge highlights and burn shadows or midtones. Experiment with different Exposure settings so that you get a sense of how effective it is. You might be surprised to realize how little you need.

Sharpen and Reduce Noise

Likewise, go though your photos and see if there are any candidates for sharpening and noise reduction. You will probably find more that could use sharpening than need noise reduction. Try using the methods I have introduced in this chapter to get a feel for how much better sharpening makes photos look—and how much is too much. Do the same with noise reduction.

Be Artistic

This is your chance to be as creative and imaginative as you can be! Gather a handful of photos that you think might look good interpreted artistically. Experiment with different techniques and effects. Get in touch with what inspires you and see if you prefer one type of artistic embellishment over another.

Share your results with the book's Flickr group!
Join the group here: www.flickr.com/groups/photo_restoration_fromsnapshotstogreatshots

Index